PALACE AND MOSQUE

PALACE AND MOSQUE

ISLAMIC ART FROM THE MIDDLE EAST

Tim Stanley

with Mariam Rosser-Owen
and Stephen Vernoit

V&A Publications

First published by V&A Publications, 2004
Reprinted 2006

V&A Publications
160 Brompton Road
London SW3 1HW

Tim Stanley, Mark Jones, Mariam Rosser-Owen, Stephen Vernoit,
Barry D. Wood and Rebecca Naylor assert their moral right to be
identified as the authors of this book

Designed by Bernard Higton
Photography by Mike Kitcatt of the V&A Photographic Studio

ISBN 1 85177 429 7

A catalogue record for this book is available from the
British Library

Front cover illustration: Glass lamp with enamelled and gilt
decoration (plate 14).
Back cover illustration: Safavid tile panel (plate 71).
Frontispiece: Ottoman marquetry table with a tile top (plate 121).
Illustration on opposite page: Bowl; fritware, with enamelling and
gilding over the glaze; Iran, probably Kashan, late 12th or early
13th century; V&A: C.85–1918.
Illustration opposite contents page: Silk velvet with metal thread;
Turkey, 16th century; V&A: 1357–1877.

Printed in Hong Kong

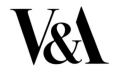
V&A Publications
160 Brompton Road
London SW3 1HW
www.vam.ac.uk

The Jameel Gallery of Islamic Art has been made possible by the generosity of Hartwell plc, part of the Abdul Latif Jameel Group, and is dedicated to the memory of the late Abdul Latif Jameel, founder of the Group, and his wife Nafisa.

Touring exhibition dates:

National Gallery of Art, Washington
18 July 2004 – 6 February 2005

Kimbell Art Museum, Fort Worth
3 April 2005 – 4 September 2005

Setagaya Art Museum, Tokyo
1 October 2005 – 4 December 2005

Millennium Galleries, Sheffield
14 January 2006 – 16 April 2006

The Jameel Gallery of Islamic Art opens at the V&A in Summer 2006

FOREWORD

The Victoria and Albert Museum in London is the world's greatest museum of applied and decorative arts, and it contains one of the world's most significant collections of Islamic art. There is a strong link between these two assertions. The Museum was founded in 1852 because the development of British design had not kept pace with the technological advances made during the Industrial Revolution. By contrast, the application of ornament to surface in what we now call Islamic art was much admired, and Islamic objects were purchased for the Museum from the start: they were seen as a potential source for improving design in Great Britain.

In the 1850s and subsequent decades, the V&A's collection was built using impressively ample funds provided by the British government. During the same period, private individuals in Britain began to acquire examples of Islamic ceramics, silks, carpets, metalwork, glass, manuscripts, paintings and other media for their own pleasure. In later years, several of these collections were acquired by the Museum, giving its holdings great depth and variety. This mixture of practical purpose and aesthetic appreciation is still key to the V&A's role as a provider both of information and enjoyment.

A great change occurred in the appreciation of Islamic art during the twentieth century, when interest was refocused on its ability to illustrate the broader history of Islamic culture. Since the 1950s, the primary galleries of the V&A have included one devoted to the Islamic Middle East, and it can now be renewed, thanks to the generosity of Hartwell plc, part of the Abdul Latif Jameel Group. When it opens in 2006, it will be named The Jameel Gallery of Islamic Art in memory of Mr Abdul Latif Jameel, the late founder of the Abdul Latif Jameel Group, and his wife Nafisa.

Mark Jones
Director

CONTENTS

Introduction
A SENSE OF GEOGRAPHY 7
Prayer, time and space by Tim Stanley 14

Chapter One
WHAT IS ISLAMIC ART? 17
The Sasanian inheritance by Rebecca Naylor 20
The art of the Qur'an by Tim Stanley 26
Textiles and burial by Tim Stanley 32
The non-Muslim presence by Rebecca Naylor 38
The Isfahan cope by Tim Stanley 40

Chapter Two
THE ISSUE OF IMAGES 43
A Safavid clock dial by Tim Stanley 46
The Chelsea carpet by Tim Stanley 54
An Ottoman tradition in calligraphy by Tim Stanley 60
Khusraw and Shirin by Barry D. Wood 66
The Ardabil carpet by Tim Stanley 74

Chapter Three
THE POETIC ENVIRONMENT 77
Ivories from Spain by Mariam Rosser-Owen 80
Hoards by Mariam Rosser-Owen 88

Chapter Four
PATRONS AND MAKERS 91
A rock-crystal ewer by Mariam Rosser-Owen 94
The minbar of Sultan Qa'itbay by Barry D. Wood 100
The Luck of Edenhall by Mark Jones 108

Chapter Five
INTERACTION 111
Caskets and Hunting Horns by Mariam Rosser-Owen 114
A bowl from Málaga by Mariam Rosser-Owen 120
Silver and brass by Tim Stanley 126
Armistice Day, 1918 by Tim Stanley 132

Epilogue: Islamic Art in South Kensington 134
Robert Murdoch Smith by Rebecca Naylor 136

Appendix: The Dynasties 138

Notes on translations 140

Further reading 140

Picture credits 141

Acknowledgements 141

Index 142

Introduction

A SENSE OF GEOGRAPHY

Left: 1. Tile with a diagram of the Noble Sanctuary in Mecca. Fritware painted under the glaze. Turkey, probably Iznik, 17th century. Height: 61 cm. V&A: 427–1900.

Right: 2. The mihrab in the 14th century mosque of Sultan Hasan in Cairo. The minbar is to the right of the mihrab niche.

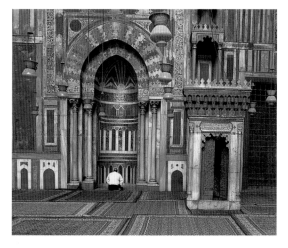

The Middle East has played a pivotal role in human civilization for thousands of years, and during its long and fascinating history it has repeatedly produced art that still has the power to engage us today. Before the twentieth century, the Middle East was a land of empires, and among the greatest of these was the state established by the first Muslims in the seventh century AD. *Palace and Mosque* describes some of the outstanding art works produced in the Muslim world over the following 1,200 years. This art is a testimony

to the gusto and talent of its makers, and it demonstrates how, during this long period, the Middle East retained a central place in the world, both as a forum for exchange and as a focus of piety.

The prophetic mission of Muhammad, who died in AD 632, led to the foundation of Islam as a religion, and it simultaneously gave rise to a new state that grew rapidly under Muhammad's successors, the caliphs. By the middle of the eighth century, its territories stretched from the Atlantic Ocean in the west to the banks of the Indus in India and the borders of China in the east. The political unification of this vast domain was eventually followed by an increasing degree of religious and cultural coherence, which survived the disintegration of this first Islamic empire. Its political unity, weakened in the ninth century, was broken altogether in the tenth. From this time, the universal caliphate was replaced by a shifting pattern of lesser states (some of which were nevertheless very large). Despite political disintegration, a form of unity was maintained, since all the entities that succeeded the caliphate took a form of Islamic law as their organizing principle. In the Middle East this tradition was maintained until the early years of the twentieth century.

Drawing boundaries

Artistic production in the caliphate's successor states
also had a great deal in common – at least, it is similar
enough to make it worth discussing as a whole, and it is
diverse enough to make this discussion interesting. For
this reason, a very broad view has been taken here, of
the Middle East as a geographical unit, including within
it all the territories held by the Islamic caliphate
around AD 750, with some changes over time (see
map). Under discussion come artefacts made in the
core of the region, in the lands between Egypt and Iran.
Also discussed are objects made in what is now
Afghanistan and the former Soviet republics of Central
Asia, in the Caucasus, in North Africa and even in
Spain, which formed part of the Islamic world from the
early eighth century until the fall of Granada in 1492.
Other boundaries were fluid, too. From the end of the
eleventh century, Asia Minor gradually came under
Muslim Turkish rule. By the mid-fifteenth century, the
Turks had entirely replaced the Byzantine empire, both
there and in south-east Europe. The art they made in
these regions also has a place in this account.

The occasional changes in the boundaries of the
Islamic Middle east were insignificant compared with
the permeability of these boundaries to the flow of
goods, people and ideas. From the foundation of the
Islamic empire in the seventh century, the enormous
wealth that accrued to its rulers from booty and
taxation allowed them to import whatever they
wished from any other part of the Old World.
In doing so, they were able to reflect their claim to
universal dominion.

The Middle East became a great mart that dealt in
goods from every quarter, whether raw materials or
finished wares. Luxury industries flourished, often
continuing Middle Eastern traditions of the pre-Islamic
period. One was glass production, which was based on
locally available materials. Another was the carving of
imported rock crystal. In some cases, demand rose,
but local production was overtaken by imports of
superior quality. The best understood example is the
introduction of high-fired ceramics from China. The
challenge from the superior Chinese wares forced
Middle Eastern potters to make radical changes in the
way they worked, and this happened not once but
repeatedly over a period of a thousand years. Middle

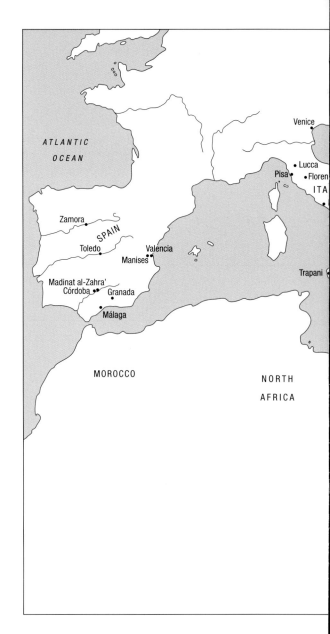

Eastern luxury wares made their way in the opposite
direction, too, and a group of early Islamic glass
objects, for instance, has been found buried intact as
an offering in the foundations of a ninth-century
temple at Xian in China.

This was not, however, a story of unending
prosperity and seamless progress. Invasions, plagues,
famines and earthquakes all played their part in the
ups and downs of artistic production. Centres of
production moved. Patterns of trade changed. The
creation of the Frankish empire by Charlemagne
around AD 800 was followed by a gradual
improvement in economic conditions in Christian
Europe, which then grew in importance as a market
for Middle Eastern exports. But these changes also
created a new rival for the Middle East in both the
military and economic spheres.

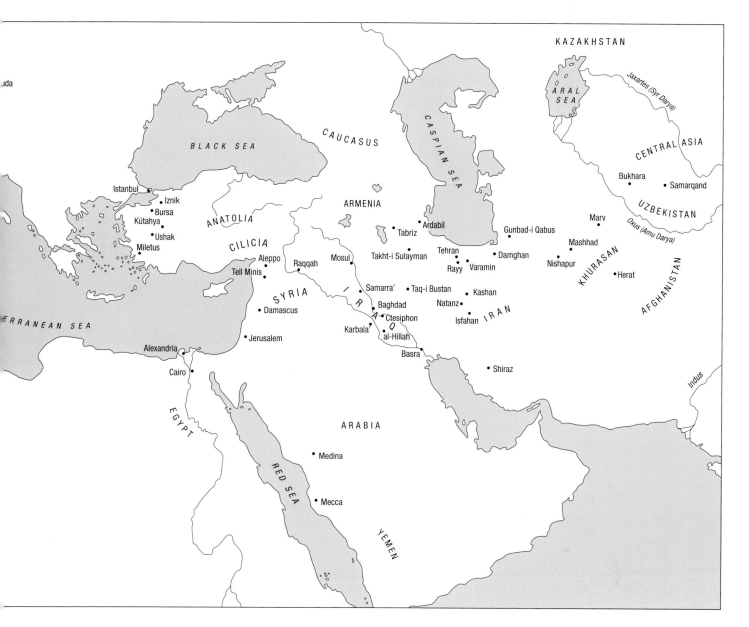

At the end of the fifteenth century, as the Middle Ages drew to a close, the Middle East lay at the centre of a pattern of commercial routes that linked Europe and the Mediterranean world in the west with eastern and southern Asia. It also drew raw materials and slaves from the less developed regions to the north and south. In this period, before the European discovery of the Americas, the Middle East truly lay at the centre of the world. The art made there reflected this fact, helping to give it a universal relevance.

Looking at it in this way, the Middle East might be expected to have lost its identity in a sea of cosmopolitanism. There was, however, one enormously important factor that acted against this, and that was the religion of Islam. Far from losing its distinctive character because of the intensity and multiplicity of its interregional contacts, the Middle East was, and still is, the source of a strong spiritual force that has radiated out over surrounding regions. Sometimes it was borne there by might of arms. At other times it was transmitted along trade routes by peaceful means – through the preaching and personal example of missionaries and merchants.

In the Middle Ages, Islam spread to sub-Saharan Africa, to India, to South-east Asia, to the great port cities of China, to the steppes of Kazakhstan, to towns along the Volga and to the mountains of Bosnia. In all those places, on every day of their lives, the observant among the Muslim population turned back towards the Middle East to say their prayers. In this sense, too, the Middle East was truly the centre of the world, and it remains so, even for Muslims in lands as far away as America and Australia, in which they have settled relatively recently.

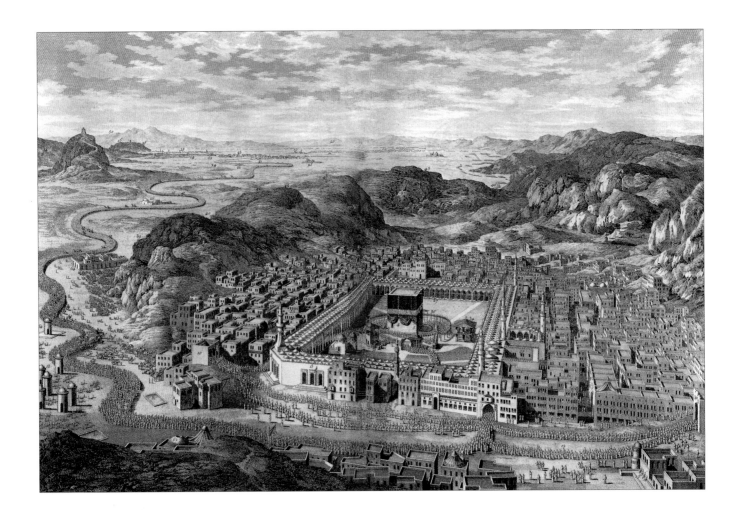

4. Depiction of Mecca, with the Ka'bah at the centre of the Noble Sanctuary. From the *Tableau général de l'Empire othoman* by Ignace Mouradgea d'Ohsson. Paris, 1788.

Sacred geography

The Middle East is the focus of Muslims' prayers because it contains the city of Mecca, situated in western Arabia and, more precisely, the structure known as the Ka'bah, which stands at the centre of the city (plate 4). This cube-like stone building had been a religious shrine long before the Prophet's time, and the Qur'an tells us that it was originally built by the Jewish patriarch Abraham as the first House of God. Later it fell into the hands of idolaters, and it was Muhammad's role to restore it to its proper use, by worshippers of the One True God.

Muhammad was born in Mecca, and it remained his home until AD 622, when he and his followers were forced to leave for the city of Medina, 350 kilometres or so to the north. Although he later gained control of Mecca, Muhammad continued to live in Medina until

his death, and he was buried in the corner of his domestic compound there, now the mosque of the Prophet. Muhammad's move from Mecca to Medina, known in Arabic as the Hijrah, marks the beginning of the Islamic era, while his point of departure in Mecca and his point of arrival in Medina became the Two Noble Sanctuaries – they are the holiest places in Islam, from which all non-Muslims are excluded.

After the Hijrah, a break was made with Jewish (and Christian) practice when, following a divine revelation on the matter, Muhammad changed the geographical focus of Muslim ritual from the holy sites in Jerusalem to the Ka'bah in Mecca. Henceforth believers turned towards this city to perform their daily prayers. This orientation, known as the Qiblah, is therefore an important factor in the life of Muslims, and it has affected their art and architecture in many ways. An

Below: 5. Prayer mat.
Silk embroidered
with silk and metal
thread.
Turkey, 19th century
Height: 205 cm
By permission of
Her Majesty Queen
Elizabeth II

Right: 6. Table used
to locate the Qiblah
at various latitudes
Ink on paper.
Cairo, 15th century
V&A: 693–1876,
folio 35A

obvious example is the layout of mosques and other religious buildings. Since the time of the Prophet, all mosques have been aligned towards Mecca, and the main wall at right angles to the Qiblah is set with one or more empty niches, known as mihrabs. From their presence the believer automatically knows in which direction to pray (plate 2).

When Muslims perform their prayers in mosques or other locations, they often use rectangular mats decorated with a bold arch motif – a two-dimensional representation of the mihrab – that can be oriented in the direction of prayer. The most familiar of these mats were made as pile carpets, but many were also produced in other techniques, such as embroidery (plate 5).

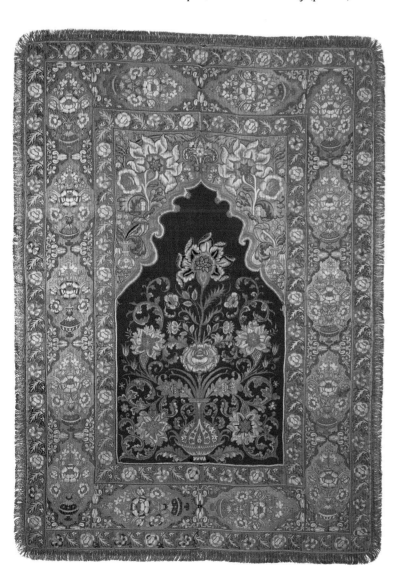

In some circumstances, Muslims may also need a means for establishing where the Qiblah lies. In the past, this could be done by a variety of methods, some far from precise. Indeed, finding the direction accurately was a complicated problem that could only be addressed by scientists. Over time, these men of learning were able to supply the rest of the population with data in tabular or graph form (plate 6), which allowed them to find the Qiblah more easily when used in conjunction with instruments adapted or specially developed for the purpose. The magnetic compass, introduced from China in the Middle Ages, was an element in many Qiblah finders, including a type produced in some numbers in nineteenth-century Iran (plate 7). The brass cases of these compasses are densely engraved with a gazetteer that gives the geographical coordinates of the Qiblah at many cities in the Islamic world, similar to that found in books of tables.

Telling the time accurately is also important for the correct performance of the five daily prayers (see

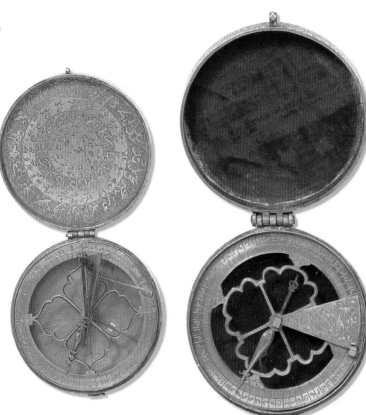

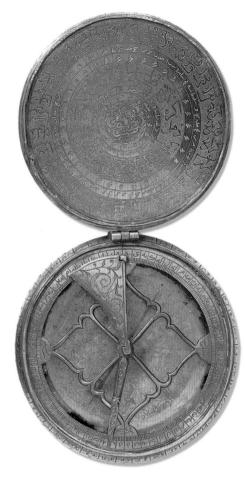

7. Three compasses for determining the Qiblah. Engraved brass. Iran, 19th century. Diameters: 9.6 cm, 6.7 cm, 9.6 cm. V&A: 574–1878, 762–1889, 307–1887

Below: 8. Pocket watch signed by 'Gianpetro' in Arabic script. Engraved and gilt brass, and silver Turkey, probably Istanbul, mid-17th century. Width: 5 cm. V&A: 136–1907.

pp.14–15), but the times of the prayers are based on a division of night and day into twelve hours each. Except at the equinox, these hours are unequal, and their length changes with the seasons. This means that mechanical clocks, which operate on a cycle of twenty-four equal hours, are of limited use for prayer times. When they were eventually introduced from Europe (plate 8), such timepieces could only be used in conjunction with calendars that gave the prayer times for each day according to the twenty-four-hour clock. Today these methods for finding the Qiblah and calculating the times of the prayers have been supplanted by digital instruments controlled by satellite.

If they have the financial resources, all Muslims are expected to go to Mecca as pilgrims at least once in their lifetime. The main pilgrimage, the Hajj, occurs once a year, at the time of the Feast of Sacrifice, and the elaborate rites on this occasion culminate in visits to the Ka'bah in the Noble Sanctuary, which is often depicted on the certificates and mementos the pilgrims acquired to record their pious journey. In the version shown here (plate 1), the sanctuary in Mecca is represented diagrammatically as though seen from the north-east (which is at the bottom). The various structures within the surrounding arcades are labelled, and the space immediately above the diagram is filled with a relevant quotation from the Qur'an (surah III, verses 96–7), which enjoins the performance of the Hajj on all believers who can afford it.

Orientation towards the Qiblah was required in many activities associated with ritual purity, such as the reading of the Qur'an and the slaughter of animals for food. It also governed burial practices: graves are dug so that the deceased will face the Ka'bah when

they rise up on the Day of Judgement. The marking of Muslim graves has varied enormously with time and place. In Iran in the late thirteenth and early fourteenth centuries, the resting places of many religious figures were renovated using splendid moulded tiles in which designs in lustre were applied over coloured glazes (plate 9). The basic outline of the design is provided by an arch motif, augmented by a hanging lamp and framed by a familiar Qur'anic quotation (surah CXII); this 'mihrab' indicated that the deceased had been buried in the alignment prescribed by Islamic law and would be among the saved on the fateful day at the end of time.

A complex legacy

All the artefacts discussed so far can be associated with the sacred geography of Islam, but their uses and significance do not necessarily stop there. The two tiles (plates 1 and 9) were restricted to religious functions, which is signalled by the presence on them of Qur'anic inscriptions, but the prayer mat (plate 5) is a different case. The simple arch motif it bears was never restricted to Muslim religious contexts. In the same period, for example, a very similar design was used to decorate the walls of imperial tents. Nor were the calculations made with an astrolabe confined to calculating the times of the five daily prayers and finding the Qiblah (see pp.14–15). The instrument could also be employed in mundane activities such as surveying, as well as in astrology.

The two astrolabes illustrated here (plates 11 and 12) represent a type made in Isfahan during the seventeenth and early eighteenth centuries, while it was the capital of the Safavid shahs (for the main dynasties, see the appendix), and the survival of many fine specimens from this period has been attributed not to religious enthusiasm but to the reliance of the Safavid court on the prognostications of astrologers. Indeed, so great was the reliance on their advice that

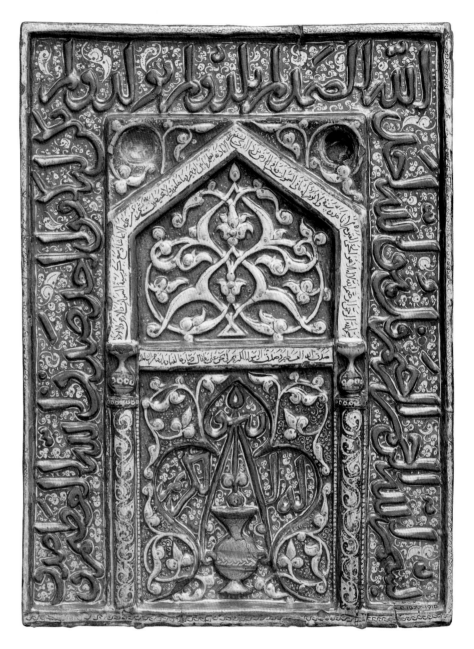

in 1667, Shah Safi II re-enacted his accession ceremony and took a new name, Shah Sulayman, following his astrologers' advice. They told him he had ascended the throne on an inauspicious day.

As the uses of the arch motif and the astrolabe show, the story of art in the Islamic Middle East is not a simple one. Although we call it 'Islamic' art, it is not so much the art of a body of believers as the art of a broad and complex culture. How, then, do we justify this name? How do we define 'Islamic art'?

9. Tile. Fritware, the decoration moulded with coloured glazes and lustre. Iran, probably Kashan, early 14th century. Height: 62 cm. V&A: C.1977–1910. Bequest of George Salting

Prayer, Time and Space

Tim Stanley

Left: 10. A celestial observation being made with an astrolabe. The seated figure holds the instrument aloft, while his assistant consults the astronomical tables in a book (compare plate 6). The tables were used to interpret the data from the sighting. See plate 60.

Below: 11. The front of an astrolabe with the star map, or rete, placed over one of the plates. The cord attached to the top was used to suspend the instrument while making observations. The instrument was made in Isfahan in 1667 by Muhammad Khalil Isfahani and engraved by Muhammad Mahdi Yazdi.
Height, including suspension ring: 18.6 cm.
V&A: M.38–1916.

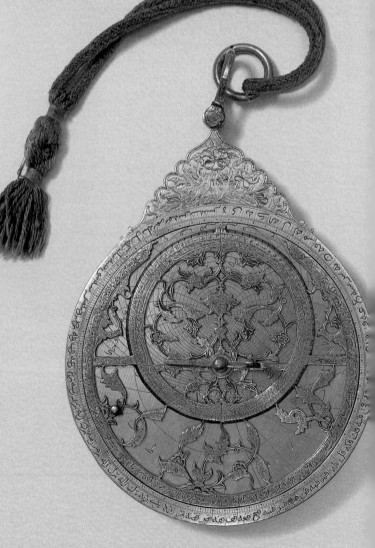

Muslims perform prayers at five set times a day while facing the Qiblah, that is, in the direction of Mecca. Telling the time and establishing the Qiblah are therefore important matters, and a variety of methods has been used to calculate both. One means of telling the time that accommodated the unequal hours (see p.12) was the planispheric astrolabe, a scientific instrument inherited from the Classical world.

The astrolabe has a star map, called the rete, in the form of an openwork disc. The positions of the stars are shown by pointers, here in the form of decorative leaves, and the circular device in the upper half is the ecliptic – the perceived path of the sun across the sky.

There are also one or more plates, each engraved for a particular latitude. A grid of coordinates above the horizon line allows the stars on the rete to be fixed in the correct position for that latitude. Below it are lines representing the

Below: 12. The back of an astrolabe, showing the alidade ready for making observations and, in the top right quadrant, the arcs indicating the altitude of the sun when it is in the direction of Mecca. The astrolabe was produced in Isfahan in 1715 by a celebrated instrument maker called 'Abd al-A'immah.
Height, including suspension ring: 19.6 cm.
V&A: 458–1888.

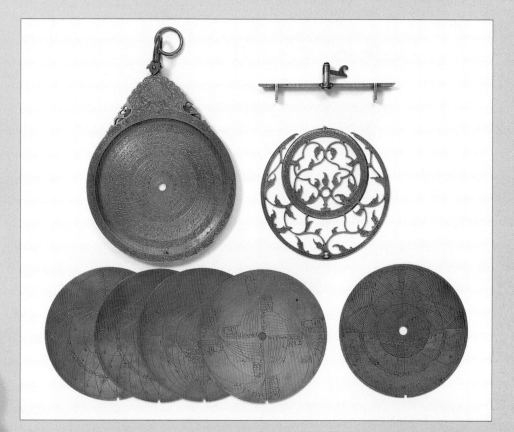

13. An astrolabe dismantled to show the mater (the casing), the plates for different latitudes, the rete (the star map), and the alidade (the sighting device), with the pin that holds them all together.
V&A: 458–1888.

division of day and night into twelve unequal hours. When the plates and the rete are pinned in the casing of the astrolabe, the rete can be rotated over the top plate until the stars are in the correct position.

On the back, the instrument is equipped with a rotating sighting device, called an alidade. If the alidade is moved into alignment with the sun or, at night, a star (see plate 10), it points at a graduated scale near the rim of the astrolabe, and the altitude of the sun or star can be read off the scale. If the rete is then rotated to reproduce this position on the plate beneath, the time can be read off the lower half of the plate.

The two astrolabes shown here could also be used to find the Qiblah: they are engraved on the back with a quadrant, which is crossed by a set of arcs that gives the altitude of the sun when it is in the direction of Mecca, each arc being valid for a different latitude (see plate 12).

Chapter One

WHAT IS ISLAMIC ART?

Left: 14. Lamp. Glass with enamelled and gilt decoration. Egypt, 1347–61. Height: 35.2 cm. V&A: 323–1900.

Right: 15. Basin. Brass inlaid with silver. Egypt or Syria, late 13th to early 14th centuries. Height: 18.7 cm. V&A: 740–1898.

Islamic art is a term that can be understood in several ways, all of which are equally valid: each simply emphasizes different features of an enormous body of material. Some definitions concentrate on the religious aspects of this art, giving pride of place to mosque architecture and calligraphy, especially that found in manuscripts of the Holy Qur'an (see pp.26–7). *Palace and Mosque* takes a broader view of the subject, treating Islamic art as the product of a culture in which not everyone was Muslim but in which Islam played a dominant role. It therefore encompasses *all* the art produced in the Muslim-ruled states of the Middle East and beyond, no matter what its particular social context may have been.

The time frame of Islamic art is also very broad, and its beginning and end are marked by two great events. The first of these was, of course, the rise of Islam in the seventh century AD, and the simultaneous founding of the first Muslim-ruled state. Thereafter, Islamic states succeeded one another in the Middle East until the end of the First World War in 1918, when the Allies occupied much of the defeated Ottoman empire (see pp.132–3). This, the second of the two events, was soon followed by the deposition of the last Ottoman sultan in 1922, and the fall of the Qajar dynasty in Iran in 1924. Most of the new regimes that emerged from these changes eschewed Islam as a political system.

Over the course of the long Islamic period, the ruling elite of caliphs, emirs, shahs, sultans and viziers set the style in every aspect of civilized life, including artistic production. The ability of these rulers to mould the character of Islamic art was all the greater in the absence of a priesthood, for which there is no real equivalent in Islam. It is for this reason that Islamic art reflects a sophisticated court milieu, where such apparently un-Islamic activities as astrology, dancing to music and drinking wine took place. Nor were the

people who commissioned, designed and made this art all Muslims, since most Islamic states had significant Christian and other religious minorities who participated in many aspects of Islamic cultural life.

Continuing traditions

Islamic art was not born into the world fully formed but came into being through a process of gradual change. When the Middle East passed under Islamic rule in the seventh century AD, there was no great break in artistic production: the early history of Islamic art formed a continuum with what had gone before.

16. Storage jar. Earthenware with applied decoration and coloured glaze. Iran, 6th to 8th centuries. Height: 62.8 cm. V&A: CIRC. 106–1929.

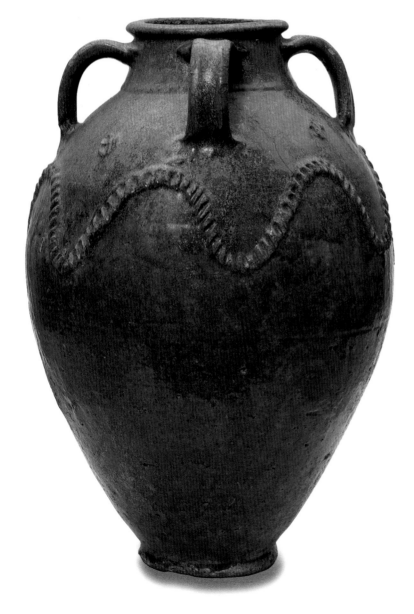

This was not a simple transition from one culture to another, since the eastern and western halves of the Islamic Middle East were heirs to two distinct artistic traditions. One originated in the Sasanian empire, which had ruled Iraq, Iran and western Central Asia for the four centuries before the Islamic conquest (see pp.20–21). The other was the Christianized form of Roman art we know as Byzantine, which was current in Egypt and Syria. Islamic art was formed by the merging of these traditions, together with the addition of novel elements.

Because of the continuity between Byzantine and Sasanian art on the one hand and Islamic art on the other, it is sometimes difficult to tell whether an item was made under Muslim rule or in an earlier period. This is particularly true of utilitarian wares, which were not generally affected by rapid changes in taste and could thus continue in production over very long periods. A type of earthenware storage jar with rudimentary applied decoration and a turquoise glaze is a case in point (plate 16). Vessels of this kind have been found in both Sasanian and early Islamic levels at archaeological sites in Iran, and as a group they are therefore described as 'Sasano-Islamic'. Sherd material from this type of jar has also been discovered at sites around the Indian Ocean and beyond, showing that the same jars were used for shipping goods out of the Persian Gulf along long-distance trade routes. In Iran turquoise glaze continued to be used long after the 'Sasano-Islamic' jars went out of production, and its use even survived major shifts in other aspects of ceramic technique. We therefore find turquoise-glazed storage jars made after the fabric known as fritware had been introduced in the twelfth century (on fritware, see p. 116).

Long before the Islamic period the use of blue-green glazes, created by the addition of copper to the glaze mixture before firing, was introduced from Iran or Syria to Egypt, where it has had a long and distinguished history, as two amulets – a head of Hercules from the Hellenistic period, and a more ancient 'eye of Horus' – show (plates 17 and 18). Any bright colour was a sign of relative wealth before the nineteenth century, when the invention of synthetic dyestuffs made the use of different colours cheap. In the pre-Islamic period, however, these coloured glazes

contemporaries. They have to be seen in terms of a common memory retained by the society that produced the artefact, passed informally from generation to generation.

Unglazed wares were also produced over a very long period. They have remained in use, especially for the storage of water, for entirely practical reasons: the porous body allows evaporation, which has a cooling effect. Although the vast majority of unglazed wares were undecorated, some examples were embellished with moulded and applied decoration that could be added without inhibiting this functional advantage. A refinement current in medieval Egypt was a filter of pierced clay that formed part of the structure of small, waisted water bottles, keeping flies and debris out of the vessel (plate 19). The filters were also the main decorative element of these humble objects, being pierced with all-over patterns or designs that include elephants, camels and other motifs (plates 20, left and centre), or with morally improving inscriptions (plate 20, right). The inscription shown here reads, 'Abstain: you shall thrive!'

Above, left: 17. Head of Hercules amulet. Faience ware with coloured glaze. Egypt, 2nd or 3rd century AD. Height: 9.53 cm. V&A: 486–1891.

Above, right: 18. Eye of Horus amulet. Faience ware with coloured glaze. Egypt, XXI Dynasty (1075–945 BC). Length: 6.35 cm. V&A: 5486–1901.

had special significance, which may also explain their longevity. In Egypt, for example, turquoise was the colour of the life-bringing waters of the River Nile, while in Iran the name for the stone turquoise is derived from *peroz*, a word the Sasanians had used for 'victorious'. Before the coming of Islam, then, the colour turquoise was auspicious in both Egypt and Iran, and this meaning may well have survived into the Islamic period. Such survivals can be difficult to prove, however, since they are not usually commented on by

19. Water jar. Unglazed earthenware with pierced and incised decoration. Egypt, 11th or 12th century. Width: 8.5 cm. V&A: C.899–1921. Given by G. D. Hornblower, Esq.

20. Three filters from similar water jars. Widths: 8.5 cm, 8.5 cm, 7.7 cm. V&A: C.863–1921, C.902–1921, Both given by G. D. Hornblower, Esq C.899–1919.

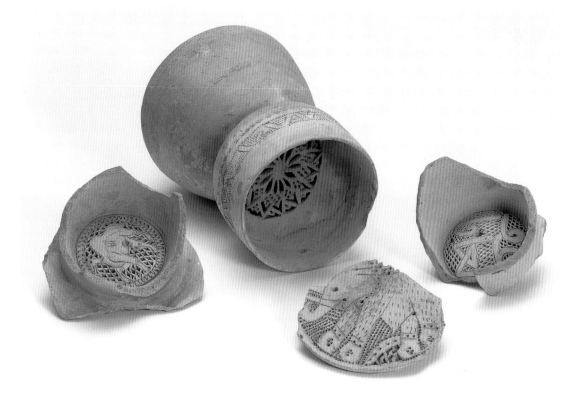

THE SASANIAN INHERITANCE

Rebecca Naylor

In the 220s AD, the Sasanian King Ardashir I founded the last of the great empires that ruled Iran, Iraq and western Central Asia before the Islamic conquest. Ardashir was from the province of Fars in south-west Iran, but he fixed his capital at Ctesiphon on the River Euphrates, near modern Baghdad. The ruins of the city survived throughout the Islamic period, and the remains of the huge third-century reception hall were known as the Arch of Kisra. This monument, which is 35 metres high at the crown of the arch, provided a constant challenge to ambitious Islamic patrons and architects.

The arch at Ctesiphon is named after the Sasanian monarch Kisra (Khusraw Anushirvan, ruled 531–79), who was regarded as the model of kingly justice in Arab tradition. The fame of his predecessor Bahram Gur (ruled 420–39) also lived on, especially in the story of his hunt with his favourite slave, Azadah (plate 100), while Khusraw Parviz (ruled 590–628) played the role of a more romantic hero in the Persian tale of *Khusraw and Shirin* (see pp.66–7).

The Sasanian empire did not long outlast Khusraw Parviz. In 636 the last king, Yazdagird III, was defeated at al-Qadisiyyah in Iraq by the Arabs, who began to occupy his territories. Yazdagird eventually fled to Marv in Central Asia, where he was murdered in a mill in 651.

The dynasty's reputation survived in literature and among Iran's Zoroastrian population, who still follow what had been the state religion of the Sasanians. The dynasty's patronage also continued to inform the arts of Iran and other parts of the Islamic world long after its fall. Motifs such as the *senmurv* and the pearl border (plate 22); genres such as scenes of the hunt and courtly love; techniques such as carved stucco and cut glass (plate 23); and forms such as pear-shaped ewers in brass (plate 24) or silver – all these were part of the rich Sasanian heritage of Islamic art. As a result, it is sometimes difficult to distinguish between Sasanian and early Islamic artefacts.

Below, left: 21. Detail from a 6th- or early 7th-century rock-cut monument in the mountains at Taq-i Bustan, in western Iran. It shows the trousers of a Sasanian king. They bear a *senmurv* motif that is strikingly similar to that on the silk (plate 22).

Below, right: 22. Fragment of silk with a repeat pattern of a *senmurv*. This example dates from the 8th or 9th century. It survived in a reliquary in the church of St Leu in Paris. Height: 35.5 cm. V&A: 8579–1863.

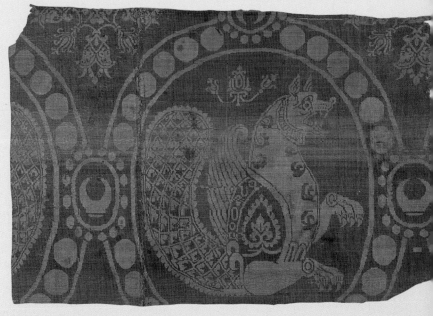

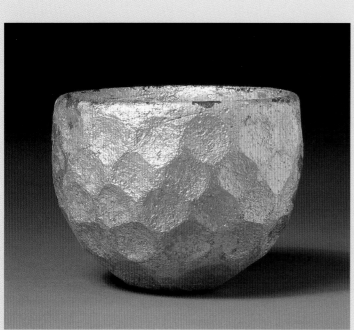

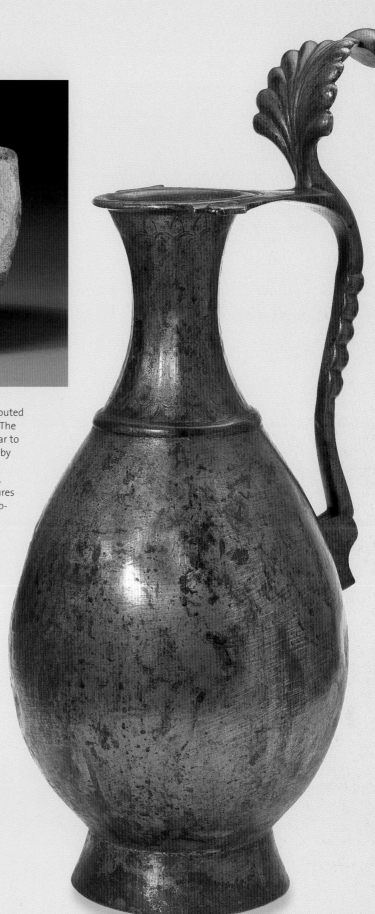

Above: 23. The cup is typical of the glassware made largely in northern Iraq and north-west Iran under the Sasanians. Originally a green-tinged translucent colour, the body has wheel-cut facets in a honeycomb pattern which would have caught the light when new. The iridescent patina is due to a long period of burial.
Height: 8.2 cm.
V&A: C.58–1963.

Right: 24. Brass ewer attributed to Iran in the 8th century. The pear-shaped body is similar to that of silver ewers made by Sasanian metalworkers, although more elongated. The main decorative features are the flamboyant thumb-rest, in a form known as a palmette, and a pair of stylized birds' heads around the mouth.
Height, including thumb-rest: 44 cm.
V&A: 434–1906.

The same theme is found inscribed on an unglazed pottery flask with elegant, moulded decoration, which is said to have been found in a well at Aleppo in Syria (plate 25): 'Drink so you may thrive – the act of an abstinent man! Drink with a thousand good wishes for your health and well-being!' In this case, it is possible that the mould maker embedded his own name in the inscription, since 'the act of an abstinent man' could also mean 'the work of al-'Afif'.

Generic inscriptions in Arabic are commonly found on everyday items in other media, although the texts

Above: 25. Canteen. Unglazed earthenware with moulded decoration. Syria, 14th or 15th century. Height: 27.9 cm. V&A: 761–1902.

Right: 26 Small dish. Earthenware with slip decoration under the glaze. Iran, probably Nishapur, 10th century. Diameter: 10 cm. V&A: C.909–1935.

Above: 27. Ampulla from the shrine of St Menas. Moulded earthenware. Egypt, late sixth to mid-seventh century AD. Height: 9.5 cm. V&A: C.79–1953. Gift of Dr W. L. Hildburgh, FSA

employed usually consist of more straightforward good wishes. One on a small dish from tenth-century Iran (plate 26), for example, calls down God's 'blessing and favour upon its owner'. An Iranian silk textile of the tenth to twelfth centuries (plate 42) bears a more elaborate version: 'Glory and good fortune, God's bounty and happiness, everlasting peace and continuing well-being to its owner – may he live long!' Expressions of this kind, intended to ward off the ever-present threat of evil in the manner of amulets, had appeared on household objects since the emergence of literate societies in remote antiquity. These

inscriptions can therefore be seen as an Arabized form of an old Middle Eastern tradition.

The pre-Islamic roots of the unglazed wares are illustrated here by a miniature mould-formed flask, or ampulla (plate 27), which bears an image of a Christian saint from Egypt called Menas. It was once filled with holy water from the saint's shrine near Alexandria, which was a major centre of pilgrimage. The image on the ampulla is clearly related to the saint's cult, just as the imagery of the ancient faience amulets – the eye of the god and the hero's head – was related to earlier cults of Horus and Hercules (plates 17 and 18). This long tradition of religious iconography was disrupted when Islam came to Egypt. The change occurred partly because all visual references to living beings were excluded from Muslim religious contexts (see Chapter 2), and partly because Islam has no priesthood who might have promoted an alternative type of imagery. A few Muslim religious symbols were established, such as the mihrab niche

(plate 2) and its two-dimensional representation as an arch (plates 5 and 9) but, as noted above, these have not become transferrable symbols like the Christian Cross: if you move the arch motif into a non-religious context, it ceases to represent a mihrab and becomes merely an arch.

The lack of a transferrable iconography means that, while many examples of continuity between the pre-Islamic and Islamic periods can be traced, it is difficult to find an equivalence in the meanings of designs. This is not to say that Islamic art was without meaning, but its significance was more political than religious.

Glory to the patron

The political character of Islamic art arose because, in the absence of a priesthood, the formative role in its development fell to those who were politically powerful. In other words, with no priests to guide them in exercising their patronage, the rulers and their advisers had to do it themselves, even in the case of religious monuments. This meant that the decisions made in building and fitting out a mosque were more like those made for a parliament house or a town hall than for a church or temple. As a result, Islamic art reflected the aims of the patron in a more direct way than happened in other cultures. The difference can be understood if we trace the career of a building form that passed from Christian to Muslim use.

When the Byzantine emperor Justinian set about rebuilding the church of the Hagia Sophia in Constantinople (now Istanbul) in the sixth century AD, he and his architects were faced with a dilemma. On the one hand, they wished to construct a building covered by a huge dome, which had become a symbol of the universal sovereignty the emperor claimed as the political head of the Christian world. On the other hand, the complex liturgy that would be conducted in the church, with its processions and the division between priests and congregation, required a directional layout and a hierarchical arrangement of space. The result was a compromise. The church was realized with all the elements of a regular basilical plan, including an apse, side aisles and a nave, but the nave was made particularly wide so that it could be covered by a great dome, about 33 metres in diameter (plan 28). The result is immensely impressive.

Above: 28. Plan of the church of the Hagia Sophia in Constantinople, as originally built in the 530s AD.

Below: 29. Plan of the Süleymaniye mosque in Istanbul, built in the 1550s.

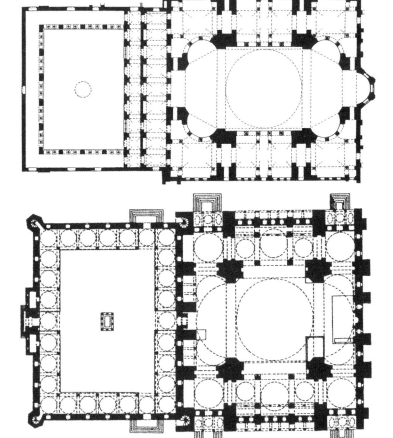

Almost a millennium after it was built, in 1453, the Hagia Sophia fell into the hands of the Ottoman Sultan Mehmed II. It became a huge trophy, a symbol of the Ottomans' achievement in surpassing all their predecessors. They had made themselves masters of Constantinople, which the armies of Islam had failed to conquer in the seventh century, and with it they had seized the greatest church in Christendom. Even the Greek name of the church was preserved, as Ayasofya, lest the epochal significance of the building be forgotten.

This great trophy became so closely associated with the celebration of Ottoman power that it was chosen as the model for subsequent imperial mosques. In Istanbul the pre-eminent example is the Süleymaniye mosque, which the court architect Sinan built for Sultan Süleyman the Magnificent in the 1550s (plate 29). The liturgical features of the prayer hall form a very modest part of the whole, allowing Sinan to retain most of the arrangement of nave and aisles: only the apse has gone, superseded by the wall containing the mihrab. Similarly, the domed superstructure is reproduced in a technically improved form, the changes barely affected by the function of the building.

The decoration of the walls in the mosque was, of course, quite different from that in the church, marking it as a Muslim place of worship. The same may be said of the additional elements on the exterior, including its four minarets. But the erection of the great dome – a miraculous feat to most contemporaries – had the same basic meaning as did the dome of the sixth-century church: both the Hagia Sophia and the Süleymaniye were commissioned as symbols of power. There is a definite difference in the expression of this meaning, however. The form of Justinian's church accommodated the complexities of the Orthodox liturgy, and it was dedicated to a theological concept – Hagia Sophia is 'Holy Wisdom', as embodied by Christ. On the other hand, Süleyman was free to adopt the design that best expressed his political ends, even if it involved the use of a Christian model, and he called his vast and imposing mosque after himself, using it to commemorate his own rule. Theological concerns had no place in the naming of the Süleymaniye.

This civil nomenclature of mosques and other religious monuments is a consistent feature of Islamic societies. Some buildings are known by an epithet (al-Azhar, 'the radiant'), by their function (al-Masjid al-Jami', 'the central mosque'), or by a locally understood reference, such as the name Ayasofya, or a location (al-Kutubiyyah, 'in the book market'); some at pilgrimage sites have a dedication to the person venerated there (the mosque of the Prophet in Medina is one example); but most commonly of all, they are, like the Süleymaniye, called after their founders. Their names are not linked, like those of most churches, to a saintly patron in the world beyond: they are memorials to a patron in this world – to the man or woman who paid for the building.

The glorification of the patron was so important to artistic production that in some Muslim societies all the works of art associated with one person were emblazoned with his or her name, even where they were made for donation to a religious institution. There can be no doubt, for example, that the minbar, or grand pulpit, that once graced a mosque in Cairo (plate 113) was placed there by Sultan Qa'itbay (ruled 1468–96), since the full name and titles of this patron are inscribed on it in several places not merely as a matter of record but as part of the decoration. The same is true of a vast, six-sided brass lamp-holder he had made for a similar building, on which his name and titles are recorded in the inlay of gold and silver (plate 111). In a glass lamp probably made for a Cairo religious institution in the fourteenth century (plate 59), the name of the patron, written in large lettering in bands that encircle the object, was given added lustre by being lit from behind.

Art and dynasty

Due to the pronounced role of the politically powerful in determining the character of Islamic art, a change in the ruling group was often followed by a change in artistic conventions. If the new group was in power for long enough, the process of change might give rise to a new style in art and architecture. As most Islamic states were created by dynasties of caliphs or sultans (see appendix), the history of Islamic art is usually conceived as a sequence of dynastic styles. Thus, use of the patron's name and titles as a significant part of the decoration is not a universal feature of

The Art of the Qur'an

Tim Stanley

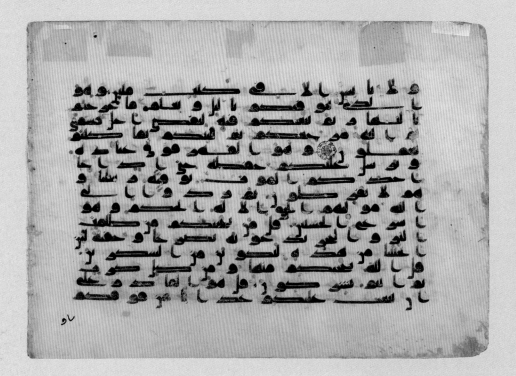

Left: 31. Leaf of parchment from a Qur'an manuscript of the 9th or 10th century AD. The text is written in the plump style known as Kufic, which was probably developed in order to distinguish the Qur'an from other texts, as was the 'horizontal' format of the leaf – it is wider than it is long. Height: 18.7 cm. V&A: CIRC.161–1951.

Below: 32. Leaf from a Qur'an manuscript of the 11th or 12th century AD, when the holy text, like other books, was copied on paper in the normal, 'vertical' format. At this date, the bold, angular hand seen here had become specifically Qur'anic, although it was originally used for the titles in non-Qur'anic manuscripts. Height: 26.5 cm. V&A: L.920–1939.

The Qur'an contains the revelations God made to the Prophet Muhammad, which form the basis of Islamic belief. As the literal Word of God, the Qur'an has a sacramental role in Islam, equivalent to the Mosaic Law in Judaism and the sacrifice of Christ on the Cross in Christianity. The preservation of the Qur'anic text has therefore been of great importance to Muslims, and the precision and clarity required in writing it have often given rise to works of considerable beauty.

For most of Islamic history, the Qur'an was preserved in manuscript – that is, it was written by hand. Great care was taken in designing scripts and training scribes, and the text was often written on parchment or paper of the highest quality, decorated with non-figural designs in colours and gold, and bound in fine gilt leather covers (see also plate 75). Reverence for the holy text is also evident in a slower rate of change: materials and styles were introduced into the production of Qur'an manuscripts only after they had acquired an air of antiquity.

There were several phases in the history of Qur'an manuscripts. A distinctive form had been established by the eighth century AD (plate 31) and continued to prevail until the

Above: 33. After the Mongol conquest of Iran in the 1250s, copies of the Qur'an of an unprecedented size and magnificence began to be produced, often as sets of thirty separately bound fascicules. This example, with only five monumental lines of script to the page, is similar to work done at Shiraz in Iran in the 1370s.
Height: 36.8 cm.
V&A: 361–1885.

Below: 34. Part of a wooden frieze that once decorated a medieval religious building. The inscription is a fragment of a longer quotation from the Qur'an (surah III, verse 191): 'Our Lord! Not for nothing hast Thou created this! Glory to Thee! Give us salvation from the penalty of the Fire.'
Length: 103 cm.
V&A: 378C–1907.

tenth century, when a series of changes in materials, script and format made copies of the Qur'an more like other fine manuscripts (plate 32).

From about the same time, more fluid styles of script were developed, probably in the Caliph's chancery in Baghdad, and by the thirteenth century these had replaced the older hands in Qur'an production. A gradual process of refinement occurred (plate 33) and eventually gave rise to distinctive regional or dynastic styles (see pp. 60–61). In the later nineteenth century reproduction of the text by lithography was permitted, but even then the text to be printed was written out by a scribe working in the traditional manner.

The calligraphic forms of the Arabic script used for the Qur'an were often transferred from the written page to other media (plates 33, 34 and 36). Indeed, calligraphic ornament became one of the most distinctive features of Islamic art.

Islamic art. It was in vogue in Egypt and Syria in the period after 1250, when these territories were ruled by the Mamluks. It lost prestige after 1517, however, when the Mamluk empire was conquered by the Ottomans. This type of inscription can therefore be seen as characteristic of the style associated with the Mamluk regime. On the other hand, it plays no part in the style developed under the Ottoman dynasty. The wording on a ceramic mosque lamp made for the Süleymaniye mosque in Istanbul provides evidence of this (plate 118). It consists of a Qur'anic quotation relevant to the object's form (surah XXIV, verse 35, known as the Light Verse), and there is no reference to the patron, Sultan Süleyman.

The use of a patron's name as a major element in the decoration of an object was not confined to items made for religious institutions. An early Mamluk candlestick of brass inlaid with silver (plate 30) has birds and animal masks among its subsidiary motifs, which make it unlikely that it was made for use in a Muslim religious building. Yet the main element in the decoration is a bold inscription naming the man for whom it was produced, which is written twice, once on the body of the object, and once around the neck.

The presence of patrons' names on Mamluk works but not on Ottoman examples means that there is not necessarily any continuity over time in the design of objects made for religious institutions. At the same time, the presence of patrons' names on Mamluk art made for both mosques and palaces is one of the indications of the considerable continuity within one period between the art made for both religious and non-religious contexts. In fact, the Mamluk pieces under discussion tend to be more strikingly Mamluk in style than they are religious or secular in content, showing how important political power was in determining the nature of religious art.

Islamic by negotiation

This emphasis on the role of secular patrons in forming Islamic art should not be seen as excluding Islam itself from any role in this process. Some of the greatest works were made in response to the needs of Muslim ritual: they can be said to have been inspired by Islam. The minbars made for major mosques are one form that cannot be understood outside an Islamic environment (plate 113). Nor can the splendid lustre tiles made for important tombs in medieval Iran (plates 9 and 65). Even the lighting implements in inlaid brass or enamelled glass made for mosques and other great religious buildings (plates 14 and 111) owe much of their splendour, and certainly their monumental size, to the context in which they were employed.

One marker of religious buildings and of objects made for religious purposes is their decoration with quotations from the Qur'an, the sayings of the Prophet Muhammad and other Islamic religious texts (plates 34, 35, 43 and 118). This is true even of swords and other arms emblazoned with Qur'anic inscriptions (plate 36), since they could be used in defending the lands of Islam, which was a religious duty.

Nevertheless, such items form a relatively small proportion of Islamic art as it is defined here. Indeed, while Islam, as the dominant religion and the basis of the legal system, provided much of the background

35. Tile with Qur'anic inscription. Fritware with carved decoration under coloured glazes. Uzbekistan, Bukhara, mid-14th century. Height: 43.6 cm. V&A: 2031A–1899.

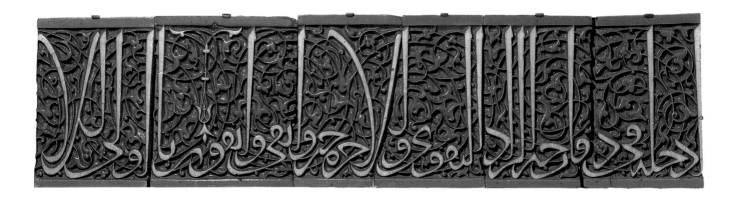

36. Sword of Shah
Tahmasp I. The
blade steel inlaid
with gold.
Iran, 1524–76.
Length: 105 cm.
V&A: 3378.IS.
Presented by Colonel
Pennington, 1855

37. Chalice. Brass
inlaid with silver.
Egypt or Syria, late
13th to early 14th
centuries.
Height: 17 cm.
V&A: 761–1900.

against which art was generated in Islamic societies, this art was not necessarily created *in obedience to* Islam and its law. Rather, it was created *in negotiation with* them. This idea of negotiation is easy to understand in the case of objects produced in an Islamic style but for Christian patrons. Islamic law guaranteed a considerable degree of protection to the non-Muslim subjects of a Muslim state so long as they submitted to its authority (see pp. 38–39). Where this arrangement was accepted, it was possible for local Christians to prosper, and many became rich enough to commission luxury objects for their own use or to donate to religious institutions.

The accommodation of these local Christians with the prevailing political system went hand in hand with their integration into the culture that grew up around it. This is why we often find objects commissioned by rich Christians that differ little in technique and style from those made for their Muslim overlords and neighbours, even when they were destined for a church or monastery. Two examples from the medieval Arab world are a cylindrical casket, or pyxis (plate 52), and a chalice-like drinking vessel (right), both made of brass inlaid with silver. Base metal wares with rich decoration inlaid in silver and other substances were a characteristic product of medieval metalworkers in the Middle East, and they are usually thought of as 'Islamic'. Yet these two pieces were made for Christian patrons, as the content of their decoration shows.

No great study of the pyxis is required to discover this, since some of the human figures in the decoration

carry crosses – they are taking part in the ordination of a priest. In the case of the drinking vessel, however, you have to read the Arabic inscription to know that the piece was made 'at the order of the reverend father at the monastery of Dayr al-Madfan'. This man must have been integrated into Islamic culture to an extraordinary degree: even though he was a Christian priest, the only decoration on the vessel is a record of his commission, as if he were a Mamluk official.

The men who ruled the Islamic world for much of its history also had to negotiate with Islam. At first, there were no clear grounds in Islamic law for the role of sultans, who emerged as the military 'protectors' of the caliph in Baghdad in the eleventh century, and their position had to be defined by joint agreement.

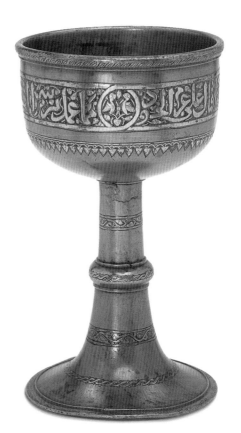

Their military power meant that the negotiations were a little one-sided, but for almost a millennium doctors of Islamic law, and the Muslim population in general, made great efforts to hold their rulers to account. The Sultan could remain in power so long as he performed his duty of protecting the status quo. He was needed to defend the realm of the true religion from internal enemies and from Crusaders, Mongols and other invaders.

Luxury and the law

As part of this arrangement, the sultans and their courts (like the caliphs before them) claimed the right to live in regal splendour, even though by doing so they infringed many religious restrictions, including those on the consumption of luxuries. One of these was the wearing of robes of silk, which, in theory, good Muslim men avoid, since silk clothing is promised to them in paradise: 'Verily the righteous shall be in a place secure,

38. A child's kaftan. Woven silk and metal thread, with cotton lining. Turkey, 16th century. Length: 77.5 cm. V&A: 769–1884.

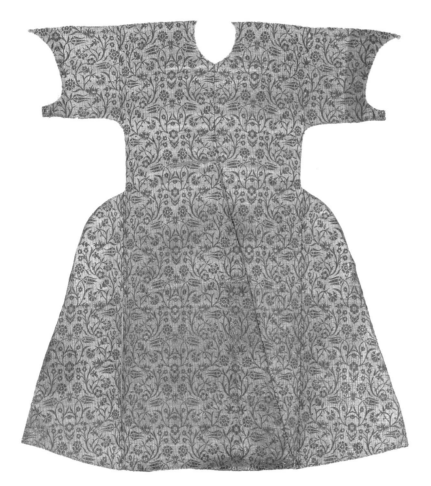

among gardens and springs, dressed in fine silk and rich brocade . . .' (Qur'an, surah XLIV, verses 51–53). The meaning implicit in this and other passages in the Qur'an is made clear by widely reported sayings of the Prophet Muhammad. One is, 'He who wears silk in this world will not wear it in the next.' Nevertheless, dressing yourself in silk – and perhaps even more so, dressing your servants in silk – had been a sign of wealth and authority in the Middle East since Antiquity, and the pressure to use this material as a means of asserting authority was so great that many sultans and their entourages dressed in silk robes.

In all societies laws on dress and other forms of consumption are regularly broken, and no doubt many Muslim rulers simply ignored the ban on wearing silk. Others sought ways around it. For example, jurists offered an exemption to warriors on campaign, since they considered that the magnificent appearance and protective strength of silk made it suitable apparel for the armies of Islam. It may be speculated that for men of the ruling class, a permanent state of readiness for war, however remote the danger, became a licence to wear silk garments at all times.

The two silk kaftans illustrated here (plates 38 and 40) were not, though, made for full-grown warriors. They were sewn for children of the Ottoman imperial family in the sixteenth century, and at some point in this period there was clearly an attempt to establish that minors were classed with women, who were allowed to wear silk. The evidence is a legal opinion, or fatwa, given by Ebüssuûd Efendi, the senior legal adviser to the dynasty for many years until his death in 1574. Ebüssuûd was asked the question, 'Are people committing a sin if they dress male children under the age of puberty in pure silk?' He responded simply, 'They are,' thus thwarting the attempt to exculpate the parents of silk-clad boys.

The Ottomans generally took care to observe the forms of Islamic law, so how did they reconcile their practice with this official view? The surviving clothing has been interpreted as evidence of a compromise: silk was not used for undergarments, so that it was not worn against the skin. If this was indeed the case, a sultan and his household were able to evade the law by dressing young princes in underclothes of cotton

and other approved materials, while simultaneously maintaining their imperial dignity by covering the underclothes with kaftans and other outer garments of lustrous, brightly coloured and boldly patterned silk. What is more, it is this patterned clothing that has found a place in the history of Islamic art, while the same can hardly be said of the unpatterned underclothes, even though they were the only part of the princes' attire that conformed to Islamic law.

The issue of silk clothing for men is just one example of how, rather than behaving like good Muslims, the sultans ignored or bent the law so that they could obey other, non-Islamic ideals on how rulers should live their lives. In this respect, those who governed the Islamic Middle East were no different from the powerful in other societies. Nevertheless, the result was that, in strictly Islamic terms, they behaved as though they had transcended the status of mere mortals – as though they had already reached paradise. This imperial behaviour was very much at odds with the original political principles of Islam, which were strongly egalitarian, at least in their treatment of believers. Vivid Arab proverbs attributed to the Prophet illustrate the earlier view. One is that men are 'equal like the teeth of a comb'. It is an irony that the abandonment of these principles at an early date gave rise to what is here called Islamic art.

Recognizably Islamic

The stylistic changes that occurred under each dynasty of caliphs and sultans were cumulative, so that objects produced in the high Middle Ages can be strikingly different in technique and aesthetic from those made in the early Islamic period. The beginning of this process can be seen in a cast brass ewer produced in the eighth century AD (plate 24). The considerable visual impact of the piece comes entirely from its shape, especially the bold thumb-rest in the form of a stylized palmette motif. Otherwise, decoration is sparse: the rim, for example, is in the form of a pair of schematic bird's heads, facing outwards and with eyes inlaid with tiny discs of copper. The ewer is of a standard type produced in Iran in the centuries immediately after the Islamic conquest, during which gradual changes in form took place, but

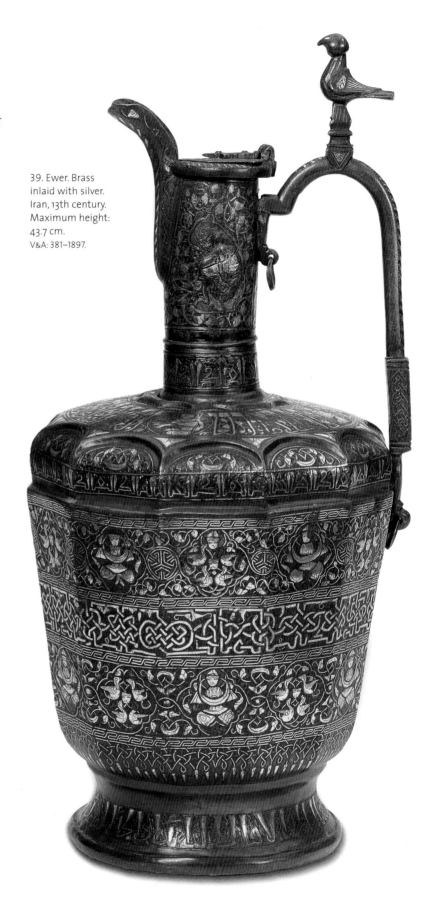

39. Ewer. Brass inlaid with silver. Iran, 13th century. Maximum height: 43.7 cm.
V&A: 381–1897.

TEXTILES AND BURIAL

Tim Stanley

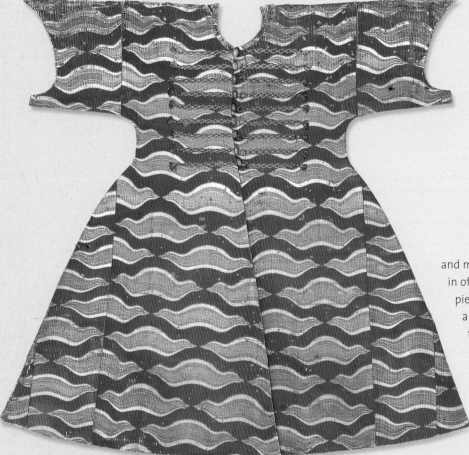

40. The front of a 16th-century silk kaftan made for a child and preserved in the child's tomb. The motif of paired wavy lines is based on the depiction of the tiger-skin coat worn by the Iranian hero Rustam.
Length: 77.5 cm.
V&A: 753–1884.

When they die, Muslims are laid in the earth wrapped in a cloth, and the body is oriented according to the Qiblah. This practice is based on a belief in the resurrection of the body at the end of time: on the Last Day, the Muslim dead will rise from their graves and will be judged on their actions during their lifetimes. Those who acted righteously will join the blessed in Paradise for eternity. As the One God will provide for everything, there is no need for the numerous grave goods characteristic of some earlier Middle Eastern societies, and in general burials of the Islamic period have not been an important source of information on contemporary material culture.

In the dry climate of Egypt, however, the textiles used in burials have often survived, if only in fragmentary condition,

and many of these were made of cloth produced in official workshops known as *tiraz*. These pieces can be identified from the presence of a band of text giving the name and the titles of the ruler, and one of the earliest known (plate 41) was made under the rule of a caliph called Marwan. This was either Marwan I (in office AD 684–5) or Marwan II (744–50).

At other times and places, local custom led to the preservation of objects that illustrate contemporary life, including textiles. In medieval Iran, the rich were sometimes laid to rest on mattresses and cushions covered with expensive silks, some of which survive in fragmentary condition (plate 42). In Turkey, members of the Ottoman dynasty were buried under coffin-shaped tomb markers over which items of their clothing were laid (plate 40).

One group of textiles, characterized by zigzag patterns and decoration with inscriptions, was made specifically as tomb covers. Those with a green ground (plate 43) were designed for the tomb of the Prophet Muhammad in Medina. Like the textile covering of the Ka'bah in Mecca, the cover for the Prophet's tomb was renewed each year. The old covers were regarded as holy relics and were preserved for the grace they could bestow.

Right: 41. Silk textile woven in Tunisia in the AD 680s or 740s and embroidered with the name of the Caliph Marwan. Length of larger fragment: 50.7 cm.
V&A: 1314–1888.

Left: 42. Silk textile produced in Iran some time in the 10th to 12th centuries. The confronted birds with human heads are usually identified with the vicious harpies of Classical mythology, but they were presumably seen as having a benevolent role by contemporaries. The inscription contains good wishes for the owner (see p.22).
Length of repeat: 48 cm.
V&A: T.399–1980.

Right: 43. Silk lampas from Ottoman Turkey, probably woven in Bursa in the 17th century. The green ground and the inscriptions indicate that the cloth was intended as a covering for the tomb of the Prophet in Medina. The main inscription is the Muslim creed, 'There is no god but God. Muhammad is the messenger of God.'
Length: 115 cm.
V&A: 780–1892.

Opposite: 44. Jar.
Fritware painted
under the glaze.
Egypt or Syria,
14th century.
Height: 37 cm.
V&A: 483–1864.

its pear-shaped body is still clearly related to the
metalwork of the Sasanian period in Iran, when ewers
with bodies of a similar shape were made in silver.

This ewer may be contrasted with one made in Iran
four centuries later (plate 39). It has a complex, more
angular shape, made by welding together elements
raised from sheet metal. This technique is easier to use
in making objects from softer materials such as silver,
and a link with precious metal wares is also suggested
by the extensive decoration inlaid in silver. The motifs
employed include two rows of cartouches, one to
each of the twelve facets of the body. Six cartouches in
each row are each filled with a personification of the
Moon (a seated female figure holding a crescent
moon), and another six contain four flying ducks. The
two rows are coordinated, so that a Moon cartouche
appears above a four-duck cartouche and vice versa.
The five bands with inscriptions include one on the
flat shoulder calling down blessings on the owner. It is
written in a bizarre style of script in which each
upright ends in a human face, and it is interrupted by
four discs containing a depiction of a musician playing
a flute, a zither, a lute or a tambourine. Despite the
anonymity of the piece, it is tempting to give the rich
and cheerful decoration a unifying explanation:
perhaps it was made for a woman with the word
'moon' in her name (a common enough occurrence in
Iran), who was loved for her beautiful singing voice?

By the first half of the thirteenth century, when the
inlaid ewer was made, the production of luxury metal
wares had undergone so many changes that links with
pre-Islamic models are no longer evident. The
decoration is instantly recognizable as 'Islamic' – it
could not be mistaken for anything else. The same is
true of the luxury metalwork produced during the
following century some way to the west, in the
Mamluk empire. A basin from this period (plate 15)
shows a better integrated but sterner approach to
form and decoration. The virtuosity of its flaring
shape, the decoration found on all visible surfaces,
and the use in the decoration of a combination of
plant-based ornament and inscriptions in Arabic script
of calligraphic quality, as well as of figural themes, all
arranged within compartments of different shapes,
mark this object, too, as belonging both to its own
time and to the Islamic Middle East as a whole.

Similar features can be seen on objects in other
media produced in the same period, including a
ceramic storage jar with predominately calligraphic
decoration painted under the glaze in black and blue
(plate 44) and vessels of clear or coloured glass with
gilded and enamelled decoration (plates 45 and 46).

The recognizably Islamic quality of these pieces is
partly due to changes in the content of the decoration
over the preceding centuries. The ornamental use of
the Arabic script was, as previously noted, an early
development. A later change was the introduction of
new Chinese motifs after the Mongol invasions in the
mid-thirteenth century, which transformed the
mythical bird known as the *senmurv*, inherited from
ancient Iran (plate 22), into a Chinese-style phoenix.
Both calligraphy and small phoenix motifs are found
in the decoration of a fourteenth-century Mamluk
glass bottle (plate 45), but it is distinguished from
early Islamic wares as much by the technique that was
used in its decoration as by its design.

Glassmaking in the Middle East was revolutionized
in the first century BC by the invention of
glassblowing, which made the production of vessels
and other wares very cheap. Glass rapidly became a
common feature of everyday life and has remained so
until the present. Luxury glass was also made using
this technique, and decorative effects were produced
principally by manipulating the glass while it was hot
(by blowing it into a mould, for example), or by
cutting designs into cold glass. Both hot- and cold-
worked glass continued to be used with great panache
during the Islamic period (plates 47 and 107), as was a
third technique, in which the decoration was painted
on to the surface of the object. In the earliest type in
this category, designs were applied to glass blanks
using a pigment based on sulphides of silver and
copper (plate 48). The painted object was then fired in
a kiln, where the sulphur, oxygen and other non-
metallic ingredients of the pigment were burned off,
and the metal fused with the surface of the vessel,
permanently staining the glass.

In the twelfth century, this decorative approach
began to be taken much further, leading to the
production of the very grand and entirely Islamic type
of glass exemplified by the two Mamluk vessels (plates
45 and 46). The colourful decoration on this type of

Left: 45. Bottle.
Glass with
enamelled and gilt
decoration.
Egypt or Syria,
14th century.
Height: 44.5 cm.
V&A: 328–1900.

Below: 46. Sprinkler.
Glass with
enamelled and gilt
decoration.
Egypt, 1295–96.
Height: 15.3 cm.
V&A: C.153–1936.

Above, right: 47.
Perfume sprinkler.
Glass, mould-blown
and trailed.
Iran, 11th to 13th
centuries.
Height: 21.5 cm
C.7–1974.

Below, right: 48.
Cup. Glass with
stained decoration.
Probably Syria,
8th century.
Height: 6.5 cm.
V&A: C.24–1932.

piece was created by painting the object with gold and
with enamel colours made by grinding down coloured
glass and mixing it with an oily medium. In this case,
firing in a kiln eliminated the oily substance and
melted the glass (and the gold) on to the vessel.

This technical advance meant that the range of
colours available to the makers of glassware was very
broad, and they were able to reproduce with much
greater accuracy the work of calligraphers and
painters working on paper, plaster, wood or other
media. The same may be said to a greater or lesser
extent of contemporary inlaid metalwork and ceramic
painted under the glaze. The techniques employed all
facilitated the transfer of motifs from one medium to
another, thereby integrating each medium more
closely into a commonwealth of Islamic art in which
the courtly arts of painting and writing were the
dominant influences.

The distinctive Islamic qualities of these objects are
clearly not a reflection of the application of Islamic
principles in artistic production. Rather, they are a
product of a long and complex process in which both
political realities and religious ideals played an
important part. The result is an art in which there was
a religious–secular split, but one that is not as clear-
cut as splits of this type that have occurred in other
societies. As a whole, Islamic art was not exactly
religious, as it was formed in a non-doctrinal context,
often one that was self-consciously political. Nor was
it exactly secular, since it included the art produced
for personal and communal devotions. The difference
between religious and secular is therefore rather
restrained, and we must be careful not to
superimpose a crude distinction between them
when dealing with Islamic art.

In many cases, though, it is possible to
distinguish religious from non-religious
art. As previously observed, the very
form and function of the minbar of
Sultan Qa'itbay (plate 113) attaches this
object to the realm of religion, while the
presence of a quotation from the Qur'an
attests to the specifically religious context
for which the mosque lamp from the
Süleymaniye (plate 118) was made. In addition,
neither item bears any representation of a living

being, and the exclusion of such images from religious
contexts may be described as one of the most
consistent features of Islamic art. Moreover, the ban
on images had an effect on the design of non-religious
artefacts. This effect varied with time and place, and
the application of the ban was clearly a matter of
debate. It can be said that images were an issue.

THE NON-MUSLIM PRESENCE

Rebecca Naylor

49. Beginning of the Gospel of St Matthew with an illuminated head-piece and a portrait of the evangelist, from a copy of the Four Gospels in Armenian. The manuscript was written and illuminated in the mid-17th century by Margar Dpir. He worked in the Church of St James, which was probably in New Julfa, the Armenian suburb of Isfahan.
Height: 16.5 cm.
V&A: 2080–1903, folios 8B–9A.

After the creation of the Islamic empire in the seventh and early eighth centuries AD, the population of the Middle East continued (and continues) to include large numbers of Christians, and there were smaller numbers of Jews and Zoroastrians. Muslims regarded Judaism and Christianity as 'scriptural' religions based on earlier versions of the divine revelation (the Torah and the Bible), and they accorded their followers protected status. The legal position of the Zoroastrians was not so clear, but in practice all three groups were able to keep their own faith, languages, alphabets and calendars.

In some areas, integration with Arab Muslim culture resulted in Christian patrons commissioning artefacts decorated in the Islamic style and with inscriptions in Arabic (plates 37 and 52). Recognizably Christian and Jewish artefacts were also produced; they included both religious items, such as holy books (plate 49), and domestic wares that reflected their owners' varied beliefs (plate 51).

One of the more distinctive artistic traditions that survived in the Muslim Middle East was that of the Armenians. Their original homeland was the vast mountainous plateau between the Black Sea and the Caspian, and they were the first nation to embrace Christianity, in the early fourth century AD. From the seventh century, the Armenians were often ruled by Muslims, but they also enjoyed periods of renewed independence, which allowed them to develop new styles of their own. The Gospels shown here (plate 49), for example, were produced in the seventeenth century, but they reflect the magnificent manuscript production of the Armenian kingdom of Cilicia in what is now south-east Turkey, which flourished between 1080 and 1375.

The formation of the kingdom of Cilicia outside the original territory of Armenia coincided with a wider dispersal of the Armenians across the Middle East and beyond. They eventually developed a worldwide network of trade routes that linked the Baltic to the Bay of Bengal. Some Armenians remained farmers, while others became accomplished craftsmen. One group long settled in the town of Kütahya in western Turkey was involved in ceramic production, sometimes for Armenian patrons (plate 50).

Far right: 50. Dish with an image of the Archangel Michael, produced in Kütahya in western Turkey, probably by an Armenian craftsman. Inscriptions give the date in the Armenian calendar, equivalent to 1718–19, and the name of the patron, the future Catholicos Abraham III, head of the Armenian Church in 1734–7. Diameter: 22.1 cm.
V&A: 279–1893.

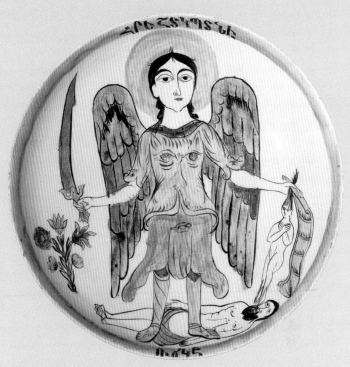

Right: 51. Spice box of gilt copper, used in the Havdalah ceremony at the close of the Jewish sabbath, when the scent of the spices is inhaled. This example has been dated to the 13th century and may be the oldest in existence. The spice holder is in the form of a tower with rows of openings topped by horseshoe arches, characteristic of Islamic Spain. Height: 14.5 cm.
V&A: 2090–1855.

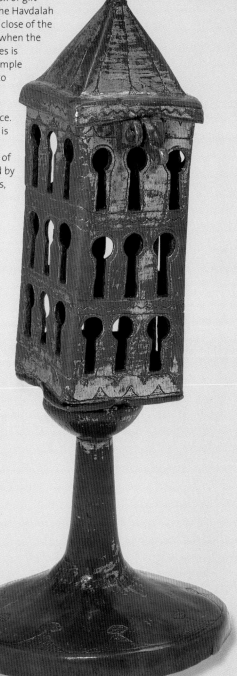

Below: 52. Cylindrical casket, or pyxis, of brass inlaid with silver. It was made in the mid-13th century, probably in Syria. The principal decoration on the body is Christian in content: the band of figures represents the ordination of a priest. Height: 8.5 cm.
V&A: 320–1866.

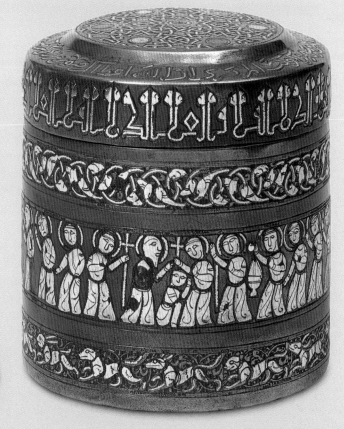

THE ISFAHAN COPE

Tim Stanley

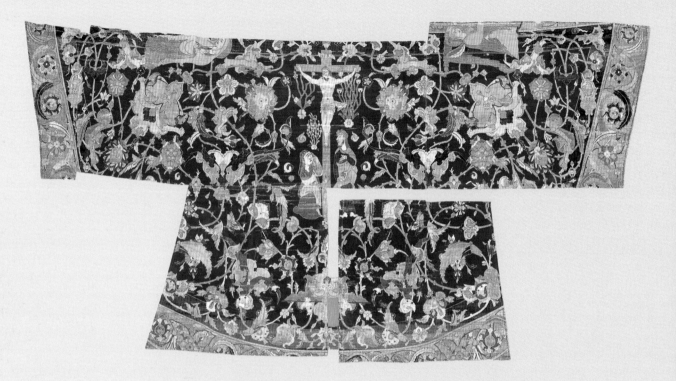

A spectacular example of the art made for a Christian community living under Muslim rule in the Middle East is provided by a unique Church vestment woven in Isfahan in Iran, probably at the expense of Shah 'Abbas the Great (ruled 1588–1629). The vestment is of the type known as a cope, which has the form of a semicircular cloak. The Isfahan example has a dense silk pile that gives it the appearance of velvet, but it is in fact one of the finest knotted textiles in existence – the cope is a carpet.

Although now fragmentary, the vestment displays striking images of the Annunciation and the Crucifixion, which are juxtaposed with Iranian scrollwork motifs. There are large areas of brocading with silver or silver-gilt thread, including the ground of the outer border. The combination of silk pile and brocading is typical of the so-called Polonaise carpets produced in Isfahan after Shah 'Abbas moved the capital there around 1598. (Some were exported to Poland, whence their name.) The scrollwork and colour scheme, though, are more characteristic of the sixteenth century, and this would support a dating early in the seventeenth century.

The cope form, which originated in Western Europe, was adopted by the Armenian Church during the Middle Ages and became the principal vestment worn during the liturgy. As a consequence, it has long been presumed that the Isfahan cope was made for an Armenian church in the city, where a large number of Armenians were settled at the Shah's orders in the winter of 1604–5. Nevertheless, an alternative claim has now emerged.

Portuguese priests of the Augustinian order founded the first Catholic church in Isfahan in 1602, and Shah 'Abbas, who paid for its decoration, visited the completed building on Christmas Day, 1608. This event was followed in 1612 by the installation of the first Catholic bishop of Persia. The cope may therefore have been donated to the church in connection with one of these events.

The design of the cope offers no conclusive evidence in favour of either theory. The Armenian elements may show only that an Armenian was employed as the designer; the Western elements may show only that the Armenians of Isfahan adopted features of Catholic iconography at an early date.

Opposite: 53. Overall view
of the Isfahan cope.
Height: 122.8 cm.
V&A: 477–1894.

Right: 54. The Crucifixion scene
on the back of the cope was
clearly based on Western
models. The bill pinned at the
top of the Cross bears the Latin
abbreviation INRI (for 'Jesus of
Nazareth, King of the Jews'),
and St Mary Magdalene,
standing at the foot of the
Cross, has long blonde hair,
hanging loose.

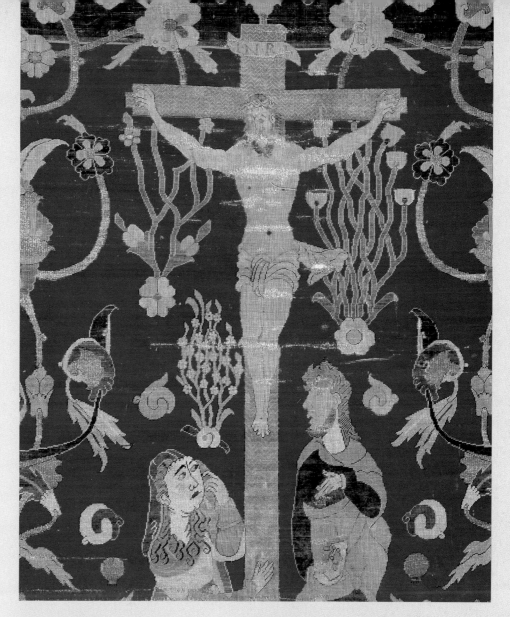

55. A depiction of the
Annunciation was placed on
either side of the opening at the
front of the cope, in the same
position as this scene is shown
on Armenian vestments.
Gabriel is an angel of an Iranian
type, and Mary's features
resemble those of women in
contemporary Iranian paintings.

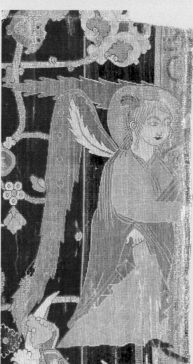
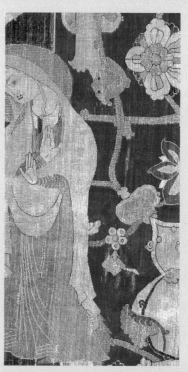

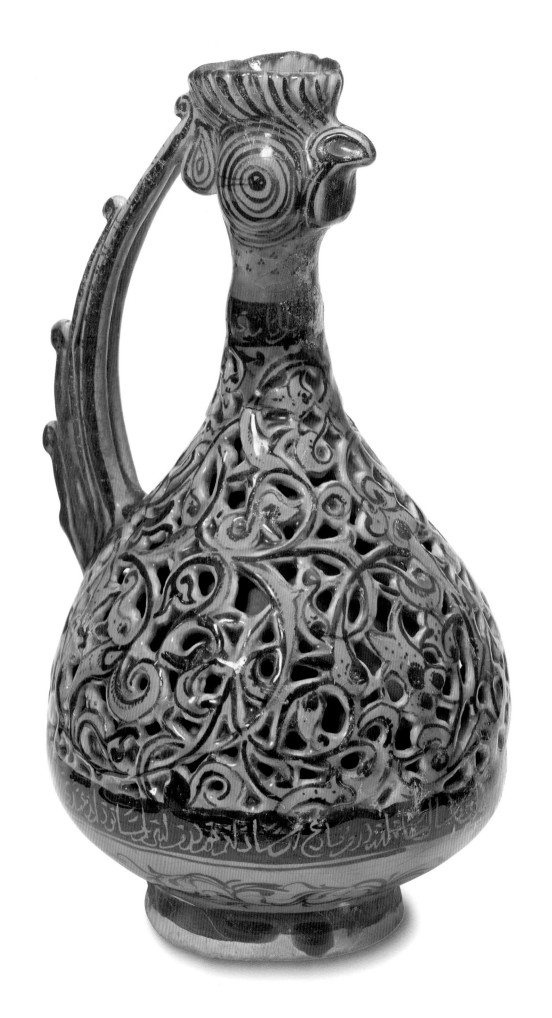

Chapter Two

THE ISSUE OF IMAGES

Left: 56. Ewer.
Fritware painted
under a coloured
glaze.
Iran, Kashan, late
12th or early 13th
century.
Height: 29 cm.
V&A: C.170–1977.
Given by Mr C. N. Ades
MBE in memory of his
wife, Andrée Ades

In Islam images of living beings are strictly excluded from religious contexts. This is linked to the heavy emphasis that the Qur'an and the teachings of Muhammad place on the absolute and ineffable oneness of God and on the rejection of idolatry in any form. Muslims believe that 'there is no god but God', and that they must on no account put any other being on a par with Him: God has no 'associates'.

Right: 57.
Hookah base.
Fritware
painted under the
glaze. Iran, second
half of the 17th
century.
Height: 12 cm.
V&A: 647–1889.

These beliefs differentiated Muslims from the followers of the two state religions of the pre-Islamic Middle East. On the one hand, the Zoroastrians believed that everyday reality was a battle between the principles of good and evil. On the other, the Christians had diverged from the strict monotheism of Judaism by creating the doctrine of the Trinity. For them, the godhead was divided into the three persons of Father, Son and Holy Spirit. In both faiths, too, there were many other spiritual powers – saints in Christianity, and the lesser divinities of Zoroastrianism – to whom believers could pray for intercession. These ideas are expressly rejected in the Qur'an, where believers are instructed to 'Say, He is the one God, the absolute and eternal Divinity. He does not beget, nor is He begotten, and there is none like Him' (Surah CXII).

The problem for the propagators of monotheism in the pre-Islamic Middle East was that most of the population had tended to confuse an image of a deity with the deity itself and to invest 'graven images', as well as found objects such as meteorites, with divine powers. The worship of graven images had been forbidden by Judaism since the time of Moses, and Islam re-enacted this prohibition.

In both Zoroastrianism and Christianity, too, idol worship was seen as repugnant. Long before the coming of Islam, the Zoroastrians developed the formal veneration of fire in temples, probably in order to combat idolatry. This principle had been compromised in actual practice, however, as it had among the Christians. In the Byzantine empire, the veneration of images of Christ and the saints was the subject of the iconoclast controversy of the eighth and ninth centuries AD, which may have been provoked by the success of Islam. The controversy was resolved by the adoption of the two-dimensional 'icon' that has since been characteristic of the Orthodox world.

The case against images

The Islamic prohibition of images is not explicit in the Qur'an but can be inferred from a number of passages. Most relate to Abraham, whose people had strayed into idol worship, using the Ka'bah to house their images. In one report of the incident (surah XXI, verses 52–67), Abraham chides the idolaters, ending with the words, 'By God, I have a plan for your idols after you go away and turn your backs.' He puts his plan into action, breaking the idols into pieces, 'all but the biggest of them'. Abraham is called to account, and when asked whether he was responsible for the destruction, he answers, 'No, this was done by the biggest of them. Ask them, if they can speak!' Realizing their error, the idolaters bend their heads, admitting that the idols could not speak. 'Shame on you,' cries Abraham, 'and on the things you worship besides God!'

In one passage not connected with Abraham, four things current in the time of Muhammad are described as 'an abomination – an example of Satan's handiwork' (surah V, verse 92). The first is *al-khamr*, 'wine'. The second is *al-maysir*, a game of chance played in ancient Arabia for stakes of camel meat. The third is *al-ansab*, stones dedicated to religious purposes. The fourth is *al-azlam*, the arrow shafts used as the lots cast in *al-maysir* and for fortune telling. The faithful are commanded to avoid these abominations, and this has long been interpreted as a ban on all intoxicants, all games of chance, all worship of inanimate objects and all forms of divination.

As in the case of the wearing of silk, it is the Hadith – the reports of Muhammad's deeds and sayings –

that bring out the full import of this Qur'anic legislation, moving from the general to the particular. Al-Bukhari, the ninth-century compiler of the Hadith, related how the Prophet was distracted during prayer by the figures on a curtain that his wife 'A'ishah had hung at the door to her room. His wife cut up the curtain and made it into cushion covers, which Muhammad found acceptable because the images no longer distracted him.

Other Hadith recorded by al-Bukhari are more categorical. One is that, 'The angels will not enter a house in which there is a picture or a dog.' The hostility to the representation of living beings shown in these texts has informed orthodox religious opinion since early Islamic times, and there is no great distinction to be made between the followers of different traditions within Islam. The Shi'ite jurist al-Hilli (died *c.* 1245), for example, was as severe as his Sunni counterparts in declaring the making of pictures unlawful. The differences between Sunni and Shi'i practice in later times has to be explained by other factors, as we shall see.

Making a distinction

The ban on images seems to have been effective from a very early date, to judge by the original mosaic decoration in the Dome of the Rock in Jerusalem and the Great Mosque of Damascus, which were completed by AD 692 and AD 715 respectively. In the latter, for example, there are landscapes with buildings and rivers, but not a single human or animal figure. The ban was not applied universally, however. The Umayyad caliphs who commissioned these two religious buildings had their own palaces decorated with figural wall paintings and sculptures. They evidently felt that a clear distinction could be made between residential and religious buildings, and this distinction was maintained by their successors over a very long period. It also extended to the decoration of objects intended for use in the two types of building.

Manuscripts of the Qur'an often have rich illumination, and the style of painting changes from period to period, but it never includes figural elements (plate 75). On the other hand, luxury copies of literary works have decoration of a similar type, but this illumination may contain figures, and some of these

Below: 58. Lamp.
Glass with
enamelled and gilt
decoration. Syria,
mid-13th century.
Height: 21 cm.
V&A: 330–1900.

Right: 59. Lamp.
Glass with
enamelled and gilt
decoration. Egypt,
mid-14th century.
Height: 26.1 cm.
V&A: 6820–1860.

books also contain illustrations (see pp.66–7). The lack of any human or animal imagery in the celebrated Ardabil carpet (see pp.74–5) supports the theory that it was made for use in a religious location, perhaps the shrine of Shaykh Safi al-Din in Ardabil. A contrast is provided by another great product of the weavers of sixteenth-century Iran, the Chelsea carpet (see pp.54–5). Its design includes numerous depictions of animals, including combats between beasts of prey and their victims, and it was certainly intended for use at gatherings of a secular kind.

The contrast between the two types of decoration, figural and non-figural, can also be seen in two glass lamps of similar shape (plates 58 and 59). They each have a boldly waisted reservoir, rounded below and flaring above. To this were added a high foot; three suspension loops and, at the bottom of the reservoir, a tubular wick-holder. They also share enamelled and gilt decoration, although the content of the decoration is very different in each case.

The earlier of the two (plate 58), which is thought to have been made in Syria in the middle of the thirteenth century, was blown in a mould, giving it a gently ribbed exterior. The sparse decoration consists principally of a trio of mounted falconers, each

A SAFAVID CLOCK DIAL

Tim Stanley

Many venerable artefacts from the Islamic period have survived because they remained in use over very long periods. Medieval brass mortars, for example, are often found to have repairs in their bases: they were pounded for so long that the thick metal was worn through. Only in the nineteenth and twentieth centuries were they taken out of use, when their status changed from that of secondhand goods to that of antiquities.

In some cases, objects survived because they were reused for other purposes. This appears to have been the fate of the unusual convex copper disc shown here, which must once have been part of a large and complex instrument of splendid appearance. The inclusion in the decoration of a Zodiac Man, a figure representing the planet Saturn, and a man taking a reading with an astrolabe (see plate 10) indicates that the original instrument had some astrological or astronomical function. It has long been presumed that it was part of a great astrological clock.

In its original state, the object can have been neither convex nor a disc but must have formed the flat, rectangular base plate of the instrument. Its current form would appear to be the result of the reworking of the base plate for another use after the instrument was dismantled. The nature of this secondary use remains a mystery.

The reason for the survival of the piece is clearly the quality of its decoration. Most of the outer surface is covered with very fine engraving, with the motifs reserved in a ring-matted ground, and this decorated area has been gilded. There are also three circular blank spaces, which were presumably once covered by dials, and each blank space has a large hole at the centre, through which the dial was no doubt attached to the mechanism behind the base plate.

The motifs used in the decoration are very diverse. The Zodiac Man at the base illustrates the belief that the different parts of the body are ruled by different signs of the zodiac: the head by Aries, and the neck by Taurus, for example. Diagrams of the Zodiac Man were current in Europe in the later Middle Ages, and we can presume that European printed versions had reached Iran by the later sixteenth century. Eleven signs are shown attached to the Zodiac Man on the disc. The twelfth, Pisces, which ruled the feet, was lost when the plate was sawn into a disc.

Above the Zodiac Man on either side are depictions of Safavid courtly figures on horseback, both young, and both engaged in the hunt. Above these on the left is the man making a reading with a planispheric astrolabe while an assistant studies a manuscript, which presumably contained astronomical tables. On the right, another man makes a measurement with a compass from a mariner's astrolabe, while his assistant stands ready with a squaring tool and a hatchet or hand-adze. In the next register up, two angels are shown in flight, as though supporting the dials that once covered the circular spaces above. The figure at the top represents Saturn as a male figure with seven arms, crowned, bearded and sitting on a throne. His arms hold seven attributes: a crown, a whisk, a hatchet, a rosary, a rat caught by its tail, a spear and a sieve.

It may be surmised that by the end of the seventeenth century a large astrological or astronomical clock was set on a wall somewhere in the precincts of a royal residence in Isfahan. The base plate and perhaps other elements had a sumptuous appearance, due to their figural designs and their gilding. During the looting of Isfahan that accompanied the Afghan occupation of the city in 1722, someone mistook the gilt copper base plate for gold and tugged it violently from its setting, thereby warping it and damaging the edges. When it was found to be base metal, it was discarded or sold to a coppersmith in the bazaar for a small sum.

60. Concave disc of copper, engraved, ringmatted and gilded, 78.7 centimetres in diameter. It was probably made in the Safavid capital of Isfahan in the 17th century.
V&A: 1577–1904.

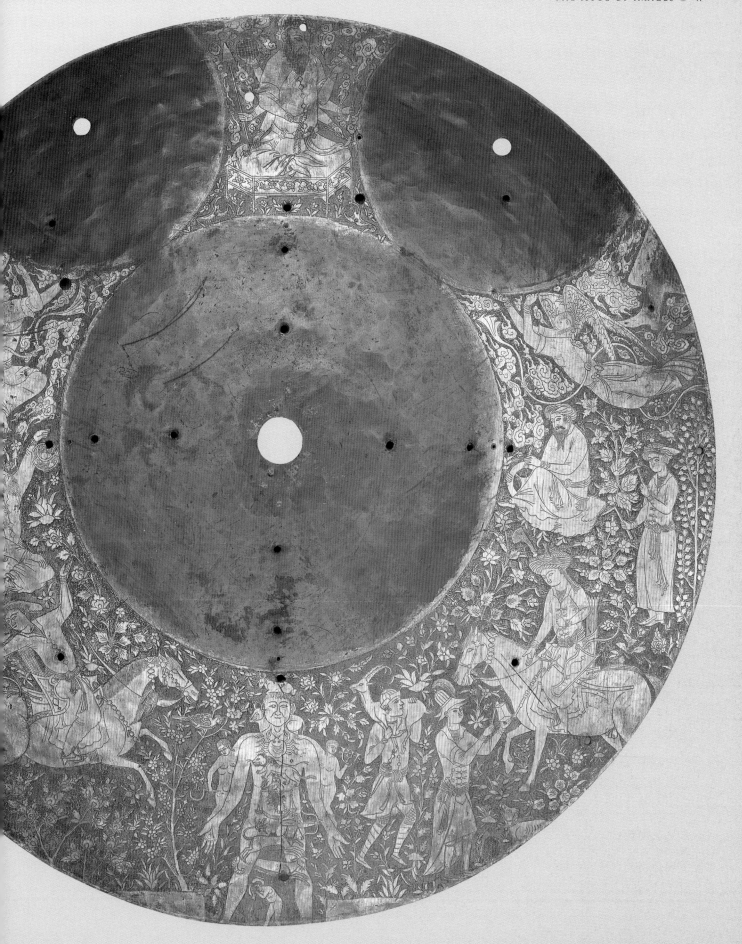

62. Jug. Fritware
with enamelled
colours over the
glaze. Iran, probably
Kashan, late 12th or
early 13th century.
Height: 15.4 cm.
V&A: C.164–1928.
Given by the executors
of Lady Marling, CBE

61. Bowl. Fritware
with enamelling
and gilding over
the glaze. Iran,
probably Kashan,
late 12th or early
13th century.
Diameter: 20.7 cm.
V&A: C.52–1952.
Purchased with the
assistance of the
Naional Art
Collections Fund

painted in gold and colours and set in the space between two of the suspension hooks. This figural element is lacking on the second lamp (plate 59), which was produced a century later, probably in Egypt. Here the decoration is much denser, covering every visible surface of the vessel, and a prominent place has been given to an inscription, arranged in two registers, which names the man who commissioned the lamp. He was Kafur al-Rumi, the treasurer of the Mamluk ruler Sultan Isma'il, who ruled briefly between 1342 and 1345. In both registers, the text is punctuated by three discs containing a six-petalled rosette, which was Kafur's badge of rank.

Like other examples of its type that have no figural images in their decoration (compare plate 14), Kafur's lamp was probably made for a religious institution, while the lamp with the three falconers was destined for use in non-religious contexts. The distinction must not be made too categorically, however, as there was nothing to prevent the lamp of Kafur al-Rumi from being used in a domestic setting. Patterns that did not include human or animal figures were common on all types of ware, and it was normal for the same type of ware to be produced with both figural and non-figural decoration. This is shown, for example, by two pieces of fritware pottery of a type made in late twelfth- and early thirteenth-century Iran, and decorated in a very similar manner to enamelled and gilded glass, with the colours applied over an opaque white glaze. One of these so-called Mina'i wares, a bowl, is finely painted with a scene showing a party in progress (plate 61), and it must have been made for domestic use. But the same can be said for a jug with non-figural ornament in the form of overall repeat patterns (plate 62).

In three dimensions

At the other extreme, as it were, are objects made for domestic use that incorporate human and animal forms. A striking example is a fritware ewer made in Kashan in Iran at about the same time as the Mina'i wares (plate 56). The body was produced in an impressively accomplished double-shell technique. The plain inner shell – the container for the liquid – was formed, given a monochrome turquoise glaze and fired in the normal manner. The perforated outer shell

was then made around the half-finished pot and decorated in black: parts of the decoration, including the inscriptions above and below the openwork area, were scratched through this black paint. It was then glazed in turquoise to match the inner shell, and the whole piece was fired again. In this example, the mouth of the ewer was moulded in the form of a cock's head and the handle as tail feathers, with details added in black. Such bird- and animal-shaped elements had been a common feature of metalwork ewers since the beginning of the Islamic period, and the double-shell technique, too, may have been inspired by metalwork with openwork decoration.

The ewer incorporates only parts of a bird form, but other vessels resembled freestanding figurines. A small lustre vase from the same period has the shape of a man, evidently a person of culture, who is shown seated and holding a glass of wine (plate 63). It is clear that many Muslims saw no harm in such objects, which had a utilitarian function and could not be confused with idols made to be worshipped. The freestanding figure of a bull, produced in Syria in the twelfth century and made of fritware covered with an opaque white glaze (plate 64), might raise

Right: 63. Vase in the form of a seated man. Fritware decorated with coloured glaze and lustre. Iran, Kashan, late 12th or early 13th century. Height: 19.9 cm. Ades Family Collection

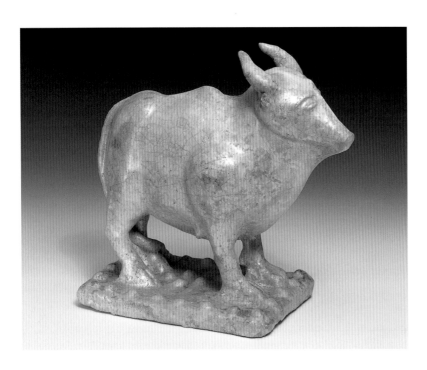

Left: 64. Figure of a bull. Fritware with an opaque glaze. Syria, 12th century. Height: 22.2 cm. V&A: C.36–1980.

Right: 65. Star and cross tiles. Fritware with lustre decoration. Iran, probably Kashan, dated 1261–62. Width: 121.1 cm. V&A: 1837–1876.

questions of impropriety, since its intended function is not immediately evident.

The practice of making domestic objects that incorporated the forms of living beings remained current for many centuries, at least in Iran, and this tradition was no doubt reinforced by the import of similar items made in China and elsewhere. It has been suggested, for example, that Chinese porcelain incense burners in the shape of a goose inspired the form of a duck-shaped fritware vessel from seventeenth-century Iran (plate 57); and the blue-and-white decoration is certainly an imitation of Chinese wares. It seems to have been designed as a hookah base, although it is only 12 centimetres high and therefore rather smaller than most examples. The hookah was a water pipe used for the consumption of tobacco. The smoke from the burning herb was drawn down a pipe and through water to cool it and filter it. It was then drawn up another pipe to the mouthpiece. The 'duck' held the water, and the holes in its back and neck accommodated the two pipes.

Overstepping the mark

The difference between the two types of decoration, figural and non-figural, extended to the decoration of walls, but such decoration is often poorly preserved.

An exception is glazed ceramic tilework. Because of the durable nature of the material used for tiles, representative amounts of tilework have survived where work in other media, such as painted designs on plaster, has been lost. In the second half of the thirteenth century and the first half of the fourteenth, tiles of many different types were produced to decorate both the palaces of Iran's Mongol rulers, who had conquered the country in the late 1250s (plate 100), and the religious buildings reconstructed or

redecorated by their Muslim subjects. The tiles used in a religious context usually bear inscriptions and patterns appropriate to their surroundings, as might be expected, but there were occasions on which this rule was not observed.

In one tilemaking technique employed in this period, the tiles were formed, glazed and fired, and decoration in lustre was then painted over the flat surface. Examples were made in 1262 for a tomb in the town of Varamin near present-day Tehran, where a

descendant of the Imam 'Ali was thought to be buried. (As Shi'ites regard 'Ali and his family as the rightful successors of the Prophet, this man was revered by them, and his tomb was a place of pilgrimage.) As was common at the time, interest was added by combining star-shaped and cross-shaped tiles in a complex pattern (plate 65) and, having been made for a religious site, they were decorated with non-figural designs. Each has a self-contained pattern composed of idealized flower and leaf motifs set on

scrolling stems or placed in symmetrical arrangements; and each is framed by a plain band on which quotations from the Qur'an were written in a relatively informal hand.

The strictly non-figural principle of the decoration at Varamin was breached in tiles found in other tombs of the same period. In 1266 and 1267, the tomb of another descendant of 'Ali at Damghan, to the east of Tehran, was decorated with star-and-cross revetments that must have been intended for a palace, since the tiles of both types bear animal themes, and the star tiles have borders inscribed with texts from the great epic poem known as the *Shahnamah*, or *Book of Kings*, rather than the Qur'an. It is no doubt for this reason that the tiles were later plastered over.

A less blatant example of inappropriate tiling is found in a monumental tomb at Natanz in Iran, which had decoration added about the year 1308. It included a frieze dominated by a magnificent moulded inscription picked out in cobalt-blue glaze (plate 66), while the background is formed of scrollwork in lustre, which is inhabited by small birds, also moulded in relief. Other birds occur in a narrow band above the inscription, arranged in pairs. At some stage before the nineteenth century, when the tiles were removed from the building, the head of each bird was carefully chipped off, so that religious sensibilities would no longer be affronted.

A harder line

The tiles at Damghan and Natanz breached the boundary between religious contexts, in which figural imagery could not be used, and non-religious ones, in which it could. Their subsequent treatment can therefore be seen as the enforcement of this boundary. There were times and places, however, when the boundary was deliberately moved, so that the ban on images affected works of art intended for non-religious contexts. This is shown, for example, by damage to the figures in manuscript illustrations, whose faces were sometimes obliterated by smudging, or who had lines drawn across their necks, as if to kill them off. Some Muslims clearly felt unease in the presence of *any* figural image made by human agency, no matter how far removed from an 'idol' it might be.

Such antipathy to images of any kind has been encouraged by two lines of thought. One is the argument that God must be honoured as the sole creator and that to make images is to rival Him in the act of creation. On this basis, not only depictions of human beings and animals, but also even the mere acts of drawing or painting such figures are subject to condemnation. The second argument arises from the principle that worship must be directed exclusively and uncompromisingly towards God. According to radical interpretations of this doctrine, such as that proposed by the theologian Ibn Taymiyyah (1263–1328), anything that can be interpreted as worship of another being, whether a prophet or other religious figure, or a temporal ruler, is to be condemned as a form of idolatry. Consequently, relics of holy men and women and political symbols, as well as images, should be abhorred and destroyed.

Such thoroughgoing radicalism began to enjoy considerable success in later times, but for most of the Islamic period it was exceptional. Indeed, attitudes to the use of images clearly differed between periods, between regions and between social classes. In Morocco, for example, there seems to have been no production of literary manuscripts with illustrations; there are no surviving buildings with figural decoration; and figures are almost entirely absent from the decorative arts. This may have been due to internal reasons, reflecting the currency there of a stricter form of Islamic law, but external factors may also have played a role: from the later Middle Ages the threat of invasion by the Christians of Spain and Portugal, who were enthusiastic worshippers of religious images, may have made the complete rejection of images a token of Muslim identity.

In Syria and Egypt, there was change over time, with the figural element in art becoming more restricted from the beginning of the fourteenth century. Indeed, although the difference in decoration between the two lamps referred to above is due primarily to their intended function, it also reflects a change in taste. In the mid-thirteenth century, when the lamp decorated with the three falconers (plate 58) was made, figural decoration was a common feature of luxury objects, but by the mid-fourteenth century, when the mosque lamp of Kafur al-Rumi (plate 59) was produced, this was no longer so. The activities of Ibn Taymiyyah and

66. Tile with part of an inscription. Fritware decorated with coloured glaze and lustre. Iran, probably Kashan, about 1307–8. Height: 35.8 cm. 1485–1876.

his followers in the intervening period may have played a role in this change, even though they were generally regarded with hostility by the rulers of the region and spent much of their time in prison. How, then, can they have exercised this influence?

Pressure from below

In the fourteenth and fifteenth centuries, the Mamluk capital, Cairo, was inhabited by hundreds of thousands of people, as was Istanbul, the capital of their Ottoman successors, which grew to a great size

over the course of the sixteenth century; in their time, the two cities were among the very largest in the world. Although they had no formal power, the huge Muslim populations of these places were capable of causing severe problems for their rulers, especially when directed by those with religious authority. This situation may be contrasted with that on the Iranian plateau, where the cities were generally prevented by poor communications and limited water and other resources from growing to a similar size. Consequently, Iranian rulers usually had no need to negotiate their

THE CHELSEA CARPET

Tim Stanley

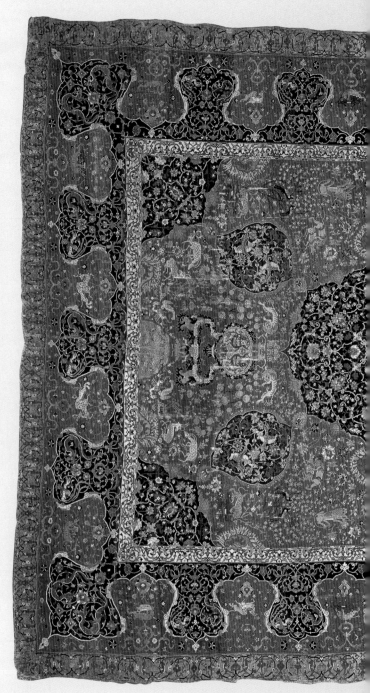

The Chelsea carpet and the Ardabil carpet (see pp.74–5) are both outstanding products of Iranian weavers of the sixteenth century, but they show different approaches to the design of carpets of great size. The Ardabil is roughly three times the size of the Chelsea and therefore presented the greater challenge. Its designer filled the enormous space of the main field by enlarging a standard 'centre-and-corner' composition, in which a large, medallion-like figure is placed in the centre, and quarter-sections of the same motif are repeated in the four corners. In this case, the medallion-like figure is partially deconstructed so that it does not become an overbearing element in the design: the central circular figure with a lobed outline is reduced in size relative to the area available, and the remaining space is occupied by a 'halo' of sixteen pointed-oval figures with different ground colours. The background is filled with a single pattern formed from two flowery scrolls, one laid over the other. The result has a rare sense of calm and harmony.

The usual approach to the design of such large carpets was to repeat a composition across the field as many times as was required to fill it. In the Chelsea carpet, the composition is repeated only twice, once in each half of the field, and the designer included an unusual device that holds the two halves together in a very successful manner.

In each half, there is a 'centre-and-corner' composition based on a circular figure with an eight-lobed outline. It has a blue ground. The central and corner elements are linked by smaller pointed-oval figures, also with blue grounds. The combination of the two X-like arrangements of blue medallions, quarter-medallions and pointed-oval figures leaves a large space at the centre of the carpet, which is filled with a representation of the type of grand Chinese porcelains that might well have been placed on top of the carpet during receptions. In the centre is a fish pond motif reminiscent of the designs found on some celadon wares, while on either side there is a fanciful depiction of a Chinese porcelain vase on an elaborate stand. To balance out the design, one half of this composition is repeated at each end of the carpet.

The rose-red ground of the main field is filled with a vivid mixture of flowering and fruiting trees, and animals either grazing or in combat. Despite the relatively small scale of these motifs, there are exquisite details such as the ripe pomegranates, which have burst open to reveal their seeds.

The main border is composed of a pattern of reciprocal lappets with contrasting blue and rose-red grounds. An asymmetrical element was introduced by the designer, who created four red lappets in the border at one end and three at

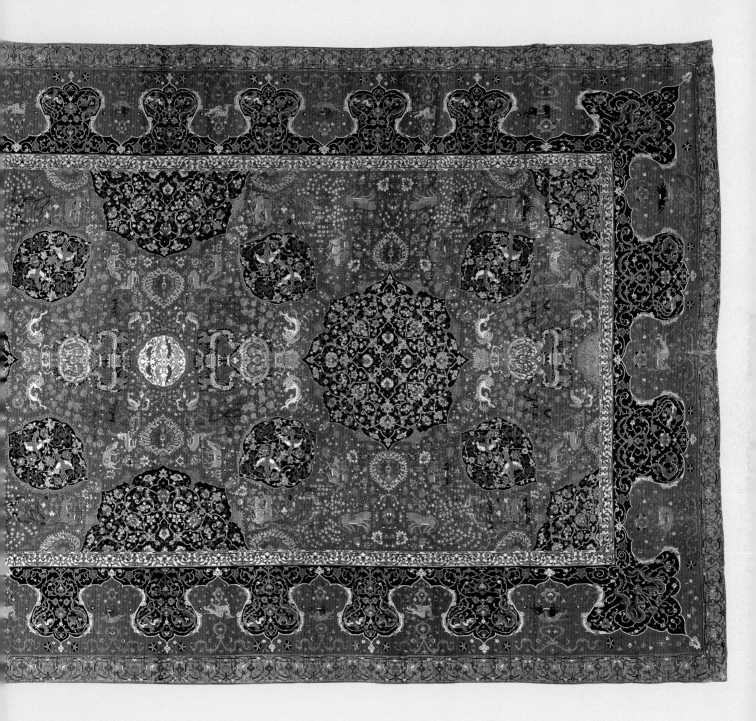

the other. This may have been done in order to give a sense of direction to those using the carpet (compare the lamps of different sizes on the Ardabil carpet), and it has been suggested that the larger lappets at one end were for the most distinguished participants in an assembly, with the central lappet marking the place of honour.

67. Carpet with woollen pile and silk warp and weft produced in Iran in the early 16th century. The Chelsea carpet acquired its current name simply because the Victoria and Albert Museum purchased it from a dealer in the London district of Chelsea. 5.41 x 3.15 metres. V&A: 589-1890.

Opposite: 68.
Panel of tiles.
Fritware with
painting under
the glaze. Turkey,
probably Iznik,
17th century.
Height: 188.6 cm.
V&A: 70–1898.

role with the type of large and complex urban society that developed on the Nile in Egypt and the Bosphorus in Turkey. One result may have been that, while the Mamluks and Ottomans eventually had to bend to public opinion and avoid the use of images, their contemporaries in Iran did not.

One of the last Mamluk rulers, Sultan Qa'itbay, enjoyed a long and successful reign (1468–96) partly because he strove to demonstrate his personal piety to the population of Cairo. According to his obituary by the historian Ibn Taghribirdi,

> His lifestyle was correct. He never drank wine, nor indeed any inebriating substance. He was learned in religious science, widely read. He even authored pious litanies that are recited in mosques to this day. He had faith in mystics, honoured scholars, respected rights of the people – acknowledging the status each merited. He particularly admired the self-effacing life of ascetics.[1]

The metalwork made for the Sultan personally, such as a brass basin inlaid with silver and gold (plate 112), reflects these attitudes, since its decoration is formed of bold calligraphic inscriptions and ornamental motifs but lacks any figural element. That figural designs were in use at the time is shown by a ewer made for the Sultan's wife (plate 103), which has all-over engraved and inlaid decoration that includes depictions of animals.

In 1516 and 1517, the Ottomans conquered the empire Qa'itbay had ruled, but they did not follow the precedent he had laid down. Indeed, during the early part of his reign, which lasted from 1520 to 1566, Sultan Süleyman showed no great sensitivity to the feelings of Istanbul's Muslim population. On one occasion, in 1526, he brought three bronze statues of human figures to Istanbul as plunder from the Hungarian capital, Buda, and set them up in the Hippodrome, alongside other famous trophies erected there a thousand years before – a sultan rivalling the Roman emperors. The city's Muslim population was outraged and blamed Süleyman's favourite, the grand vizier Ibrahim Pasha, whose palace stood nearby. As Ibrahim's given name is the Qur'anic form of Abraham, a satirical couplet referring to the

patriarch Abraham's clearing of idols from the Ka'bah was circulated:

> Two Abrahams came into the temple of the world.
> One threw down idols, the other set them up.

Ibrahim held the young poet Figani responsible for this insult and had him hanged. Ibrahim himself was put to death in 1537, having gone too far in another matter, and the Sultan's subsequent advisers were careful to be more sensitive to public opinion, no doubt partly because the city's population was growing apace and was more difficult to control. The statues were removed.

Confrontation

The story of the three statues is an unusually explicit example of the eclecticism of Ottoman court culture in the period 1450–1550. With their capital in newly won territory, beyond the long-established frontiers of the Islamic Middle East, the Ottomans were more exposed to the traditions of Orthodox and Catholic Europe. Unlike the Moroccans, however, their state was expanding at the Christians' expense, and the Ottomans had no need to feel overly threatened. There was therefore no barrier to the adoption of European Renaissance motifs of various types, even portraiture (plate 144).

Yet Europe was not the only supplier of new motifs to the Ottomans: it shared the role with the courts of Iran, which were the source, for example, of the small-scale spiralling arabesques found on Ottoman 'Golden Horn' ceramics (plate 116). Sometimes these diverse elements were merged in works of an unusual character, such as silver ewer that is Netherlandish in form but Iranian in decoration (see plate 151).

Circumstances put a stop to this eclectic approach to design, and from the mid-sixteenth century the Ottomans developed a distinctive and coherent court style. One factor behind this change was the configuration of states that emerged in the Middle East after 1500. In that year the Turkoman rulers of western Iran and Iraq were overthrown by the hereditary leader of the mystic, or Sufi, brotherhood founded by Shaykh Safi al-Din of Ardabil (1252–1334; see the Ardabil carpet, pp.74–5).

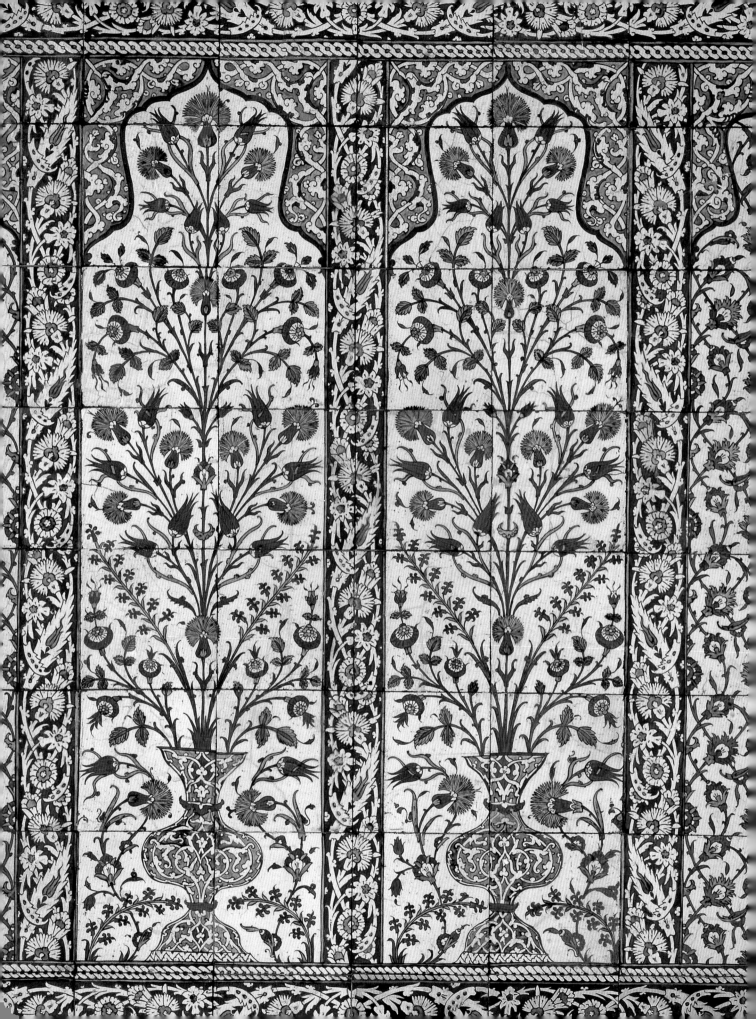

Top, right: 69.
Woven silk. Turkey,
17th century.
Length: 120.5 cm.
V&A: 763–1900.

Top, left: 70.
Cloth of silver.
Woven silk and
metal thread.
Turkey, second half
of 16th century.
Length: 120 cm.
V&A: 835–1904.

Opposite: 71.
Tile panel.
Fritware with
decoration in
enamel colours
(*cuerda seca*).
Iran, Isfahan,
17th century.
Length: 221.5 cm.
V&A: 139–1891.

The brotherhood had adopted a radical form of Shi'ism, and the first Safavid ruler, Shah Isma'il (1500–24), declared himself to be the Hidden Imam, the leader who, Shi'ites believed, was to come at the end of time to restore just rule. He was initially successful in the east, where he was able to overthrow the last Timurid rulers in 1507 and reunite Iran under one ruler, a situation that has persisted to the present day. But he soon suffered checks at the hands of the Uzbek rulers of Central Asia and the Ottomans, who defeated him in battle in 1514 and seized the westernmost territories of his empire. The Ottomans were successful again in 1534, when they conquered Iraq, but in subsequent wars victory often went to the Safavid side.

Since in the meantime, in 1516–17, the Ottomans had eliminated the Mamluk empire, almost the whole Middle East was now divided between two rival powers, the Sunni Ottomans and the Shi'ite Safavids, whose

mutual suspicion was reinforced by the presence of pro-Safavid Shi'ite tribes within the Ottomans' borders and of Sunni groups inside Iran. Vitriolic propaganda was produced by both sides, and by the second half of the sixteenth century their antagonism was being expressed in their dynastic styles.

For the Ottomans it was necessary to retain the support of the Sunni majority among their subjects, and this may explain why the court style they developed is devoid of elements that would have been unacceptable to them, specifically in the absence of figural motifs. This feature becomes truly apparent only when a wide range of Ottoman artefacts from the sixteenth and seventeenth centuries – tilework (plate 68), for example, or silk textiles used for both kaftans and furnishings (plates 69 and 70), or carpets (plate 76) – is compared with those produced for the Safavids in the same period. It is clear that the Safavids

AN OTTOMAN TRADITION IN CALLIGRAPHY

Tim Stanley

72. Ottoman tile dated 1727. The main motif is a calligraphic pattern formed from the names of God, the Prophet Muhammad and the first four caliphs, Abu Bakr, 'Umar, 'Uthman and 'Ali. The combination indicates an allegiance to Sunni Islam, as the legitimacy of Abu Bakr, 'Umar and 'Uthman is rejected by Shi'ites.
Height: 29 cm.
V&A: 1756–1892.

Below: 73. Sheet inscribed with the *basmalah* in the *muhaqqaq* style, probably written in the 18th century. The *basmalah* is the phrase 'In the name of God, the Merciful, the Compassionate', which Muslims say or write at the beginning of many activities.
Width: 31.5 cm.
V&A: E.808–1926

The history of one type of Ottoman calligraphy provides a clear example of the emergence of a dynastic style. This development was a prolonged affair, but its effects were long lasting and pervasive: the same style of calligraphy was used almost everywhere in the vast Ottoman empire for more than two centuries.

The Ottomans used different types of script for different purposes. In religious manuscripts they employed the group of styles known as the Six Pens, which had been formulated in Iraq in the thirteenth century (compare plate 33, which is in the monumental style called *muhaqqaq* by the Ottomans). The most famous Ottoman practitioner of the Six Pens was Şeyh Hamdullah, who died about 1520. With the encouragement of Sultan Bayezid II (ruled 1481–1512), Hamdullah developed a personal manner that was to prove influential, especially in the case of the smaller hand called *naskh*,

which was used for copying Qur'an manuscripts of average proportions (plate 75).

During the sixteenth century, Hamdullah's reworking of the Six Pens continued to be practised by his pupils, but his was only one of several schools of calligraphy that flourished in this period. Then, around the beginning of the seventeenth century, the Six Pens went out of fashion due to a number of factors. One was the increased popularity of *nasta'liq*, a style used primarily for copying literary works (see pp.66–7, for

Left: 74. A pair of *karalamas*, or exercise sheets, by Berber-zade Ahmed Efendi (born 1711, died 1787 or later). Connoisseurship of calligraphy led to the preservation even of minor works by recognized masters. In this case, the two sheets were stuck down on boards and given illuminated highlights. They were then framed in green silk and bound as a small album. Height: 14.2 cm. V&A: E.786 and 787–1926.

Above: 75. Qur'an manuscript, probably from 17th-century Istanbul. It was written in the *naskh* style and, as was standard, the beginning of the text is laid out on facing pages and is surrounded by a richly illuminated frame. It is possible that the scribe responsible, who calls himself Mustafa ibn Muhammad, was the Ottoman Sultan Mustafa II. Height: 30 cm. V&A: 23.ix.1890.

example), which had been given new grace by the Iranian master Mir 'Imad. Mir 'Imad was a Sunni, and his murder in 1615 at the court of the Shi'ite Shah 'Abbas I made him a cultural hero for the Ottomans.

From the 1650s, a major reform of Ottoman institutions took place, and this was accompanied by a revival of interest in the Six Pens, and specifically in the version developed by Şeyh Hamdullah. By the middle of the eighteenth century, his style was dominant: it had become the style of the Ottoman state, and it was used until the demise of that state in the 1920s.

showed no restraint in using human figures in the design of their tilework (plate 71) and silks (plates 77 and 78), for example.

The extent to which the Safavids employed human figures in the decorative arts cannot, of course, be attributed merely to the smaller sizes of their capital cities and other ecological factors. It reflects a difference in political traditions. The rulers of Iran had enjoyed great freedom of action since the Mongol conquests in the thirteenth century, when the Mongol customary law, or Yasa, had temporarily replaced Islamic law as the basis of the state.

Even after the Mongols' conversion to Islam, the Yasa continued to be very influential, both under their rule (to 1335) and that of their successors down to the fall of the Timurids in 1507. Isma'il's claim that he had been directly appointed by God to rule the world added a new dimension to this tradition, giving it a religious gloss. The Mongols and Timurids had felt no compunction about wearing silks with figural motifs, as can be seen from contemporary paintings and drawings and surviving textiles, but these generally bore animal themes, employed with elegance and restraint. The boldness of the Safavid examples, and the frequent use of human figures, was new.

Coats made of cloth covered in courtly motifs, such as those illustrated here (plates 77 and 78), or with scenes derived from the illustrations to Persian narrative poems, demonstrated the wearers' allegiance to their charismatic rulers, just as kaftans made from silk with large-scale plant-based designs (plates 69 and 70) identified a servant of the Ottoman sultan. One result of these developments is that it is not too difficult to identify the retinues of Safavid ambassadors in contemporary Ottoman miniatures, since they are shown decked out in coats decorated with pictures of handsome young men and women or scenes from the Persian classics. Safavid policy in this respect appears all the more deliberate when we remember that not all Safavid silks were figural.

Boom and bust

The development of the Ottoman court style in the second half of the sixteenth century was followed by a period of crisis in the early years of the seventeenth century, and lack of funds explains why the Ottoman

Previous page: 76. Carpet. Knotted woollen pile. Turkey, 16th century. Length: 522 cm. V&A: T.71–1914.

Above: 77. Silk velvet. Iran, 16th century. Length: 109.7 cm. V&A: 282–1906.

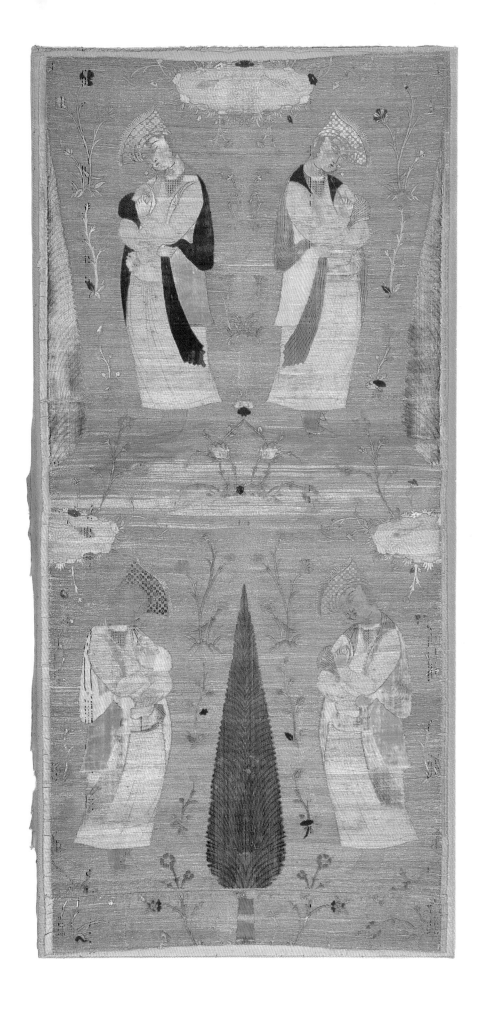

78. Silk velvet. Iran, late 16th to early 17th centuries. Length: 156 cm. V&A: T.226–1923. Purchased with the assistance of the National Art Collections Fund

KHUSRAW AND SHIRIN

Barry D. Wood

79. The binding is made of fine morocco stretched over light, hard pasteboard. It was decorated on the outside by pressing a raised design into the leather with large stamps, and on the inside by cutting the leather away to create exquisite openwork patterns. Both types of decoration were coloured with gold and paint.
V&A: 364–1885.

For much of Islamic history, the possession of luxury copies of poetic works in Persian was a necessity of culture. These books were produced in manuscript, and until the late seventeenth century many of the finest examples were provided with painted illustrations. The consumption of such works was not confined to Iran, where Persian was a spoken language, but the cities of Iran were the main centres of production, and some conducted a lively trade in exporting illustrated books to other parts of the Middle East and to India.

The *Book of Kings* of Firdawsi, completed around AD 1000, was the earliest and most popular of these works (compare plate 100), and illustrated material survives from the beginning of the fourteenth century onwards. The second most popular was the *Khamsah*, or *Five Tales*, of Nizami, who died in the early years of the thirteenth century. From the fifteenth century, manuscripts were produced containing all five stories or just one. The book illustrated here contains his romance of *Khusraw and Shirin*, completed after 1184.

The poem tells of the protracted courtship of the Sasanian monarch Khusraw Parviz and the Armenian princess Shirin. There are many twists and turns in the plot, including the point when Khusraw catches sight of Shirin bathing without realizing who she is (plate 80). The pair are eventually united, but the story ends tragically when Khusraw is assassinated. The tale was recounted in a straightforward manner in the *Book of Kings*, but Nizami turned it into a virtuoso exploration of human passion, leavened with insights from his own considerable erudition.

Although the technique of painting remained remarkably consistent, the style of painting changed a good deal over time, reflecting changes in taste among Iran's rulers, who were the most important patrons. The last major stylistic phase began after Shah 'Abbas I moved the court to Isfahan around 1598. The most influential painter in the following decades was Riza', called 'Abbasi due to his connection with the Shah. Riza' 'Abbasi signed every one of the eighteen paintings in the V&A's copy of *Khusraw and Shirin*, and one he dated 1632. Nevertheless, it seems likely that in many cases, Riza' worked out the design of the illustration and then handed it over to be painted by an assistant.

Two other signatures appear on the manuscript. The magnificent binding (plate 79) was signed by Muhammad Muhsin Tabrizi, while the text was the work of a celebrated calligrapher in the *nasta'liq* style called 'Abd al-Jabbar. As 'Abd al-Jabbar died in 1655, a great puzzle of the manuscript is that he dated his signature 1680, presumably in error.

It was common practice to remove individual paintings from illustrated manuscripts and to preserve them as separate works of art, especially when the manuscript as a whole had become too worn or damaged for normal use. Western dealers and collectors were even more inclined to break up such manuscripts, simply because they could not understand the text. Fortunately, the painting removed from the V&A's *Khusraw and Shirin* by a former owner, Sir Sidney Churchill (plate 81), has been reunited with it.

Above: 80. Khusraw, riding to Armenia, catches sight of Shirin bathing in a stream without knowing who she is. As Shirin chastely combs her hair, he puts his finger to his mouth in astonishment at her beauty. The signature in the margin includes the date 20 Safar 1042, equivalent to 6 September 1632. V&A: 364–1885, folio 47A.

Left: 81. This painting is generally considered the work of Riza 'Abbasi himself, and because of its quality, it was detached from the manuscript and mounted as a display piece in 1885. It shows Khusraw bravely rescuing Shirin from a lion that has attacked at night. The king is engagingly shown in his nightclothes. V&A: L.1613–1964.

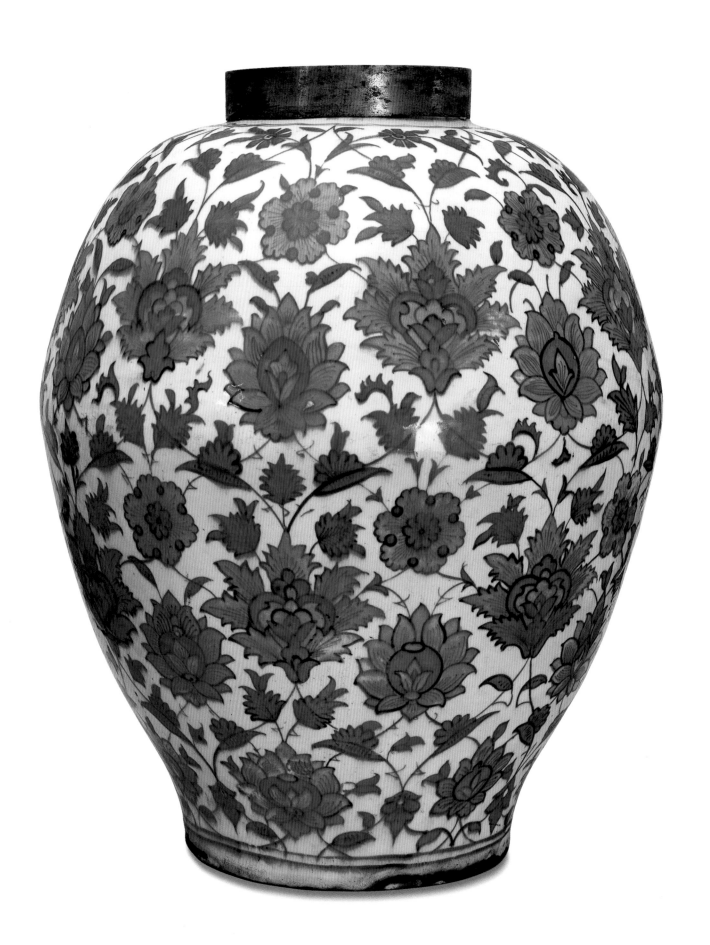

Left: 82. Storage jar.
Fritware painted
under the glaze.
Iran, 17th century.
Height: 52.5 cm.
V&A: 692–1902.

Right: 83. Storage
jar. Fritware painted
under the glaze.
Iran, 17th century.
Height: 29.8 cm.
V&A: 1544–1903.
Given by Sir Charles
Marling, KCMG

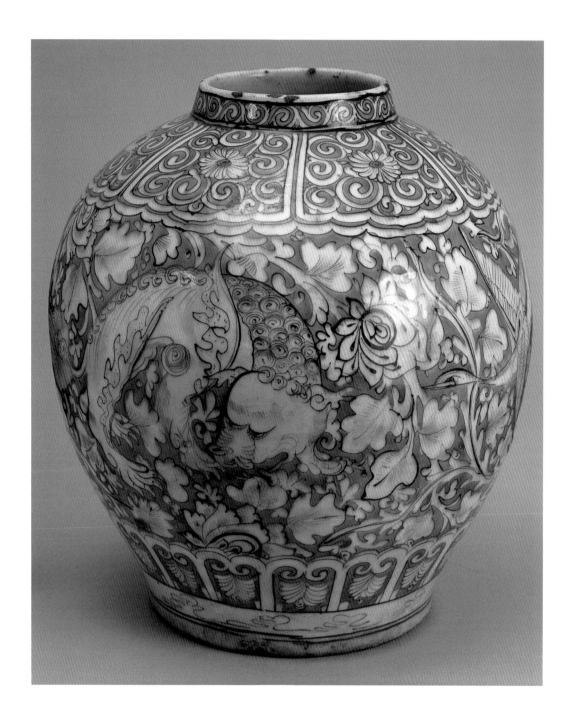

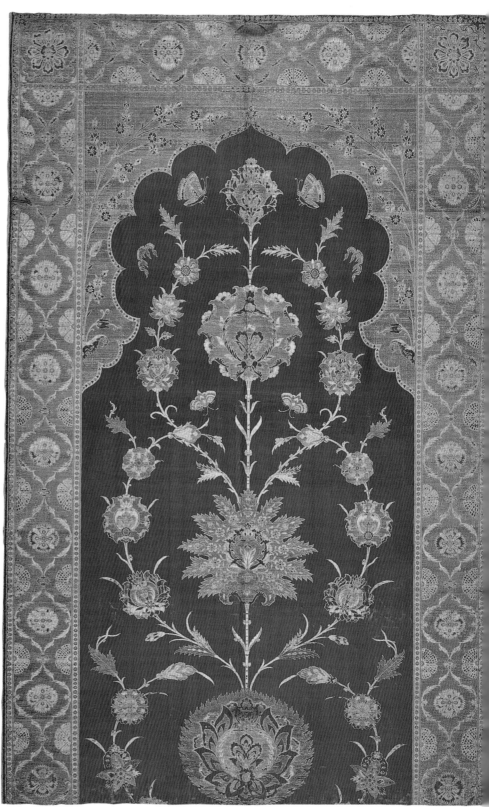

Above: 84. Spandrel
tile. Fritware
painted under
the glaze.
Turkey, probably
Iznik, 16th century.
Height: 60 cm.
V&A: 1879–1897.

Right: 85. Woven
silk. Iran, late
17th century.
Length: 179 cm.
V&A: T.9–1915.

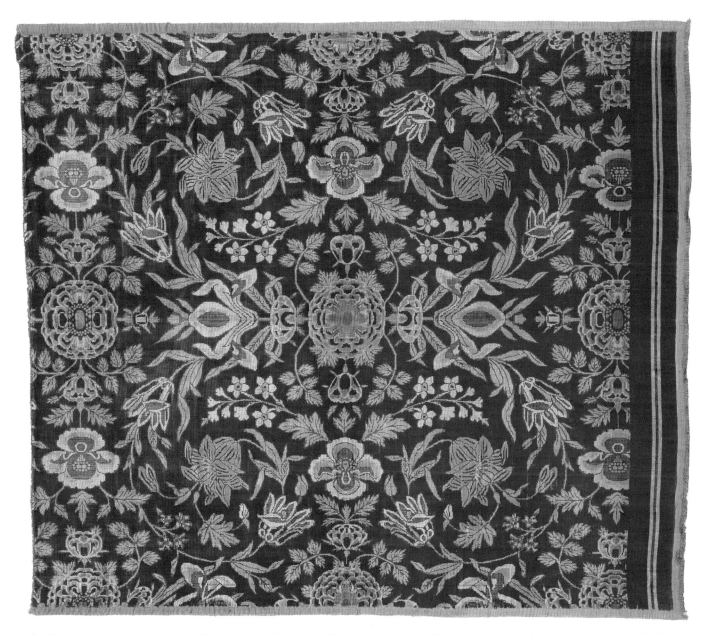

86. Silk velvet.
Probably India,
late 17th century.
Height: 106 cm.
V&A: 733–1892.

decorative arts did not thrive in the period that
followed. By contrast, the Safavids entered a period of
prosperity, brought on by an increase in international
trade. Their new capital at Isfahan, established around
1598, began to welcome large numbers of Europeans,
Indians and other foreigners (see pp.40–41). This
cosmopolitanism had its effect, as is shown by the
blue-and-white ceramics produced in this period: they
vary between outright copies of Chinese wares to
homegrown compositions executed in the same
combination of colours (plates 57, 82 and 83). A self-

confident eclecticism is also seen in a non-figural silk
textile with a deep-blue ground (plate 85). The panel
in question has an arch motif filled with a tree-like
arrangement of highly stylized floral motifs, which by
this date had become characteristic of Iranian art, as
had the wispy cloud of Chinese origin, found beside
the central 'tree' motif. The spandrels of the arch,
however, are filled with an Ottoman-inspired design:
the sprays of naturalistic flowers found there can be
compared with those in Ottoman spandrel-shaped
tiles (plate 84). At the same time, a third floral pattern,

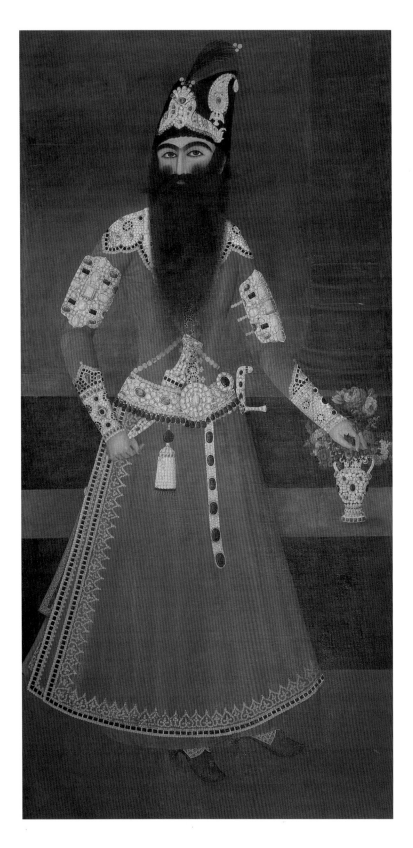

that in the border, can be matched to Indian textile patterns, where naturalistic flower motifs are often shown head-on (plate 86). To this list can be added the small insects fluttering about the central 'tree': these were derived from similar animals found hovering above the specimens in European herbals.

It was in the seventeenth century, too, that European painters arrived in Iran in some numbers and helped to establish a local tradition of painting in oils. As a result, full-length portraits began to find a place in Safavid palaces, although they were not necessarily of outstanding quality. Even when bust followed boom, leading to the collapse of the Safavid state in 1722, the dynasty's prestige was so great in Iran that the currency of figural imagery survived, and with it the technique of painting in oils.

When a new dynasty, the Qajars, emerged at the end of the eighteenth century, portraits in oils began to assume a highly political function. The founder of the dynasty, Agha Muhammad (died 1797), had been castrated as a youth by his father's enemies, and his successor, Fath 'Ali Shah (ruled 1797–1834), was keen to emphasize his masculinity. As a way of doing this, he commissioned numerous portraits of himself that showed him as slim-waisted, youthful and heavily bearded (plate 87). Some were sent abroad as diplomatic gifts, and many were placed in his palaces, where they were flanked by paintings showing either an enormous entourage, including many of his sons and grandsons, or harem women engaged in the entertainment of their lord (plate 88).

At least in Iran, the division between non-figural and figural art was maintained into the nineteenth century, when the figural tradition was reinforced by new techniques such as photography. Elsewhere this tradition was far more erratic, for the reasons discussed above. Nevertheless, the sources of both the figural and non-figural motifs in Islamic art of the Middle East deserve our attention. The most important of these was poetry.

87. Portrait of Fath 'Ali Shah by 'Abdullah Khan. Oil on calico. Iran, probably Tehran, early 19th century. Height: 233.9 cm. V&A: 707–1876.

88. Dancer performing
acrobatics. Oil on
calico. Iran,
early 19th century.
Height: 151.5 cm.
V&A: 719–1876.

THE ARDABIL CARPET

Tim Stanley

The Ardabil carpet is one of the largest, finest and historically most important carpets to survive from the Safavid period in Iran (1500–1722), but it is also one of the most problematic. Its historical importance rests on the inscription found at one end, which begins with a couplet by the fourteenth-century poet Hafiz of Shiraz:

> Except for thy threshold, there is no refuge for me in all the
> world.
> Except for this door, there is no resting-place for my head.
> The work of the slave of the court, Maqsud Kashani.

This text is followed by the date 946, which is equivalent to AD 1539–40.

The references to 'threshold', 'door' and 'court' (literally, 'doorway') in this short text could have two meanings. Conventionally, words for 'doorway' or 'portal' were used to indicate the residence of the ruler, but they were also applied to shrines, and this would seem to support the association of the carpet with the complex of buildings surrounding the tomb of the Sufi master Shaykh Safi al-Din (d. 1334), which is at Ardabil in north-west Iran. In fact, the earliest evidence for this association is the sales pitch of a late nineteenth-century London dealer, and documents relating to the shrine, such as an inventory of its contents drawn up in 1795, make no mention of the carpet. Despite the lack of documentary evidence, the purported connection with Ardabil has proved durable, since it is consistent with circumstances in Iran around 1540, when the carpet was made.

Until the end of the fifteenth century, the descendants of Shaykh Safi al-Din were the hereditary leaders of the Sufi brotherhood he had founded, but in the first years of the sixteenth century, they made themselves the rulers of Iran as the Safavid dynasty. The legitimacy of this line was partly based on its descent from the Shaykh buried at Ardabil. As a consequence, Shah Isma'il (ruled 1500–24), and his son, Shah Tahmasp I (ruled 1524–76), enlarged and improved the tomb complex, which was transformed from a location for Sufi devotions into a dynastic shrine. During these two reigns, no other religious building in Iran received more attention from the country's rulers.

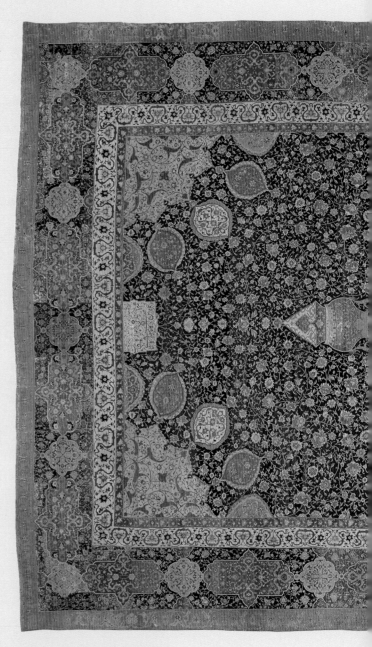

89. Carpet with woollen pile and silk warp and weft, produced in Iran in 1539–40. In 1893, the famous British designer William Morris considered it 'the finest Eastern carpet which I have seen'. The design was 'of singular perfection; defensible on all points, logically and consistently beautiful'. 10.97 x 5.34 metres. V&A: 272–1893.

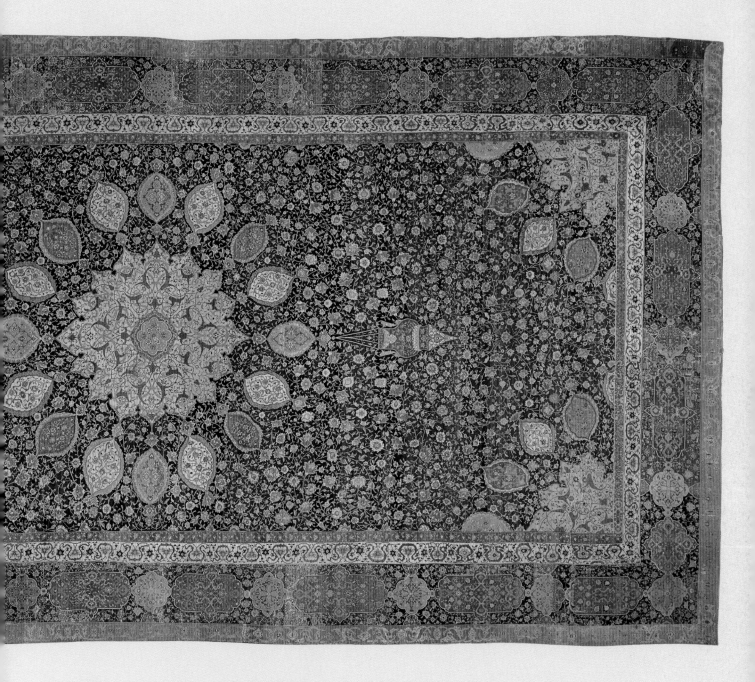

The Ardabil carpet is so outstanding in every way that it must have been made in response to a specific commission from someone with enormous resources at their disposal, and in 1540 this description best fitted Shah Tahmasp. The design of the Ardabil carpet, unlike that of many other examples from the same period (compare pp.54–5), is free from figural images, and it may therefore have been intended for a religious context. As we have seen, the main focus for Shah Tahmasp's religious patronage was the shrine at Ardabil. It is therefore entirely possible that the carpet was made for the shrine.

The Ardabil carpet in London is one of a pair, but the second carpet, now in the Los Angeles County Museum of Art, has lost its border and one end of the main field. It has become clear that in the 1880s both pieces were owned by the Manchester firm of Ziegler & Co. To make the London carpet more saleable, Ziegler & Co. used material from the Los Angeles example to restore it.

ادب پرور ندیمان خسرو منه
نشسته به هر کرسیتی چند

به دست هر یکی از طرف گنجی
مکلل کرده از غنچه تر نجی

لبالب کرده ساقی جام خونش
پیالی کرده مطرب نعمه درکوش

نهاده توده توده برکرانها
زیاقوت و زمرد نقل دانها

رقم کشیده صفا عباسی

Chapter Three

THE POETIC ENVIRONMENT

Poetry was the most prestigious form of creative
literature in the Islamic culture of the Middle East, and
it provided the inspiration for much of the content of
Islamic art. The poetry itself is very diverse. It was
written in different languages following different rules
of prosody, and it encompasses a wide range of
subject matter and a great variety of forms that were
current at different social levels: among villagers,
ordinary townspeople and tribal groups, as well as in
courtly circles. Of these forms, courtly poetry is
generally the best known, as it was the type most
often written down.

Because of the diversity in poetry styles, matching
the right poetry to the right object can be difficult,
but where it is possible the results are very
informative. A match can be made easily when
an image is accompanied by verse, as occurs in
illustrated manuscripts (see pp. 66–7) and
occasionally in the decorative arts (plates 97 and 98),
and it can be done almost as easily when the design
on an object illustrates a passage in a work of
narrative verse (plate 100).

A pairing of texts and iconography can also be
achieved where the patrons of a group of objects are
known to have been the patrons or authors of extant
poetry. This combination of objects and verses created
for the same clientele is not difficult to identify for the
fifteenth century and later, but it is rarer for earlier
periods, when the survival rate for both is much lower.

One important early example relates to the exquisite
caskets of carved ivory produced in Muslim Spain
between the mid-tenth and the early eleventh century
AD (see pp. 80–1). These objects were made for the
caliphs of the Umayyad dynasty, who ruled, in name at
least, until 1031, and for their relatives and courtiers.
After the caliphs, the most prominent patrons were the
regents who governed in the caliph's name between
976 and 1010, and who belonged to one family, the
Banu 'Amir. These patrons can be identified because
most of the caskets are inscribed with dedications. The
one exception is a pyxis, or cylindrical casket, that bears
a self-referential poem describing both its own
appearance (it has a domed top) and its function, as a
container for precious perfumes:

The sight I offer is the fairest, the firm breast of a
delicate girl.
Beauty has invested me with splendid raiment,
which makes a display of jewels.
I am a receptacle for musk, camphor and
ambergris.[2]

These verses remind us that the ivories of Córdoba
were once richly painted and studded with small
precious stones, the mounts for which can still be seen.

Praising the Caliph

We know from historical sources that poetry played
an important part in the lives of the original owners of
the caskets, and that this verse was not read silently as
it might be by a modern reader: it was recited in front
of audiences as a part of social events. The grandest of
these were the receptions that the caliphs held in their
palace at Madinat al-Zahra', outside Córdoba, at which
panegyric poems in Arabic were recited in praise of
the host. The descriptions of these events usually
contain excerpts from the 'greatest hits' among the
poems composed for the occasion. The poems include
the authors' names, and from this it is obvious that
they were high officials of the caliphal court, who
formed a close circle around the ruler and, to an
extent, maintained a personal relationship with him.
These highly educated men were well placed to

understand the mutual relationships between literary
and artistic imagery, and to perpetuate these
relationships through their involvement both as
patrons of the arts and as poets.

The fertility of the land was an important theme in
the panegyrics recited at the Umayyad court. In the
moral universe of the time, there was a direct link
between the conduct of the ruler and the well-being of
the state, and the happiness of the people. The Caliph
ruled by the grace of God, and if he acted well and
pleased his Maker, he would be rewarded. The rains
would come, the rivers would flow, and the harvest
would be ample. This is the background to verses sung
in praise of the Caliph Hisham (ruled 976–1009):

Do you not see that God has put him in charge of
his earth,
and he has made fertile any uncultivated land?
He fights sterility with gifts . . .[3]

Luxuriant vegetation was therefore intimately
connected to beneficent rule. It was a sign that all was
well with the world thanks to the justice and prudence
of the monarch. To describe the fertility of the land was
thus to laud the Caliph, and the same may be said for
parallel themes in the visual arts: to depict the fertility
of the land was to celebrate the Caliph's just rule.

It is for this reason that the audience hall at
Madinat al-Zahra' was lined with a veritable forest of
plant motifs, carved into the marble revetments
(plate 91). They reminded visitors that the Caliph
was an essential element in the well-being of his
domain. He was responsible for its God-given
prosperity, and should anything happen to him, that
prosperity would be threatened. The plant motifs were
also suggestive of future bliss: God's approval of the
monarch was evident from the prosperity of the realm,
and he must therefore be sure of a place in the
ultimate garden, in Paradise.

The same type of plant-based ornament is found in
the contemporary decorative arts. An example is the
leafy scrolls that cover most of the surface of a small
casket which, its inscription tells us, was made for a
daughter of 'Abd al-Rahman III (ruled 912–61), the
caliph who built Madinat al-Zahra' (plate 92). On the
face of it, these scrolls would not seem to signify a

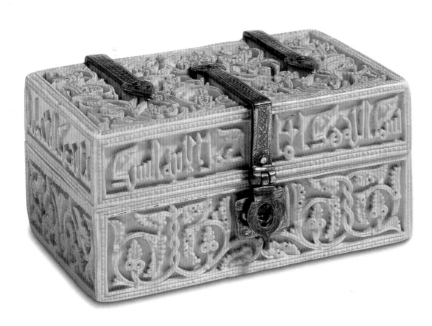

IVORIES FROM SPAIN

Mariam Rosser-Owen

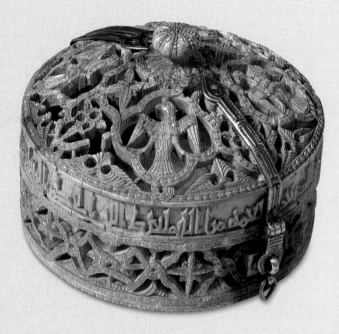

In 711, most of the Iberian Peninsula was conquered by the Arabs, and the 800-year history of Muslim Spain began. One of the most glorious moments in this history was the Umayyad caliphate, which flourished from the mid-tenth to the early eleventh century. The capital, Córdoba, was the greatest city in medieval Europe, and it became a centre for the production of luxury goods, including magnificent ivories, some thirty of which survive.

All the ivories are carved in fairly deep relief, and the decoration is predominantly figural, depicting courtly scenes, such as the seated drinker or the mounted huntsman, and conflicts between stronger and weaker animals – all images that also had currency in contemporary poetry. Many of the caskets also bear inscriptions, which provide a great deal of information about them. Some give the date, and some the place of manufacture, which in two cases is the caliphal palace at Madinat al-Zahra' near Córdoba. One indicates the casket's function as a container for perfumes, and several preserve the names of their patrons. From this information, we know that the ivories were commissioned almost exclusively by members of the ruling family.

The only Córdoban ivory that has a named patron who was not a member of the Umayyad dynasty is the pyxis of Ziyad

ibn Aflah (plate 94), who is known to have been an important courtier of the Caliph al-Hakam II (ruled 961–76). In fact, Ziyad may not have ordered the piece himself: it is more likely that it was commissioned by the Caliph as a gift bestowed, like honorific titles, upon a favoured member of his court.

In the eleventh century, after the collapse of the Umayyad caliphate, Islamic Spain was divided between a number of small states ruled by the *reyes de taifas*, or 'party kings'. These rulers attempted to recreate the luxury of the caliphal court by reviving the patronage of ivory carving, and to achieve this they employed craftsmen who had previously worked for the caliphs in Córdoba (see plate 95).

As is the case with other types of precious object from the Islamic world, the majority of the ivories from Spain have survived because they were used as reliquaries in Spanish cathedrals. Their Arabic inscriptions were sometimes erased (plate 95), and in some cases Christian iconography was added to their decoration (plate 96).

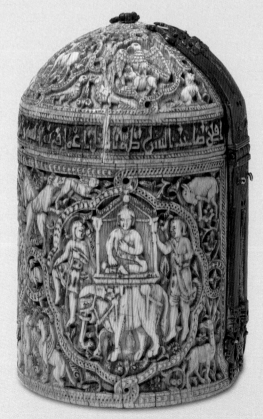

Opposite, top: 93. Pyxis of carved ivory made about AD 964 for the Caliph al-Hakam II. It probably formed a pair with a pyxis from the Cathedral of Zamora in Spain that was commissioned in AD 964 for al-Hakam's favourite wife, Subh. Both were made under the supervision of the chief eunuch, Durri al-Saghir. The openwork carving of the lid was presumably to allow perfume stored in it to circulate.
Diameter: 10 cm.
V&A: 217–1865.

Opposite, bottom: 94. Pyxis of carved ivory made for Ziyad ibn Aflah in AD 970. It preserves traces of blue and red paint, which suggests that the carved decoration of these ivories was originally enhanced by colour, and perhaps also by small jewels.
Diameter: 12.2 cm.
V&A: 368–1880.

Below: 95. Casket of carved ivory made in the first quarter of the 11th century. The inscription around the lid has been erased, but the casket is stylistically similar to other ivories produced near Toledo in the 11th century by craftsmen who had migrated there from Córdoba. The nielloed silver mounts were probably added at a later date.
Width: 26.2 cm.
V&A: 10–1866.

Right: 96. Rectangular plaque from the front of a casket of the mid-11th century. The small bust of an angel was carved, probably in the 13th century, into the small rectangle that was formerly covered by the lock-plate, when the plaque was reused in a Christian context.
Height: 9.5 cm.
V&A: 4075–1857.

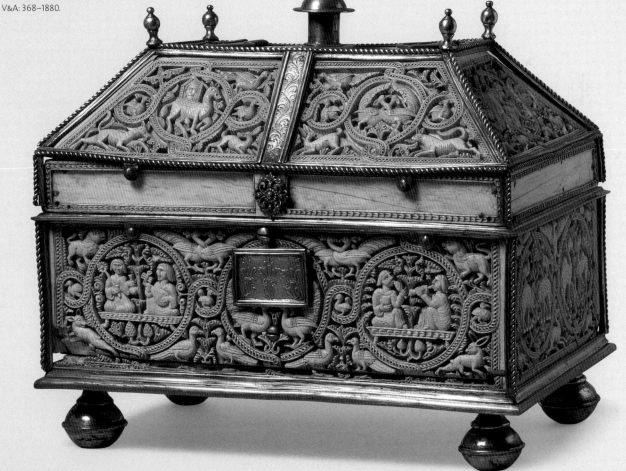

Above, left: 97.
Bowl. Fritware
painted under
the glaze.
Iran, probably
Kashan, early
13th century.
Diameter: 29.7 cm.
V&A: C.125–1931.

Above, right:98.
Dish. Fritware
painted in lustre
over the glaze.
Iran, 1208.
Diameter: 35.2 cm.
V&A: C.51–1952.
Purchased with the
assistance of the
National Art
Collections Fund and
the Bryan Bequest

great deal, but when viewed in the context of court panegyrics, they emerge as an auspicious symbol associated with royal power.

The leafy scroll motif was not confined to Spain: it is a ubiquitous element in Islamic art, to the extent that it has come to be known as the 'arabesque' – the Arabian motif par excellence. Its form altered gradually from period to period, and from dynasty to dynasty, but it was always present. Its nearest rival in this respect was the repertory of geometric designs that was also characteristic of Islamic art for much of the Middle Ages (see pp.100–101 for example).

A garden setting

In Spain, the intimacy of the relationship between ruler and courtier-poet increased under the Banu 'Amir, since the regent and his circle were more equal in terms of social class. The regent al-Mansur (in office 976–1002) and his sons encouraged the courtly virtues of physical elegance and verbal eloquence, and they provided an environment in which these qualities could be displayed: their courtiers were invited to private gatherings where lyric verse was extemporized, and much wine was drunk. The favoured setting for these events was a verdant garden, blossoming with all kinds of flowers, watered by fountains and canals, and

inhabited by birds and sculptures of animals. Nature was evoked, but the highly urbane tastes of the times required that it was a nature tamed and made elegant through artificial cultivation.

This setting helps us to understand the decoration on a large casket from the early eleventh century (plate 95). Although it has lost its original inscription, it can be dated from its similarity to the so-called Pamplona casket, which was made in 1004 for al-Mansur's heir, 'Abd al-Malik. On both pieces the background displays luscious growth inhabited by birds, and there are depictions of animals. Here there is a difference between the two. On the Pamplona casket the animals, set within roundels, are shown in combat, a motif shared both with contemporary panegyrics, where it is used to convey the ruler's heroism in defeating his enemies on the battlefield, and with lyric poetry, where it evokes the lover's chase. On the casket shown here, however, the animals are depicted in more restful poses, and the impression created is one of an idyllic world of nature in harmony (compare plate 96).

Both the London and Pamplona caskets bear roundels depicting figures participating in a drinking party. In the two roundels illustrated, paired figures sit in relaxed poses under the shade of leafy canopies. Each scene contains a musician: on the right, he plays

a wind instrument, perhaps an end-blown flute, and on the left, a lute. The other figures each hold a wine cup or a wine bottle and a stem of flowers, which one of them sniffs. It may be presumed that, inspired by wine or the scent of the flowers, and soothed by the music of flute and lute, these two courtiers are about to extemporize verses of the most refined kind. A suitable floral theme occurs, for example, in a lyric composed by al-Sharif al-Taliq, a poet of the caliphal court who was also a member of the ruling dynasty:

> Just as the sun gives the garden back its breath,
> So the beloved's brightness restores the lover burnt
> up with desire.
> Just as the rose's petals are covered with dew,
> So my love's cheek is sprinkled with drops of
> perspiration.
> It bursts into flower beside a pure yellow narcissus,
> Which I thought was concealing a tender love for
> the rose . . .
> How lovely they are, those stars of the garden
> That have risen towards the horizon from their
> flowerbeds. [4]

Poetry and pottery

Another early source for comparing images and verses created by the same people is the fritware pottery produced at Kashan in western Iran in the period immediately before the Mongol invasions, during the later twelfth and early thirteenth century. This pottery shows a very high degree of technical and artistic accomplishment, as in the case of the ewer with a double-shell body and a mouth in the shape of a cock's head (plate 56). It is also notable for the great variety of methods employed in its decoration, which included painting over or under the glaze with non-figural patterns, figural motifs and inscriptions (compare plates 61–3 and 102). What is more, the inscriptions often include quatrains and other short snatches of poetry in Persian, some of which may have been written by the potters themselves. Even where these verses are absent, there can be a poetic element in the decoration.

A bowl decorated in the Mina'i technique (plate 61) shows a group of androgynous figures attending an entertainment at court. The central figure is evidently of royal rank, as he (or she) is seated on a throne, while the figures arranged in a ring around her are seated on the ground, in the traditional Middle Eastern manner. They are engaged in a number of activities. One is playing a lute, the two on either side hold glasses filled with red wine and others gesticulate, as though to add emphasis to the lyrics they are singing. A more obviously male participant in such a party is depicted in the small vase in the form of a man (plate 63). Decorated in lustre over coloured and uncoloured glazes, the figure is bearded and wears the turban favoured by men of education. He sits with a wine glass in his hand.

The Umayyad 'floral' poem quoted above has love as its underlying concern, and love and the difficulties associated with it was a major theme of lyric verse in all the languages of the Middle East. On some pieces of Kashan fritware of the pre-Mongol period, Persian quatrains dealing with this subject are juxtaposed with images of handsome young men and women.

A lustre dish dated 1208 (plate 98) represents a glamorous young polo player on his horse, while a bowl with an inverted rim (plate 97) is painted with a group of three women who were, by the conventions of the time, very beautiful. On both pieces, bands containing poetry and other texts run around the image. On the outside of the bowl with the three beauties, just below the rim, there is a single band of inscriptions scratched through black paint. There is a conventional benediction for the owner ('May the Creator protect its owner, wherever he may be!'), and two quatrains. One presents love as an obsession:

> I brought love for you into the very core of my soul.
> I discussed every small matter with it.
> Last of all the world, I raised my head
> So that I could put my love for you into words.

The other describes the pain it causes:

> You have driven your servant to the utmost despair.
> The pain you have caused has made his heart bleed,
> and his eyes.
> You are as stony hearted as an idol, and as
> inconstant.
> Even the idol has ended up in the dust at your feet.

The script was executed very rapidly, and the poems were written without a great deal of care (two lines are repeated, for example), but the intended effect is clear. The three young women are of the type with whom one can fall in love, and the poems comment on the fate of those who do. Yet there is no direct link between the two: the painting does not, as in illustrations to narrative verse, represent what is described in the poems. The two decorative elements – the picture and the verses – are merely juxtaposed, and the viewer is expected to provide the link. It is almost as though the painter has continued the process of poetic composition to the design of the pot, by assembling parts that play off one another.

Unrequited love

The love referred to in the quatrains was not something the (presumably male) poet could act out, since the social status of the women depicted in both the verse and the painting made them inaccessible to him. In medieval Iran, beauty, and therefore desirability, were largely the result of good nutrition, good health care and other attributes of wealth. Wealth was in turn an attribute of power, which was concentrated in the hands of a very few individuals.

The prince, with his large harem, had a store of female beauty at hand, but this was not the case for the non-royal poet. When he composed verses about his love for a woman of peerless beauty, real or imaginary, he was dealing with an object of desire beyond his reach. Indeed, had his love been real, and had he crossed social boundaries to achieve his desire, he would have been in great danger. The expression of his love in verse, however, was not necessarily dangerous. If our non-royal poet recited his poem in the presence of a prince, much of his audience may have sympathized with his plight, but the prince would have had the pleasure of hearing his higher social standing implicitly restated, since he was the person in the room least likely to suffer the poet's predicament.

Because of the lack of gender in Persian grammar, it is not always apparent whether the person a poet adores is male or female. This can sometimes be guessed from the context, but it often remains obscure. The same type of quatrain, even the same quatrains, could therefore be inscribed on ceramics

depicting men as well as women. This does not mean, however, that acting out homosexual desire had any sort of social sanction. Islamic societies did not deny the existence of homosexual desire, but the avoidance of homosexual acts, like the avoidance of fornication and adultery, was seen as necessary to find salvation. The young polo player on the dish (plate 98) might therefore be desired by a poet but, like the ladies from a prince's harem, his rank made him unattainable, and that was how things were meant to be.

This is borne out by the six quatrains inscribed on the polo-player dish, where they are arranged in three bands, two on the inside and one beneath the rim on the outside. Some warn of the consequences of love and the shame it brings: 'To die from the pain of passion is not part of manliness.' Others extol desire for the inaccessible beauty, including one written immediately next to the painting of the young man:

O Heart! Do you see any cause for joy?
Do you see anything but one whose glances are like
 scattering jewels?
While I live I am content to wish for a moment
 together.
People are all as you see them.

A quatrain on the outside of the dish is particularly direct:

It has not been my habit, where lust is concerned,
To speak of the pain in my heart to anyone.
Despite this, I wish to say one word:
I have died for love of you! Respond to my cry for
 help!

The purpose of this poetry was not, though, confined to the public expression of private emotions, or to comment on social inequality. The language of unrequited sexual desire had been redirected to the literary expression of a pre-Islamic philosophical idea which, by the time these ceramics were produced, had become widespread among educated people in the Middle East. This was the Neoplatonist theory that our eternal souls were once in communion with their Creator and, although they are now trapped in material bodies, they have an unquenchable yearning

for what they have lost. They long to return to God.

This theory was a basic component of the Sufi movement, which claimed that it was possible to regain a state of communion with God through mystic practices of various kinds. Sufis had used poetry to promote their beliefs and recruit followers, and in it they used the language of love to describe humanity's unhappy state of separation. The unrequited love for another human being described in the quatrains can therefore be interpreted as a metaphor for our souls' desire for reunion with God. By the same measure, the beautiful inhabitants of the world depicted on the vessels are an imperfect manifestation of the divine beauty for which our souls pine.

Wine by a stream

Poetic quotations were also used to decorate the metalware produced in eastern Iran in the fifteenth century, including a brass jug produced in 1462 (plate 99). It is inlaid in silver with good wishes, according to a long-established pattern, but the main element in the decoration are two lyrics of Hafiz of Shiraz, the greatest master of this form in Persian, who had died towards the end of the previous century. The verses provide a justification for using the jug in drinking wine. One begins:

99. Jug. Brass inlaid with silver. Iran, probably Herat, 1462. Height: 13 cm. V&A: 943–1886.

What is sweeter than making merry in good
 company and gardens in spring?
Where is the potboy? Say, why are we waiting?
Every pleasant moment proffered you, count as a
 precious prize.
No one is allowed to know how matters will turn
 out.
The link of life is tied by a single hair. Take note:
Be your own sympathetic friend, for what
 commiseration does the world offer?
What meaning have the Water of Life and the
 Garden of Iram
Except the banks of a stream and wine that goes
 down smoothly? [5]

Many paintings and other works from Iran portray exactly the type of rustic scene referred to in the last line. In an illustration painted in Isfahan in the 1630s for a copy of the *Khusraw and Shirin* of Nizami (plate 90), the hero, the Sasanian King Khusraw Parviz (see page 20), is served wine by the heroine, Shirin, while they make merry on the grassy banks of a brook. In the foreground musicians play on a lute and a tambourine, while in the background a young gentleman in the King's retinue sits on a second gold throne, perhaps reciting poetry. A similar picnic is depicted on a tile panel made in Isfahan in roughly the same period (plate 71).

In some senses there is a great deal of similarity between this Iranian theme of merrymaking and the festivities depicted on the Spanish casket (plate 95), but the setting has changed. The scene has moved beyond the walls of the palace garden, where horticultural skill and irrigation could maintain pleasant surroundings for much of the year, to open country, and to those brief moments between the rigours of winter and the heat of summer when the landscape comes to life with greenery and flowers. Implicit in it is the warning that pleasure is fleeting, and life short: 'Every pleasant moment proffered you, counts as a precious prize.'

Tale on a tile

Narrative verse also played a part in providing themes for Islamic art, as in the case of a moulded tile decorated in lustre (plate 100). It once constituted

one tiny element in the rich and diverse decoration of the Mongol palace now known as Takht-i Sulayman, which was built on a hill-top site in north-west Iran in the 1270s. The tile represents an incident in the life of the Sasanian prince Bahram Gur. The theme is a popular one, taken from the *Book of Kings*, the epic history of Iran written around the year 1000. Bahram was famous for his love of the hunt, and in this work, the poet Abu'l-Qasim Firdawsi recounts how the future King Bahram V 'went to the chase with a damsel and how he displayed his accomplishment'.

Bahram is given a slave-girl called Azadah who is skilled at playing the harp, and he falls in love with her. One day they go hunting alone. They mount a dromedary:

> For such occasions he required a camel,
> And set thereon a housing of brocade,
> While from it hung four stirrups. Thus he sped
> O'er hill and dale. Two stirrups were of silver,
> Two were of gold, and all were set with jewels.

Bahram is armed with a bow and arrows and a crossbow, and Azadah with her harp:

> He came upon a pair of deer and laughing
> Said to Azadah: 'O my Moon! when I
> Have strung my bow and in my thumb-stall
> notched
> The string, which shall I shoot? The doe is young,
> Her mate is old.' She said: 'O lion-man!
> Men do not fight with deer. Make with thine arrows
> The female male, the agéd buck a doe,
> Then urge the dromedary to its speed,
> And, as the deer are fleeing from thy shafts,
> Aim with thy crossbow at one creature's ear
> That it may lay its ear upon its neck,
> And when the beast shall raise its foot to scratch
> The ear that hath been tickled though not hurt,
> Pin with one arrowhead both ear and foot
> Together if thou wouldest have me call thee
> 'The Lustre of the World.'

Bahram does exactly as instructed, much to Azadah's amazement. On the tile they are depicted seated on the speeding camel: Azadah plays her harp,

while Bahram has just fired a shot at the buck, now hornless. The poor beast has raised his foot to scratch his ear, which has been tickled by a shot from Bahram Gur's crossbow, and the two are about to be pinned together. The story ends badly. Azadah is upset by the animals' fate:

> . . . and when the prince
> Said: 'When I hunt I bring them down by thousands
> Thus,' she replied: 'Thou art the devil,
> Else how canst thou shoot thus?' Bahram stretched
> out,
> Flung her from saddle headlong to the ground,
> And made his dromedary trample her,
> Besmearing hands and breast and harp with blood.
> He said to her, 'O thou harp-playing fool!
> Why shouldst thou seek for my discomfiture?
> If I had drawn mine arms apart in vain
> My race had been dishonoured by the shot.'
> When he had trampled her beneath his camel
> He never more took damsels to the chase. [6]

In addition to the account found in the *Book of Kings*, the tale of Bahram Gur and his favourite would have been known from other sources, both oral and written. As discussed, however, the design of the tile reproduces a particular point in the account of it given by Firdawsi, and it does so in a fairly precise manner. It is even possible that the painter thought that the missing elements – the strings of the harp and bow, and the arrow fired by Bahram, which was presumably in mid-air – were too fine to see and this is why he did not include them. Such literal renditions of a single moment in the narrative are characteristic of the pictures found in the earliest illustrated copies of the *Book of Kings*, and this tile suggests that there was a close relationship between manuscript illustration and work in other media. Since no illustrated copies of the *Book of Kings* survive that were made before 1300, the Bahram Gur tile of the 1270s and other objects of the twelfth and thirteenth centuries decorated with similar themes show how Firdawsi's poem was illustrated before this date.

It is perhaps ironic, given the misogyny implicit in the tale of Bahram Gur and Azadah, that women of high rank were the principal residents of Takht-i

100. Tile. Moulded fritware decorated with coloured glaze and lustre. Iran, Takht-i Sulayman, late 13th century. Height: 31.5 cm. V&A: 1841–1876.

Sulayman for much of the period in which it functioned as a palace. Indeed, they and other female members of the Mongol dynasty played a prominent role in state affairs, which was an unusual occurrence in Iran. In other ways, however, the design of the tile seems to fit well with the political message that the Mongol regime was trying to convey.

Takht-i Sulayman was built over, and partly incorporated, the ruins of an important Zoroastrian shrine built by the pre-Islamic Sasanian dynasty, and it seems that the choice of site was a conscious one:

lacking any religious sanction for their rule until they finally converted to Islam in 1295, the earlier Mongol rulers sought to present themselves as revivers of Iran's pre-Islamic tradition of kingship. Firdawsi's epic was a leading source for this tradition, which would explain why quotations from the *Book of Kings* and figural themes derived from it appear on tiles made for Takht-i Sulayman, in addition to subjects of East Asian origin associated with imperial rule, such as the phoenix and the dragon, with which they would have been more familiar.

HOARDS

Mariam Rosser-Owen

Left: 101. A small hoard of jewellery reportedly found packed in an earthenware pot somewhere in the province of Murcia in south-east Spain. The coins date the hoard to the early 11th century.
V&A: 1447 to 1454–1876.

One token of the disasters that periodically affected parts of the Islamic Middle East is the discovery of hoards, that is, material that was deliberately hidden by its owner and never recovered. As a rule, hoards consist of valuable objects that the hider wished to save from looting or theft, and many therefore include possessions made of precious metal. Groups of items made from other materials have also been found, and one important hoard consists entirely of ceramics. This was found at the site of medieval Jurjan in north-east Iran in the 1930s (plate 102) and was probably concealed shortly before the Mongols arrived to destroy Jurjan in 1220 (see pp. 91–2).

The history of the site allows us to reconstruct the background to the Jurjan hoard, but other finds have often been made in places where there was no informative context to explain why or when the objects were concealed. The presence of coins often assists in dating such finds. This is the case with a small hoard of precious metal objects reportedly found buried in an earthenware pot in the province of Murcia in south-eastern Spain some time before 1870. It contains ten silver coins (*dirhams*) that were minted

Right: 102. Items from the Jurjan hoard, all fritware vessels from Kashan, early 13th century. The hoard was probably the stock-in-trade of a merchant who dealt in fine ceramics such as these.
Ades Family Collection and V&A: C.162–1977, C.165–1977, C.153–1977, given by Mr C. N. Ades MBE in memory of his wife, Andrée Ades.

during the reigns of two Umayyad rulers of Spain, the Caliphs al-Hakam II (961–76) and Hisham II (976–*c.* 1010), and it shows that the hoard was buried some time early in the eleventh century (plate 101). Other hoards from Spain that contain coins can also be dated to the early eleventh century. This was a period of great political upheaval, caused by the declining authority of the Umayyad caliphate. It eventually led to the disappearance of this institution in 1031.

The remaining ten pieces of the Murcia hoard consist of women's jewellery, and hoards are in fact the main source of the surviving jewellery from Islamic Spain. They usually contain short bracelets, formed from strings of pearls or coloured glass interspersed with silver gilt beads, and hinged

metal plaques that may have formed bracelets or the decorative parts of a belt. The Murcia hoard contains a particularly fine pair of gold earrings, whose style is closely related to indigenous Roman or Visigothic traditions. Other loose elements, often shaped like stars or flowers, may once have been sewn on to a headdress or clothing. The coins found in the hoard are perforated, suggesting they were also used as jewellery.

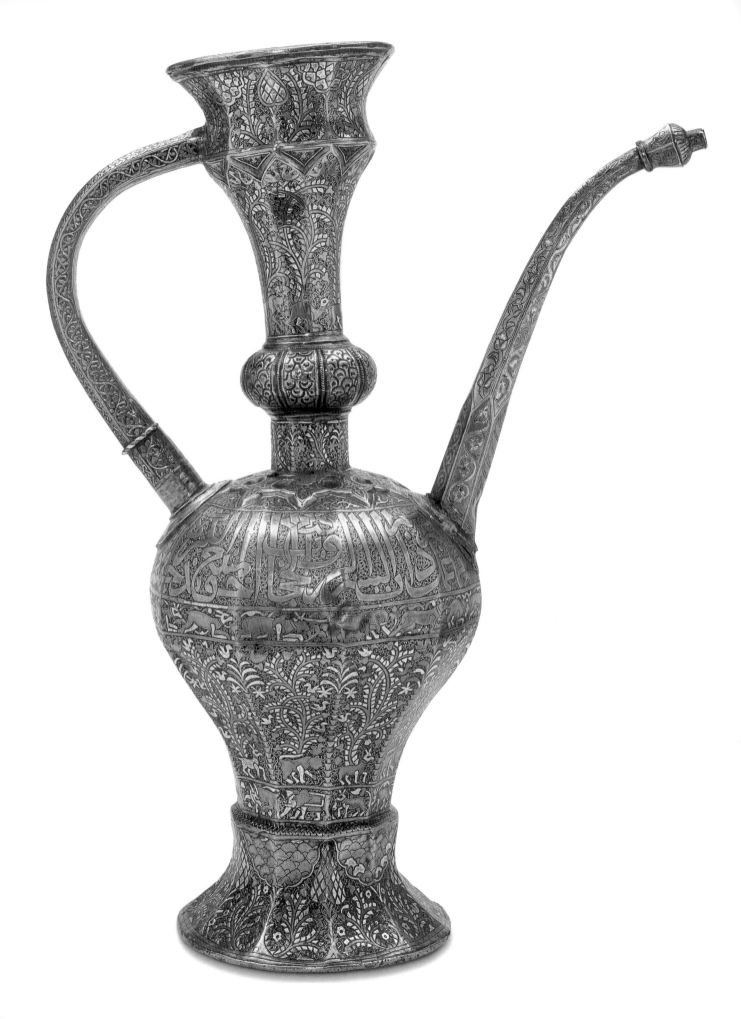

Chapter Four

PATRONS AND MAKERS

In terms of their patronage, most of the artefacts discussed in the previous chapter – the ivory caskets (see pp.77–83), the Kashan ceramics (plates 61, 63, 97 and 98), and the Bahram Gur tile (plate 100) – fall into two distinct categories. The inscriptions on the ivories show that they were produced for the

Umayyad caliphs and their immediate circle, and the archaeological investigations at Takht-i Sulayman have shown that the Bahram Gur tile was originally made to decorate part of this Mongol palace. These artefacts belong to the domain of the politically powerful, who played a determining role in the formation of Islamic art, and they were made as the result of specific commissions. The pots from Kashan, on the other hand, were trade goods made for the market rather than for specific patrons.

This can be said with some certainty because of the context in which some of the Kashan pottery was discovered. A large cache was unearthed in the late 1930s at Gunbad-i Qabus in north-east Iran. The site was in the ruins of the old city of Jurjan, which was destroyed by the Mongols in 1220. The burial of the pottery must relate to this calamitous event, since it consists entirely of fritware of the late twelfth and early thirteenth centuries: there are pieces covered with monochrome glazes (see plate 102, left); some have designs painted under the glaze (see plate 132); and others were painted over the glaze in lustre (see plates 63 and 102) or with Mina'i enamelling. There can be no doubt that their source was the great

ceramic centre of Kashan in western Iran, as the poetic inscriptions on one of the lustre pieces (plate 102, central bowl) end with a short text invoking blessings on its owner and giving the information that, 'Its scribe is Muhammad son of Muhammad Nishapuri, resident in Kashan.'

Most of the pieces in the cache are in remarkably good condition, as they were found buried in large storage jars. The form of burial suggests that it was deliberate. It seems very likely that the pottery was the stock-in-trade of a merchant, who had brought it from Kashan for sale in Jurjan or further east. His journey was probably cut short by the devastating Mongol invasions of western Central Asia and eastern Iran in 1219–22, and he presumably fled westwards, burying the jars before doing so, with the intention of returning to dig up his stock when the danger was over. The destruction of Jurjan ensured that he never recovered the pottery.

Not all works of art can be allocated so easily to one of the two categories defined above – court commissions and production for the market. The inlaid jug of 1462 inscribed with two odes of Hafiz (plate 99) is a case in point. It belongs to a group of similar items that were made from the 1450s onwards, and are attributed with some confidence to the city of Herat, in what is now western Afghanistan. One jug is inlaid in silver with a dedication to Sultan Husayn Mirza, the Timurid ruler of Herat from 1470 to 1506, and this information would tend to place the group in the courtly category. But it is also possible that this piece was made for a man of lower station in circumstances that we do not understand: perhaps it was made as a gift for Sultan Husayn, for example. The presentation of gifts to the ruler was, like the composition of panegyrics, a normal part of court life, and if their offerings proved acceptable, both gift-givers and poets hoped for valuable favours in return.

Further evidence that the inlaid jugs were not made for patrons of the highest rank is provided by similar pot-bellied jugs with dragon-shaped handles made of far more expensive materials. Some are of carved jade, and one of these bears a carved inscription stating that it was made for the Timurid ruler Ulughbeg Mirza, who was killed in 1449. The fashion for jugs of this shape spread westwards to the Ottoman empire,

where they were made in silver gilt (plate 149). Other Timurid jades have the shape of contemporary gold and silver wares, and it can be postulated that gold and silver jugs with dragon-shaped handles were made for use at the courts of eastern Iran before 1400, and that in the fifteenth century they were copied in jade for the Timurid princes, and in inlaid brass for their prosperous subjects.

Rock crystal and the caliphate

The carving of vessels from hard stones such as jade was not confined to eastern Iran in the fifteenth century. Indeed, it was a tradition inherited from the pre-Islamic world, and in the eighth to eleventh centuries, large blocks of rock crystal were carved into items of considerable size (plate 106). A taste for these extremely expensive objects seems to have been current at the court of the Umayyad caliphs in Syria. The Caliph al-Walid II (ruled 743–4), for example, is reputed to have been served wine from the largest rock crystal basin ever seen. Soon after, in 750, the Umayyad regime was overthrown by the Abbasids, the descendants of the Prophet's uncle, 'Abbas. At this time, the centre of the caliphate was moved from Syria to Iraq, where the carving of rock crystal soon began to flourish. The industry is thought to have had its centre at the port of Basra in southern Iraq, which became the landing place for many precious commodities in the early years of Abbasid rule.

The Abbasids' right to rule did not, however, go unchallenged. Some anti-Abbasid movements were based on the egalitarian tradition within Islam, which was opposed to the autocratic rule of the caliphs in principle. Other opponents were Shi'ites, who wished to replace the Abbasids with the direct descendants of the Prophet who, they believed, had a greater right to lead the Muslim community. Eventually, in AD 909, a revolution in North Africa brought to power a Shi'ite pretender, who became the first caliph of the Fatimid dynasty. In 969, the armies of the fourth caliph conquered Egypt, where they founded Cairo as their new capital. The caliphate was split in two.

In Cairo, the Fatimid caliphs wished to establish a court that rivalled that of the Abbasids in every respect, and this required the production of a wide range of luxury goods. A rock crystal industry may

105. Tra
inlaid v
and silv
c. 1314–
Diamet
V&A: 420–1854.

have been established in Egypt before the Fatimids arrived, but the superb quality of production that had been achieved by the end of the tenth century was certainly due to the intervention of the Fatimid caliphs: the names of two of them and of a senior military figure in Fatimid service appear on three surviving pieces. The names date the three pieces to the period between 975 and 1036, and on this basis, other objects of similar quality can also be attributed to the first century of Fatimid rule (see pp.94–5).

A great deal of prestige could be earned by owning luxury wares such as those made from rock crystal, but for the rulers it was not enough that there should be just one item of this type in the palace treasuries: they had to own large numbers of the best and largest pieces. In Cairo, many thousands of rock crystal vessels were commissioned for the palace over the first century of Fatimid rule, and if a person of lower rank acquired one of these it was only by favour of the Caliph – or by theft from his treasury.

A ROCK CRYSTAL EWER

Mariam Rosser-Owen

When this spectacular ewer (plate 106) was acquired by the Victoria and Albert Museum in 1862 for the then astronomical sum of £450, it was thought to be Byzantine. It has long since been linked to a substantial group of rock crystal objects made in Egypt in the Fatimid period (969–1171). Three of these pieces are inscribed with the names of a ruler or of an important Fatimid official, and this allows us to date them to the period between the 970s and the mid-eleventh century. This short period evidently coincided with the apogee of rock crystal production in Egypt.

The three inscriptions also indicate the esteem in which rock crystal was held at the highest levels of the Fatimid court. In this the Fatimids were following the example of the Abbasid caliphs, who ruled from capitals in Iraq from AD 750. Few rock crystal pieces have been identified as Abbasid, but the close resemblance of the Fatimid ewers to surviving cut

glass objects from the contemporary Iranian world (plate 107) suggests that when the Fatimids adopted the practice of working rock crystal they also appropriated Abbasid forms. This would parallel the Fatimids' appropriation of the Abbasids' production of lustre pottery (see Chapter 4).

Rock crystal was admired for its clarity and transparency, and the natural historian al-Biruni (973–c.1050), described it as 'combining the properties of air and water'. It was also believed to have magical properties, such as that of shattering on contact with poison, something also attributed to Chinese porcelains, another highly prized group of objects.

The scale of production under the Fatimids is indicated by an anonymous work, the *Book of Gifts and Rarities*, which contains a contemporary account of the famous treasuries of the Fatimid caliphs. It mentions that some 36,000 items of rock crystal and cut glass were housed there. Among them were 'ninety basins and ninety ewers, of the clearest and best crystal'. The V&A ewer is one of only seven that now survive.

Rock crystal is an extremely hard stone, and to hollow out a solid block without breaking or blemishing it requires great skill. To show off the purity of the material, surface decoration was usually kept to a minimum, and where decoration does occur, it consists of simple floral designs or features animal groups from the repertory of medieval Islamic courtly art. The V&A ewer is decorated on each side with a design of a bird of prey swooping down on a horned deer, which is one of the most common visual references to the power of the ruler over his enemies (see Chapter 3). This figural group is set within a swirl of palmette branches, while the shoulder, neck and foot of the ewer are left plain. To judge by a ewer in the Treasury of St Mark's in Venice, a crouching animal must once have decorated the thumb-rest.

Most of the 180 Fatimid rock crystals that survive have done so because of their reuse as reliquaries in Christian contexts. During the political crisis that hit the Fatimid dynasty in the mid-eleventh century, the contents of the Caliph's treasuries were dispersed around the Mediterranean basin, along mercantile and pilgrimage routes, and many ended up in Church treasuries in the Latin West. Here they were prized as precious curiosities, and their transparency made them eminently suitable for the display of holy relics.

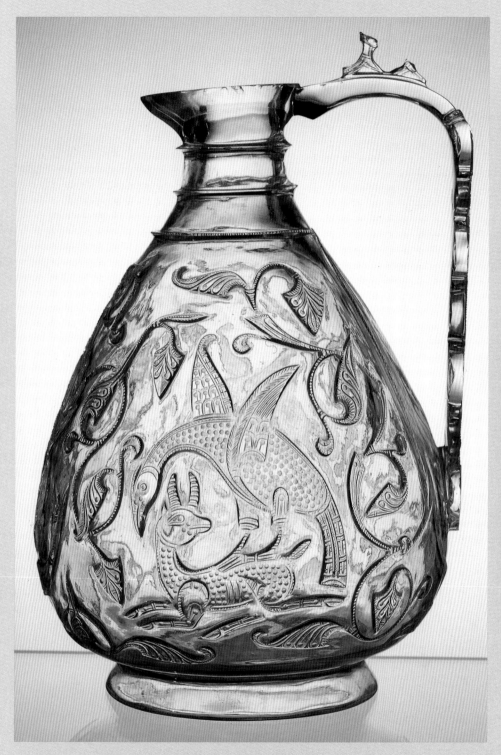

Above: 106. Ewer of rock crystal made in Cairo in the first half of the 11th century.
Height: 19.5 cm.
V&A: 7904–1862.

Left: 107. Ewer of cut glass, known as the Buckley Ewer. It was produced in Iran about AD 950–1050. It was first made as a thick-walled vessel. The decoration was then cut back to leave motifs that stand in high relief. Its pear-shaped form very closely resembles those of Fatimid rock crystal ewers.
Height 23.8 cm.
V&A: C.126–1936.

Top right: 108. Detail of a cylindrical bottle of rock crystal, made in Cairo in the tenth or eleventh century. It must once have been used for holding a precious liquid.
Height: 15 cm.
V&A: A.45–1928.

Above: 109: Flask of rock crystal made in Cairo in the first half of the 11th century. It has a flattened, ovoidal form, which may represent the translation into rock crystal of a type of object in a different material.
Height: 11 cm.
V&A: 1163–1864.

110. Mosque of
Qa'itbay in Cairo, by
Antonio Schranz.
Watercolour on
paper. Mid-19th
century.
Width: 44.2 cm.
V&A: SD.953.
Purchased with the
assistance of the
National Art
Collections Fund, the
National Heritage
Lottery Fund, Shell
International and the
Friends of the V&A

A twelfth-century source tells us that when the Fatimid princess 'Abdah died in 1051, she was found to own a basin and ewer of rock crystal, which were admired for their beauty and value. They would have been returned to the Caliph's treasury, but his vizier asked for them as a gift, and his request was granted. The reputation of these pieces suffered in retrospect, however. Fiscal crises in the 1060s led to the looting of the palace by soldiers who had been left without pay, and at this time no less than ninety basins and ewers of rock crystal of the highest quality were brought out of the treasuries. Beside these, 'they found the basin and ewer of 'Abdah, which they had considered so splendid, very modest and insignificant'. [7]

In Spain, too, luxury goods of great distinction were produced in the tenth and eleventh centuries, including the celebrated ivories of the period, discussed in Chapter 3. This development also

followed a change in the status of the main patron. The rulers of the region were descendants of the Umayyads of Syria, and in the mid-tenth century, after the Fatimids had appeared in North Africa, the amir 'Abd al-Rahman III assumed the caliphal title. In Spain, however, the trend was not so much emulation of the Abbasids or Fatimids, as reaction against them, since the Umayyads of Spain wished to revive the glories of their own ancestors. Indeed, the two examples of Fatimid Egypt and Umayyad Spain show that, although the Syrian Umayyads and then the Abbasids had set a standard for the patronage of luxury arts, this 'caliphal model' was not transmitted as a simple linear tradition, with each new power group merely imitating its predecessors. It was a more complex process. Some new patrons reacted to the art of their immediate predecessors with admiration, others with hostility; some drew on an imagined golden age in the more

distant past; and some introduced innovations from other parts of the Islamic world, or from outside it.

Saladin and his successors

In Egypt a new power group and a very different style of patronage emerged after 1171, when the celebrated Salah al-Din (Saladin) abolished the Fatimid caliphate and restored Sunni rule. The dynasty he founded, the Ayyubids, had a relatively brief life, but the Mamluk sultans who replaced the Ayyubids in 1250 were equally committed to the Sunni cause. By the end of the thirteenth century, the Mamluks had eliminated the last of the Crusader states from the Syrian coast; they had deflected the pagan Mongols from their eastern territories; and they were the guardians both of the Noble Sanctuaries in Mecca and Medina and of the person of the Abbasid Caliph, whom they had installed in Cairo. They were the paragons and defenders of orthodoxy, and the elaborate titulature they assumed advertised their role.

In some respects, the break between the Fatimid period on the one hand and the Ayyubid and Mamluk periods on the other seems to have been very sharp. There were even significant changes in the materials and techniques employed. The inlaid brass wares of the thirteenth and fourteenth centuries, for example, had no earlier precedent in Egypt: the taste for them seems to have been imported from the east, along with restored allegiance to the Caliph.

At first, the subject matter of the inlaid decoration included a wide range of figural themes (see plates 15 and 52, for example), following the tradition established in Iran in the twelfth century (compare plate 39). These were supplemented by ornamental motifs and inscriptions in Arabic, which assumed greater and greater importance. A candlestick made between 1260 and 1309 (plate 30), for example, is inscribed in large lettering with the name and titles of the official for whom it was made, Rukn al-Din Muhammad, son of Qaratay of Baghdad, an 'exalted personage, a man of lordly rank, an emir in the service of Rukn al-Din'.

By the early fourteenth century, the use of figural motifs had receded, for the reasons discussed in Chapter 2, and the repertory of designs was dominated by plant-based ornament and inscriptions,

as on contemporary work in other media, such as glass (plates 14 and 59). The inscriptions sometimes rehearse the many titles borne by the Mamluk sultans, so that the ancient tradition of inscribing objects with good wishes for their owners had been transformed into a bold political statement.

A large tray, formerly extensively inlaid with silver (plate 105), is a striking example. It was produced in the fourteenth century for, or in the name of, a sultan identified as al-Malik al-Mansur ('the king made victorious', i.e. by God) – presumably Sultan Abu Bakr (ruled 1341) or Sultan Muhammad (1361–3), who both bore this regnal name. On this piece, the same basic invocation in praise of the Sultan supplies the content of the seven main inscriptions, with large variations in the number of honorifics included.

The shortest version is that written in the largest script, which reads:

> Glory to our master the Sultan, the wise, the diligent, the just, the warlike king – May his victory be glorified!

The longest, which occurs on the outside of the rim, declares:

> Glory to our master, the triumphant, the wise, the diligent, the just, the warlike Sultan, who engages the enemy, who defends his territories, who guards his frontiers, who enjoys God's support, whom He makes victorious, who protects the world and the true religion, who kills unbelievers and idolaters, who revives justice among God's creatures, the father of the poor and the indigent, the Sultan al-Malik al-Mansur . . .

Even the small roundels join in the chorus of praise, being inscribed with the phrase, 'Glory to our master, the Sultan!'

Imperial investment

Over the course of the fourteenth century, interest in inlaid metalwork declined, at least partly because of the increasing availability of Chinese blue-and-white porcelain, made specifically for the Middle Eastern market. In the reign of Sultan Qa'itbay (1468–96),

111. Lamp holder.
Brass inlaid with
gold and silver.
Egypt, Cairo,
1468–96.
Height: 1.6 m.
V&A: 109–1888.

however, luxury metalwork with inlaid decoration in silver and silver reappeared, and this seems to have been an initiative of the Sultan. Some of the pieces made in Qa'itbay's name or that of his wife were presumably produced for their personal use (plates plates 103 and 112), but even more were made for donation to the numerous religious monuments the Sultan founded or restored in Egypt (plate 110), Syria and Mecca and Medina. An example is an enormous six-sided lamp holder of brass decorated with openwork designs and with inlay in gold and silver (plate 111). The piece is now very fragmentary: the domed upper structure, the base plate into which the small glass oil lamps were fitted and the hinged door that once covered one side are now lost; only the walls and the suspension hook (not shown) remain, and these have had to survive fire and a long period of burial. Nevertheless, the lamp holder retains a good degree of its original splendour.

Qa'itbay's patronage of religious buildings was part of his deliberate presentation of himself as a pious defender of Sunni Islam, which has already been noted in connection with his attitude to images (see Chapter 2). In addition to metalwork, the fittings he supplied included magnificent wooden minbars, from which the names of the Sultan and his puppet caliph were proclaimed at the noon prayer every Friday (see pp.100–101), and perhaps also carpets made at workshops set up at his instigation.

Qa'itbay's sponsorship of trades such as inlaid metalwork production and carpet weaving may also have been part of an attempt to promote the prosperity of his empire. Considerable quantities of what may be Mamluk export products of the later fifteenth and early sixteenth centuries have been found in Italy and other European countries, including inlaid metalwork of the type called 'Veneto-Saracenic' (plates 154 and 156) and fine silk textiles. In the case of Veneto-Saracenic metalwork, however, the attributions of these items to Egypt or Syria in the Mamluk period are far from secure (see Chapter 5).

The history of the ceramics production in Ottoman Turkey offers sounder evidence for the effects of imperial investment on a domestic industry. This story, too, begins with the triumph of Chinese blue-and-white porcelain in Middle Eastern markets during the

fourteenth and fifteenth centuries. Local potters were unable to match the Chinese wares in terms of quality, not least because they lacked the right materials, and their response was to make imitations of the originals for people of more modest means. In the fifteenth century, these were produced in many parts of the Middle East, including western Turkey, which was under Ottoman rule. There the imitations usually took the form of earthenware bowls of Chinese shape, coated with a white slip and decorated under the glaze in blue (plate 104).

Pottery of this type was first excavated in large numbers in the ruins of ancient Miletus in south-west Turkey, but kilns that produced this 'Miletus ware' have now been found at Iznik in the north-west, where a completely different type of pottery began to be made during the second half of the fifteenth century. This transformation was effected through imperial patronage, which generated a new ware of such splendid quality that it is regarded as the epitome of Islamic ceramics. The interest shown by Ottoman rulers in ceramic production at Iznik

seems to have been exceptional, and their investment in the industry explains the exceptional quality of the wares made there.

Ceramics for sultans

The first stage in the emergence of Iznik occurred in the reign of Sultan Mehmed II (1451–81). By the 1460s or 1470s, the fashion for Chinese blue-and-white seems to have reached such a pitch that the Sultan commissioned pottery replacements for objects usually produced in other media. Their connection with Chinese prototypes was not particularly strong. The shapes employed were mostly drawn from local metalwork. They were formed from fritware, a composite body made principally from ground quartz (see page 116), and the decoration was in the contemporary court style, although the motifs were mainly executed in reserve against a cobalt-blue ground, in imitation of a type of porcelain made earlier in the fifteenth century. In other parts of the Middle East, fritware had been used as a substitute for porcelain since the eleventh century, but it had not

112. Basin.
Brass inlaid with gold and silver.
Egypt or Syria, 1468–96.
Diameter: 41.5 cm.
V&A: 1325–1856.

The Minbar of Sultan Qa'itbay

Barry D. Wood

One of the largest types of furniture made in the Islamic Middle East were the minbars placed in more important mosques. They were used for the midday prayer on Friday, when the whole population of a place assembled to worship together. A sermon formed part of this service, and the minbar was the structure from which it was delivered. It generally stood to the right of the mihrab (see plate 2).

The minbar had its origins in the raised seat used by the Prophet Muhammad in addressing the Muslim community in Medina, and it was traditionally made of wood, although there are examples made of marble and other materials. Over time, the seat acquired a canopy and was raised higher and higher – the example shown here is more than six metres high (plate 113). Early minbars were portable and were brought out into the mosque when needed, and some, especially those used in Spain and North Africa, were mounted on wheels. In later times, however, the majority of minbars were stationary.

In its fully evolved form, the seat became a canopied platform at the top of a tower-like structure, which was approached by a set of stairs with an arched doorway at its foot (plate 114). In this example, the doorway is closed by a door with two leaves, and there are two further doors at the base of the 'tower', one on either side. These probably indicate that the interior of the minbar was used for storage.

This minbar is richly decorated in a variety of ways. Small sections of the parapets are filled with latticework made from turned spindels, a technique more familiar from the projecting window screens of Cairo and other cities known as *mashrabiyyah*. Parts of the surface are inlaid in tiny geometric patterns of wood and ivory, but the most striking element in the decoration is the enormous geometric pattern that fills the triangular sides of the structure. This was made from small pieces of wood that were cut individually and then fitted together like a mosaic. The design is based on a series of stars from which lines radiate out, forming small compartments of different shapes as they intersect. Emphasis is given to certain elements by setting them with pieces of ivory that include finely carved decoration matching the decoration of the woodwork. The result is a beautifully integrated ensemble.

The minbar bears a number of inscriptions. Some contain quotations from the Qur'an, while others praise the Mamluk sovereign Sultan Qa'itbay, who ruled between 1468 and 1496. Qa'itbay was one of the most important patrons of the arts during the Mamluk period in Egypt and Syria (1250–1517), partly because his great personal prestige allowed him to retain the throne for almost three decades – far longer than any of his fifteenth-century predecessors had done. He founded a number of religious institutions in his own name, but also spent large sums on the restoration of older buildings in various parts of his empire, and this minbar was probably made for a mosque in Cairo that he renovated, the identity of which is not known.

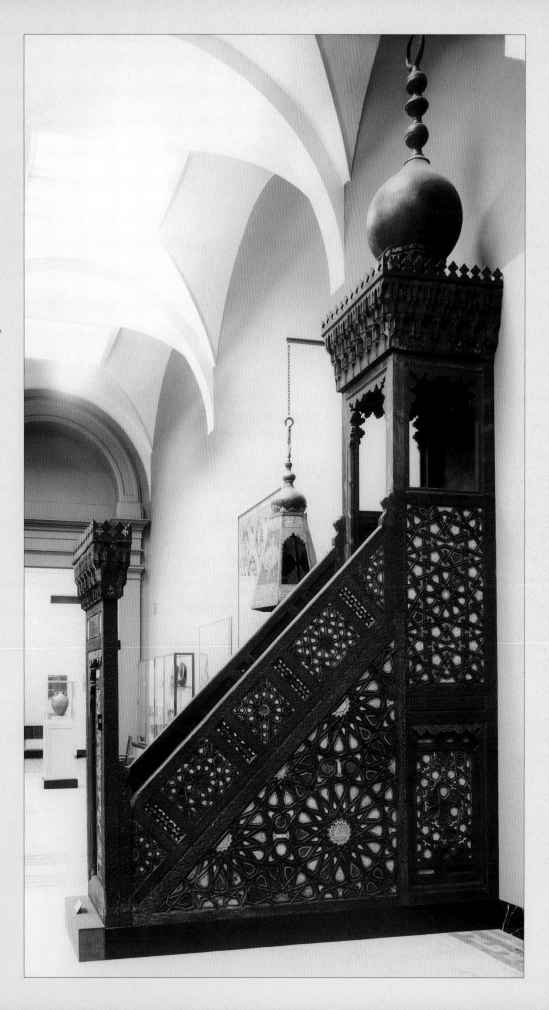

113. Minbar of Sultan Qa'itbay, made, probably in Cairo, in the period 1468–96. Minbars were important to Muslim rulers such as Qa'itbay as the Friday sermon read from them included their name as an acknowledgement of their authority.
Height: 6.1 metres.
V&A: 1050–1869.

Left: 114. Detail of the minbar of Sultan Qa'itbay, showing the double doors that give access to the stairway.

115. Footed bowl.
Fritware painted
under the glaze.
Turkey, probably
Iznik, mid-16th
century.
Height: 26.5 cm.
V&A: C.1979–1910.
Bequest of George
Salting

Below: 116. Footed
bowl. Fritware
painted under
the glaze.
Turkey, probably
Iznik, first half of
16th century.
Height: 28 cm.
V&A: 243–1876.

previously been manufactured in western Turkey. It
had no technical link to the earlier earthenwares of
this region, and its appearance there required the
invention of an industry – at considerable expense to
the Sultan.

Once created, the Iznik fritware industry seems to
have taken on a life of its own, reacting to ups and
downs in court demand by producing wares for a
wider market. Over the eighty years following Mehmed
II's death in 1481, the range of shapes increased, and
new decorative schemes were adopted, including some
from Chinese sources (plate 133). The abilities of the
Iznik potters in this period are exemplified by the
extraordinarily large and sophisticated basins they
produced (plates 115, 116 and 117). The scale and
quality of these pieces, and the costs their production
must have incurred, suggest that they were made for

117. Footed bowl
Fritware painted
under the glaze.
Turkey, probably
Iznik, 15th to 16th
centuries
Height: 23.5 cm.
V&A: C.1981–1910.
Bequest of George
Salting

patrons at the highest level, although evidence for this is lacking. One major advance in Iznik production can, however, be connected securely to another act of imperial patronage.

In the early sixteenth century, the range of colours employed in decorating Iznik wares increased, eventually encompassing shades of blue, turquoise, green and purple, all set off by a brilliant white ground. In the second half of the century, the colours increased in clarity, and their range expanded further to include a vibrant red: this was obtained by using a special clay, which was diluted and applied to the ceramic as a slip before glazing and firing. The addition of red to the colour range was accompanied by the appearance of tile revetments made of Iznik fritware, and the two developments can both be associated with a single act of architectural patronage

– the building of the Süleymaniye mosque and its dependencies in Istanbul in the 1550s (see plan 29). A mosque lamp from the complex (plate 118) shows an experimental use of the red, which had been perfected by the time the tiles were produced for the mosque, and for the tombs of Sultan Süleyman and his wife, Hürrem Sultan.

Once the initial investment in the production of Iznik tilework had been made, it rapidly became a feature of architectural decoration in both religious buildings and palaces (plate 68). The tiles were also produced for other uses, including grave markers (plate 119) and table tops of great quality (plate 121). In the seventeenth century, the kilns at Iznik did not receive the same level of investment from the court, and the quality of production drifted downwards. By the beginning of the eighteenth century the ceramics

Left: 118. Lamp-shaped vessel. Fritware painted under the glaze. Turkey, probably Iznik, about 1557. Height: 48 cm. V&A: 131–1885.

industry in Iznik was in a state of collapse, and when the court again began to take an interest in tile production in the reign of Sultan Ahmed III (1703–30), it had to reinvent the industry, which was relocated to Istanbul. The result was that Ottoman grandees were again able to decorate their palaces with tilework ensembles, including whole chimney-pieces (plate 120).

Brands and memorials

The emphasis on the patrons in this account of Islamic art does not mean that artists and craftsmen were merely automata carrying out their patrons' orders. Artists were often known by name to a wide circle of their contemporaries, and they depended for their prosperity on the reputation they were able to construct. It can also be assumed that, once the artists' standing had been established, courtly patrons were happy to take their advice on artistic matters. Yet the presentation of the artist's role in Islamic culture was different from that current today.

Artists were not honoured so much for their ability to express themselves through the originality of their work. Rather, they were honoured for their virtuosity. The initiative for change came from above or, at least, it had to be seen as coming from above, while artists

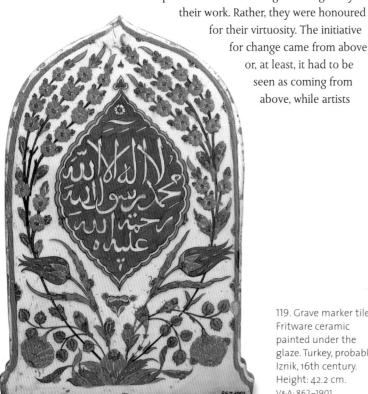

119. Grave marker tile. Fritware ceramic painted under the glaze. Turkey, probably Iznik, 16th century. Height: 42.2 cm. V&A: 862–1901.

tried to show themselves as conforming either to the will of a mighty patron, or to convention. The training of artists prepared them for this subservient role: as far as we can tell, most spent many years as apprentices in the personal service of older masters, who may have been their fathers or, if they were slaves, their owners.

In general, we lack archival materials for the artistic production of the Islamic period, and where they do exist, as is the case for the Ottoman empire after 1453, work on them is at an early stage. Signatures on works of art are therefore very important, but isolated examples need to be interpreted with care. When, in 1540, Maqsud Kashani placed his name on the two Ardabil carpets (see pp.74–5), he was 'signing' works that are so outstanding in every way that they must have been made in response to a specific commission, almost certainly from the Safavid monarch Shah Tahmasp (ruled 1524–76).

In the text Maqsud composed for the occasion, he used the conventions of self-deprecation, describing himself, for example, as a 'slave of the court'. Paradoxically, there is a strong possibility that, through both the placing and wording of the signature, Maqsud was celebrating his privileged relationship with his august client.

Maqsud cannot have been the solitary weaver of the carpets – several weavers would have worked on each carpet side by side at any one time. He may have been the head of the workshop that produced them, who was using his 'signature' as a means of publicizing its wares. But it seems more likely that he was the court official who organized the supply of carpets. This meant developing a design that met the patron's approval; building a loom that may well have been larger than any then known; supplying labour with the appropriate skills; and ensuring payment from the treasury for his own work and that of the workforce, and for great quantities of materials of the highest quality. In signing the two enormous Ardabil carpets, Maqsud may have been commemorating a considerable achievement in administration as much as in art.

As the Ardabil carpets were probably made for an important shrine, it is also possible that Maqsud included his signature in the design for religious reasons. A rare insight into such a motivation is

Opposite: 120.
Fireplace. Fritware
painted under the
glaze, and stone.
Turkey, probably
Istanbul, 1731.
Height: 365 cm.
V&A: 703–1891.

Below: 121 (see also
frontispiece). Table.
Wood inlaid with
ebony and mother
of pearl; and
fritware painted
under the glaze.
Turkey, probably
Iznik, about 1560.
Height: 48 cm.
V&A: C.19–1987.

provided by an Iznik mosque lamp that Sultan Süleyman the Magnificent donated to the Dome of the Rock in Jerusalem (compare plate 118). An inscription in small lettering was written around the base, which is now broken, so that some words have been lost.

From what remains of the inscription, we learn that the lamp was decorated in June 1549 by Muslu the Painter, and that he wished that, '. . . the ocean who is Eṣref-zade in Iznik may enjoy it.' Eṣref-zade Rumi (1378–1470) was the most important Sufi sheikh the city of Iznik produced, and Muslu was no doubt referring to the boundless character of his mystic knowledge when he called him an 'ocean'. But what is Eṣref-zade supposed to 'enjoy'? The painter could not have meant the lamp itself, which was to be sent to Jerusalem, but its destination may be the key: the only gift at Muslu's disposal was the religious merit to be gained by decorating a lamp for one of the holiest shrines in Islam. It seems likely that Muslu belonged

to the brotherhood founded by Esref-zade, to whose soul he assigned the grace arising from his meritorious action.

In the wider world beyond the court, master artists and craftsmen were men of standing in their communities, and their reputations offered the purchaser an assurance of quality. The inlaid jug of 1462 (plate 99) has an inscription under the base that reads, 'Made by Habiballah son of 'Ali Baharjani'. The same man was responsible for several jugs of this type, and if as suggested above, these items were made for the market, Habiballah's signatures may have functioned as a type of brand mark.

The evidence for such a role is better for later periods, for which larger numbers of objects by the same maker survive. This is the case with the many astrolabes that bear the name of the Isfahani instrument maker 'Abd al-A'immah, who flourished in the late seventeenth and early eighteenth centuries (plates 12 and 13); his name was also engraved on later forgeries to give them spurious authority.

With calligraphic specimens, a signature such as that of Berber-zade Ahmed Efendi (plate 74) assured connoisseurs that they were buying the work of a certified master of the Ottoman tradition, and it assured trainee calligraphers that the piece could be used as a model for copying. In the case of some paintings signed by Riza 'Abbasi (see pp.66–7), the artist was the outstanding figure in his field at the time, and he may have been using his own name to pass off illustrations executed by juniors in his workshop as his own.

External factors

In this discussion, the import of Chinese blue-and-white porcelain into the Middle East was credited with the fall in the production of Mamluk inlaid brass wares during the later fourteenth century (a connection made as long ago as the fifteenth century by the Egyptian historian al-Maqrizi), and with stimulating the production of the fritwares of Iznik. Yet these are only two of the many occasions on which Chinese trade goods had an impact on artistic output in the Middle East, and China was only one of the regions that interacted with the Middle East in this way.

THE LUCK OF EDENHALL

Mark Jones

The 'Luck of Edenhall' is a glass beaker made in Egypt or Syria in the thirteenth century. It is elegantly decorated in blue, green, red and white enamel, with gilding. The survival of this fragile and beautiful masterpiece in perfect condition for more than 700 years seems astonishing and it is the story behind that survival that makes this object so magical.

Edenhall was a house in the far north of England, an area much troubled by border raids. In such areas the Church's normal insistence on the use of precious metal for chalices rendered churches a target for raiders. The rule was therefore relaxed, and glass vessels of this kind assumed a sacred function. Certainly the 'Luck of Edenhall' was regarded as especially precious by its fourteenth-century owner, who provided it with a finely decorated leather case, bearing the sacred monogram IHS.

We think of our society as a global society and it is easy to forget how cosmopolitan many aristocrats and churchmen were in medieval Europe. Even so the impression made by an object like this, brought back by some crusader after years in the Near East, must have been dazzling. The technology needed to make clear glass was unknown in northern Europe at the time; the skill needed to apply and then refire enamels to produce such an object must have seemed miraculous.

As the centuries passed, the true origin of the glass was forgotten, and a new myth grew up to explain the presence of this exotic and beautiful object in Edenhall. According to this:

> . . . a party of Fairies were drinking and making
> merry round a well near the Hall, called St Cuthbert's well;
> but being interrupted by the intrusion of some curious
> people, they were frightened, and made a hasty retreat, and
> left the cup in question: one of the last screaming out

> If this cup should break or fall
> Farewell the Luck of Edenhall

The author of this passage in the *Gentleman's Magazine* of August 1791 speculates that 'ancient superstition may have contributed not a little to its preservation'.

This superstition, fortunately, continued to exert its influence. Henry Wadsworth Longfellow, in his mid-nineteenth century translation of Johan Ludwig Uhland's ballad about the 'Luck', envisages the terrible consequences of its careless destruction during a banquet at Edenhall:

> As the goblet ringing flies apart
> Suddenly cracks the vaulted hall;
> And through the rift the wild flames start;
> The guests in dust are scattered all,
> With the breaking Luck of Edenhall!

> In storms the foe with fire and sword;
> He in the night had scaled the wall,
> Slain by the sword lies the youthful Lord,
> But holds in his hand the crystal tall,
> The shattered Luck of Edenhall.

Fortunately the 'Luck' remains intact, though Edenhall itself was demolished shortly after the glass was placed on loan at the V&A in 1926. By its survival it reminds us of a time when conflict in the Near East was mitigated by chivalric behaviour on both sides, and when the technological and scientific sophistication of their Arab opponents were much admired by European crusaders. It reminds us too of the power that an object's history confers upon it; of the hold that such a piece can exert on the imagination. If this piece were only an exquisite Syrian glass we would not mind if it was smashed and replaced by a new archaeological find of the same date and quality. But to me, at least, this would be scant consolation. Uhland's ballad reminds us in dramatic form, as he intended, of the fragility of human society and of the dangers of destroying the material history that connects us to our common past.

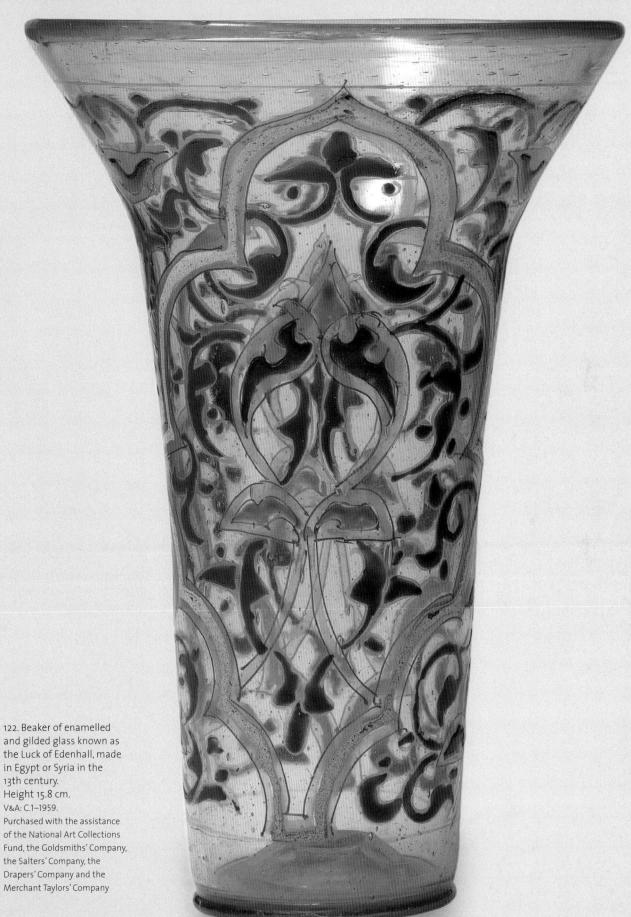

122. Beaker of enamelled
and gilded glass known as
the Luck of Edenhall, made
in Egypt or Syria in the
13th century.
Height 15.8 cm.
V&A: C.1–1959.
Purchased with the assistance
of the National Art Collections
Fund, the Goldsmiths' Company,
the Salters' Company, the
Drapers' Company and the
Merchant Taylors' Company

Chapter Five

INTERACTION

Left: 123. Vase and cover by Giorgio di Gubbio. Earthenware with opaque glaze and decoration in lustre. Italy, Gubbio, around 1510. Height: 26 cm. V&A: 500–1865.

Right: 124. Bowl. Earthenware with opaque glaze with decoration painted in the glaze. Iraq, 9th century. Diameter: 20.8 cm. V&A: C.1447–1924.

Until the sixteenth century, the Middle East sat firmly at the centre of the known world, and its connections with East and South Asia, Europe and Africa made it the hub of a great system of trade routes. One result of this near-global pattern of commerce was that the artists and craftsmen of the Islamic Middle East had to compete with the best in the world, as in the case of Chinese ceramics. On many occasions they met the challenge with considerable success, and the new wares they created were exported to other regions,

where they were sometimes replicated by local craftsmen. In other words, artistic ideas circulated in an international system that existed in parallel to, and in dependence on, the system of trade.

Meeting a challenge

From as early as the eighth century AD, Chinese manufactures were brought to the Middle East in considerable numbers. The carriers were Arab and Iranian mariners who, having mastered the sea routes in the Indian Ocean, had moved northwards, traversing the Malay archipelago and reaching the coast of China. Guangzhou, for example, was the home of many Muslim traders during the Tang period (618–907), and the city still boasts a monumental tenth-century minaret.

The goods shipped to East Asia included foodstuffs, some of which were carried in the 'Sasano-Islamic' jars discussed in Chapter 1 (plate 16). These storage jars are indicative of the level of ceramic production in the Middle East at the beginning of the Islamic period, since neither the Byzantines nor the Sasanians produced tableware of any distinction. Their contemporaries in China, however, were producing

125. Bowl.
Earthenware with
opaque glaze.
Iraq, 9th century.
Diameter: 24 cm.
V&A: C.178–1984.

high-fired ceramics of great quality, and when the Chinese wares arrived in the Middle East, they altered the social customs of the upper strata of society by making it respectable to eat off ceramic dishes rather than those of silver and other materials. Once this new fashion was established, it in turn stimulated the local production of tableware.

The residence of the Abbasid caliphs in Iraq from AD 750 brought the region great wealth and made it the centre of the trade in luxuries. It was here that the use of Chinese tableware first gained currency, and it was here, too, that the local imitations were first attempted, probably in the port of Basra. The imported white wares were appreciated for the purity of their colour, as well as for the hardness of their body, but the raw materials and kiln technology needed to reproduce these qualities were not available in Iraq. The local potters' response was to use different means to achieve the same visual effect: they made pots with Chinese shapes from yellow clay, which they masked with an opaque white glaze. One bowl of this type (plate 125) has the same general form as two small whiteware bowls from Tang China (plates 126 and 127), and it shares the shape of its footring with one and its everted rim with the other.

The invention of an opaque white glaze, made by the addition of tin oxide to the glaze mixture, was only the first stage in the evolution of fine ceramic production in Iraq in the ninth century. The white surface of the pots is often compared to a blank 'canvas', on which the potters were tempted to display their ingenuity for decoration. One means for doing so was provided by cobalt blue, which proved stable in the tin glaze, and designs in this pigment began to be painted into the glaze before firing (plate 124). The wares decorated in this way have long been thought of as the world's first blue-and-white ceramics, although a small number of ninth-century Chinese ceramics with decoration in cobalt blue has now been discovered, and it is not yet clear who had priority.

A second development was based on an aspect of local glassmaking, in which compounds of copper and silver were used to stain transparent glass (plate 48). In ceramic production, the same substances were used to create the shiny, metallic decoration known as lustre. It was a two-stage process. In the first stage, the glazed pot was produced in the normal way by firing in a kiln. In the second, a design was painted over the glaze using the metallic compounds, and the pot was refired at a lower temperature in a kiln with a restricted supply of oxygen. During this second firing,

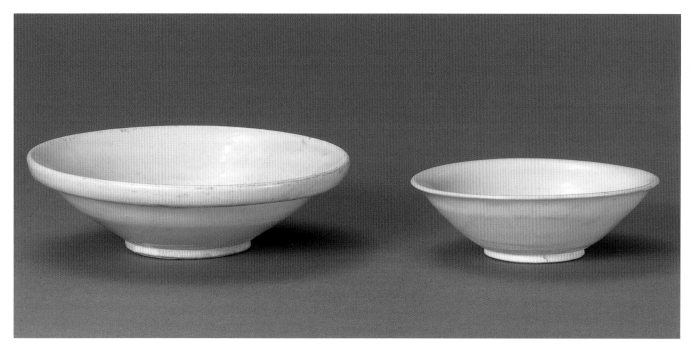

Above: 126. Bowl. White porcelain China, 7th or 8th century AD. Diameter: 10.5 cm. V&A: C.22–1950.

Above, right:127. Bowl. White porcelain. China, 8th or 9th century AD. Diameter: 13.7 cm. V&A: C.23–1950.

Below: 128. Bowl. Earthenware painted in lustre over an opaque glaze. Iraq, 9th or 10th century. Diameter: 19.9 cm. V&A: C.99–1929.

the heat converted the metallic compounds into oxides, and the carbon monoxide produced by the fire then drew the oxygen out of the oxides, leaving the metal as a thin deposit on the vessel (plate 128). The result was a surface with an attractive golden glow. Both these forms of decoration – blue-and-white and lustre – were to have a very long history, and they are both still in use today.

The challenge renewed

Over the centuries that followed, the challenge from Chinese ceramics was regularly renewed, stimulating experiments by Middle Eastern potters. As in the case of the invention of the opaque tin glaze, the initial aim of these experiments was to make convincing copies of the Chinese originals, but they soon gave rise to distinctive new forms. In the twelfth century, a challenge came in the form of *qingbai* porcelain, which is very finely potted and has subtly carved decoration under the glaze. This led Middle Eastern potters to develop similar carved effects in their own wares. The bowl shown here (plate 134) has a Chinese form, but the motifs carved into the body are of local origin, and the use of a monochrome cobalt-blue glaze also reflects a Middle Eastern ceramic tradition.

CASKETS AND HUNTING HORNS

Mariam Rosser-Owen

Left: 129. Wooden casket covered with thin panels of ivory, decorated with painted designs of scrolling arabesques and animals within roundels. The double outline of the roundels helps to place the casket within the chronology of painted wares from Norman Sicily, as this feature seems to have been introduced in the early 13th century. The painting has traces of gilding, and the silver gilt mounts were probably added later.
Height: 17 cm.
V&A: 700-1884.

Below: 130. Detail showing the base of the same casket (plate 129), formed from a panel that seems to have been reused from another object, perhaps one made in Fatimid Egypt at a slightly earlier date.

At some point in their history, all the major courts of the medieval Mediterranean world commissioned luxury objects made from elephant ivory. The quality, size and quantity of the items their craftsmen made depended on the availability of the raw material, and its high value meant that craftsmen took care to maximize the use of a single piece of ivory. This explains why the two hundred or so caskets that can be attributed to Norman-ruled Sicily in the eleventh to thirteenth centuries have ivory facings made of very thin plaques, which were decorated with painted and gilded designs (plate 129). Because of their method of construction, which used far less of the precious material than the ivory caskets of Islamic Spain (see pp.80–81), these objects could be made in large quantities for the market.

A very different group of artefacts are the hunting horns called 'oliphants', of which eighty or so are extant. They each required a large section of a tusk for their production, and they are so heavy that it is a matter of debate whether they were ever actually used for hunting: they may have been made for ostentatious display rather than to meet a practical need.

The Normans of Sicily may have relied for their supply of ivory on the Fatimids of Egypt, with whom they maintained close diplomatic and commercial relations. These ties are reflected in a group of oliphants and caskets produced in southern Italy during the eleventh and twelfth centuries (plate 131), which

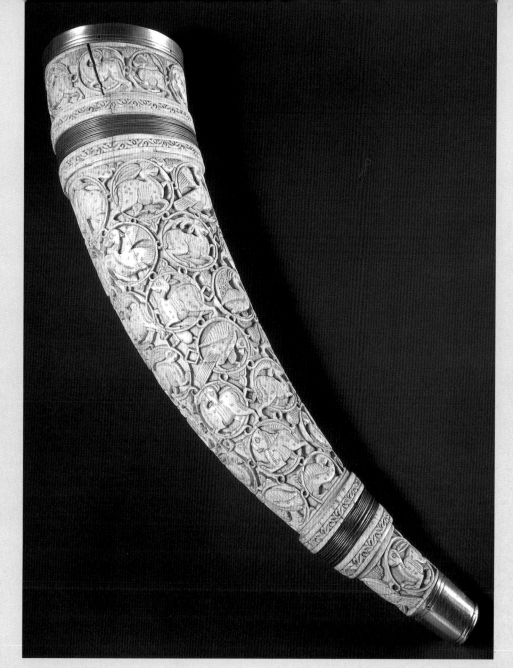

Right: 131. Hunting horn of ivory, probably made in southern Italy some time in the late 11th or early 12th century. The form is also known as an oliphant, a term found in the *Chanson de Roland* (written *c.* 1098–1100), where it was used for both elephants and hunting horns. Length: 64 cm.
V&A: 7953-1862.

have densely carved decoration in a style strongly influenced by Fatimid art. The decoration of these items in a conspicuously Islamic style would have served to associate the owners with the Norman court, which had set the fashion for it.

The iconography of the objects consists mainly of birds and animals known from the Islamic repertory – lions, antelopes, hares, peacocks and elephants – as well as human figures and mythical creatures such as griffins and harpies. They may also feature motifs unknown to medieval Islamic art, such as unicorns. Each animal is always circumscribed by a thin medallion, though it often steps outside this border; the animals have large, rounded bodies, and the tips of their tails frequently terminate in a small, secondary head.

The way the animals are conceived betrays a close relationship to the designs of Fatimid lustre pottery, where a similar aesthetic of disproportionately large bodies is common, and where animals' tails frequently terminate in a palmette. We know that Fatimid lustre was available in Italy, since it was also during this period (the late eleventh century to mid-twelfth century) that ceramic bowls, including many Fatimid pieces, were built into the facades of Italian churches, especially in the region of Pisa in Tuscany.

The close stylistic relationship between these ivories and Fatimid art indicates that their production centre was located in one of the Italian maritime cities that traded with Egypt. The area around Amalfi and Salerno has been proposed as the home of this ivory group, since a cylindrical writing case in the Metropolitan Museum in New York bears an inscription in Latin that names a member of the Mansone family, which was prominent in Amalfi at this period.

Above, left: 132. Bowl. Fritware painted under the glaze. Iran, probably Kashan, early 13th century. Diameter: 24.4 cm. V&A: C.158–1977. Given by Mr C.N. Ades MBE in memory of his wife, Andrée Ades

Above, right: 133. Dish. Fritware painted under the glaze. Turkey, probably Iznik, early 16th century. Diameter: 39.1 cm. V&A: 716–1902.

The ability to create such refined pieces was based on the replacement of earthenware with the compound body material called fritware. This is also known as stone-paste and quartz-paste ware, and in the context of pre-Islamic Egypt, where it was produced over a very long period (plates 17 and 18), as faience. Fritware is based not on clay but on finely ground quartz powder made from sand or pebbles, to which small quantities of fine white clay and a glassy substance known as frit are added – the clay to give it plasticity, and the frit to bind it after firing. This mixture is fired at relatively low temperatures, and the result is soft and porous, but the body is also white all the way through, and it can be adapted to a wide range of decorative techniques. It therefore sustained a great variety of ceramic traditions that arose in the Middle East, many of which were inspired by Chinese models.

In the later thirteenth and fourteenth centuries, a great land-based trade network developed in the aftermath of the Mongol invasions, which united a large part of Asia under the rule of a single dynasty. A new wave of imports from China began, and in

ceramics the most important type was blue-and-white porcelain, which proved very popular in the Middle East. A large porcelain storage jar of the fourteenth century (plate 136) probably arrived in Iran soon after its manufacture; it later sustained damage to its neck, which was repaired with an engraved brass collar in the nineteenth century. The export trade expanded considerably after the overthrow of the Mongol Yuan dynasty by the first Ming emperor in 1368, and blue-and-white porcelain remained the preferred tableware of Middle Eastern rulers and their richer subjects for many centuries.

Before the Mongol invasions, in the late twelfth or early thirteenth century, the technique of painting designs under the glaze had appeared in Iran. A fritware bowl from the Jurjan hoard (plate 132) shows an early stage in its development. The flared sides are divided into compartments, some of which are filled with a floral device in black on a white ground, and some are painted blue. At this stage, potters were unable to manage the blue very well (compare plate 97), and it tended to run during firing.

The solution here was to create areas where blue could run into itself without spoiling the pattern.

The handling of the blue later improved and, as discussed in Chapter 4, the popularity of blue-and-white porcelain meant that by the fifteenth century the technique of painting under the glaze was frequently used in imitating the Chinese wares. When it was applied to a fritware body, the result could be a passable pastiche of a Ming original, as in the case of Iznik 'grape' dishes of the early sixteenth century (plate 133). But the largest output of such imitations occurred in Iran in the seventeenth century, when it was a rare occurrence for motifs of local origin to be rendered in the blue-and-white colour scheme (plate 82) rather than as outright copies of Chinese designs (plate 83). By the time that these pieces were produced, Islamic potters had been meeting the challenge from China for eight hundred years.

While the imitation of Chinese wares forms a major theme in the history of Islamic ceramics, it is not by any means the only theme involving interaction with other cultures. Another was the transmission of

Middle Eastern techniques such as tin glaze and lustre to Europe, where they were taken up by local ceramics industries. Indeed, just as superior Chinese imports introduced the use of ceramic tableware to the upper classes of the Islamic Middle East, so at a later date the import of fine Islamic wares and the adoption of Islamic techniques raised the status of ceramics in Europe.

The patronage this stimulated gave rise to local production of great accomplishment, which included the Italian tin-glazed pottery of the sixteenth century known as maiolica (plates 123 and 143). At the beginning of the same century, however, the Portuguese had arrived in China, marking the beginning of a new phase. Europeans now began to obtain luxury wares directly from East Asia, and this was followed, in the eighteenth century, by the successful imitation of porcelain in Europe. The relationship between European and Islamic ceramics was revived in the nineteenth century, when, for example, the historical collections in the Victoria and Albert Museum inspired the potter William de Morgan (1839–1917) to reinvent the lustre technique

Above, left: 134. Bowl. Fritware with carved decoration under a coloured glaze. Iran, late 12th century. Diameter: 18.5 cm. V&A: C.68–1931.

Above, right: 135. Dish designed by William de Morgan. Earthenware painted in lustre. England, 1882–8. Diameter: 36.5 cm. V&A: 832–1905. Given by Sydney Vacher

in order to achieve the aesthetic qualities he had seen in medieval Iranian wares (plate 135).

A technique travels

After its invention in Iraq in the ninth century, the lustre technique proved a commercial success, and vessels were exported across much of the Old World – archaeological finds have been made as far apart as Portugal and Thailand. From the tenth century, however, Iraqi production was replaced by production at a series of locations across the Middle East and beyond: Egypt, Syria, Iran and Muslim-ruled Spain were all the home of important centres of production at one time or another.

The lustre technique is so sophisticated that its reinvention in each of these places seems most unlikely, and it can therefore be presumed that it was transmitted by the movement of craftsmen. The knowledge of how to make lustre was probably a carefully kept secret, as it was to be in sixteenth-

century Italy. In 1558, Cipriano Piccolpasso described how, 'Many potters make the lustre kilns on the floors of houses which are locked and under close guard, for they look on the manner of making the kiln as an important secret and say that in this consists the whole art.' [8]

The second major centre for lustre production was established in Cairo after the city became the capital of the Fatimid caliphate in 969. As in the case of the carving of rock crystal, it seems that the Fatimids sought to outdo the Abbasid court in Iraq in all the luxury arts for which it was famous, and examples of great refinement were produced. These include a bowl decorated with a figure identified as a Coptic priest carrying a lamp (plate 137). The motif on the right is taken to be an *ankh*, an Ancient Egyptian symbol for life that had become associated with Christ. This would seem to tie the object closely to the Coptic community in Egypt, for whom lustre pieces with explicitly Christian iconography were made. Alternatively, the

Right: 138. Dish.
Fritware with
decoration in
lustre. Iran,
probably Kashan,
12th or 13th century.
Diameter: 37 cm.
Ades Family Collection

A Bowl from Malaga

Mariam Rosser-Owen

The transmission of the lustre technique from lands under Muslim rule to those under Christian rule occurred in Spain, where it was probably introduced by craftsmen who had learned their trade in Fatimid Egypt. The main centre of production was Málaga, an important port on the south coast that remained under Muslim rule until 1487. By the end of the thirteenth century, the potters there were producing the astonishing objects known as Alhambra vases, which vary in height between 1.2 and 1.7 metres and were the largest Islamic ceramics ever produced.

More conventional wares were exported over a wide area. Sherds have been found at Fustat in Egypt, for example, while in 1289 Eleanor of Castile, wife of King Edward I of England, was recorded as receiving 'forty-two bowls, ten dishes and four earthenware jars of strange colour' that had been brought from Málaga. In Europe *opus de Melica* (Málaga ware) became the tin-glazed ware *par excellence*, and its name, rather than that of Mallorca, was probably the origin of the Italian *maiolica*.

The fame of Málaga as a centre of lustre production was subsequently overshadowed by producers situated in the region of Valencia, on the east coast of Spain, in an area already under Christian rule. Production began there in the early fourteenth century, probably after the lustre technique had been introduced to the region by potters from Málaga. By the beginning of the fifteenth century, Valencia was overtaking Málaga as a supplier of fine pottery (plate 139), and production at Málaga seems to have ceased altogether in the mid-fifteenth century.

For this reason, a magnificent bowl bearing an image of a ship in lustre (plate 140) was long thought to be an early example of the wares made at Valencia. In 1983, however, scientific analysis of the clay body of the bowl showed that it contained schistose inclusions characteristic of the wares from Málaga. The bowl therefore demonstrates that the lustre workshops of Málaga were still producing ceramics of outstanding quality during the last decades of their existence. It stands at the culmination of one tradition and the beginning of another.

Below: 139. Tin-glazed earthenware dish with lustre decoration over the glaze, the outline of the lion motif incised. It was probably made at the kilns of Manises, near Valencia, about 1500. Large and showy wares of this kind are typical of production at Valencia, where ceramic techniques of Islamic origin were used to produce wares that suited Late Gothic taste. Diameter: 42.7 cm. V&A: C.2050–1910.

Right: 140. Tin-glazed earthenware bowl decorated with lustre, produced at Málaga in the second quarter of the 15th century. The ship depicted has the arms of Portugal on its sail, and it may have been commissioned by a Portuguese maritime merchant. Diameter: 51.2 cm. V&A: 486–1864.

141. Footed bowl. Fritware with decoration in lustre. Syria, probably Raqqah, around 1200. Diameter: 21.9 cm. V&A: C.150–1986.

Right: 142. Jar. Fritware with decoration in lustre over a coloured glaze. Egypt or Syria, 14th century. Height: 39 cm. V&A: 1601–1888.

westwards. By the later thirteenth century, sophisticated wares were being produced in Spain, where the lustre technique was presumably introduced by craftsmen migrating from Egypt. The main centre of production was originally Málaga, which remained under Muslim rule until 1487 (plate 140), but lustre ceramics later became a speciality of the Valencia region, where Muslim and Christian craftsmen worked under Christian rule (plate 139).

The products of this industry were designed to meet the needs of the European market, and over the centuries they reflected changes in taste in Europe. Nevertheless, the Spanish wares maintained the Iraqi

motif may be a stylized cypress tree, and the combination of priest and tree may relate to the numerous Arabic poems about monastery gardens, where wine could be drunk and beautiful young women seen unveiled.

Towards the end of the Fatimid period, in the twelfth century, the centre of lustre production moved again, to Syria, where two different types of pottery were made. Both are named after a site in northern Syria where they were first found – the refined Tell Minis ware of the mid-century and the later and more coarsely potted Raqqah ware (plate 141). By 1180, the best production was taking place at Kashan in Iran, and it continued there until the mid-fourteenth century, both in the form of vessels (plates 63, 98 and 102) and of tilework (plates 9, 65, 66 and 100). During the fourteenth century, lustre was also being produced in Syria, from where some was exported westwards, as is evidenced by two jars decorated in this technique that were purchased at Trapani in Sicily in the nineteenth century (plate 142).

The manufacture of lustre was also taken

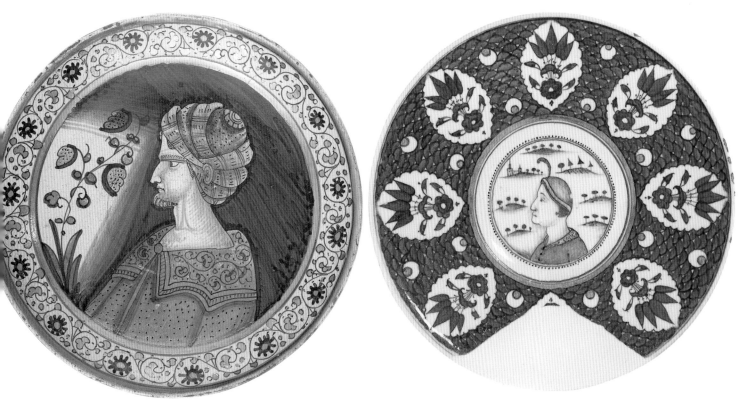

Above, left: 143.
Dish. Earthenware
with decoration in
lustre. Italy, Deruta,
1500–40.
Diameter: 25 cm.
V&A: C.2185–1910.

Above, right: 144.
Plate. Fritware
with painting
under the glaze.
Turkey, probably
Iznik, first half of
the 16th century.
Diameter: 25.4 cm.
V&A: 5763–1859.

tradition of painting the lustre over a glaze opacified with tin oxide, and in the fifteenth century this formula was transmitted to Italy, where it became the basis of the production of maiolica. The most famous exponents of lustre in this tradition were Maestro Giorgio of Gubbio (died 1536) and his descendants, who produced wares of great presence (plate 123). The other lustre-producing centre in Italy was Deruta, where a dish depicting the Ottoman Sultan Mehmed II was made, probably in the 1530s (plate 143). This rare example of a Turk's portrait on a maiolica dish is matched by an Iznik piece of the same period, which is decorated with a portrait of an Italian gentleman (plate 144).

Weaving silk and gold

This discussion has so far been confined to the history of ceramics, since ceramics are the most consistently well preserved of all media, but interaction with China and Europe also occurred in other fields, especially textiles, which were the staple commodity in international trade. After the Mongol expansion in the thirteenth century, for example, demand for cloth of gold and other high-value textiles was very strong, and the Mongols organized production on an Asia-wide

scale, moving craftsmen about between East and West Asia in an unprecedented manner. There were also interchanges with Europe, at least in terms of design.

As a result, patterns and techniques became internationalized to such a degree that it is often difficult to decide where in all of Asia and Europe a textile was made. This was true even for contemporaries, it seems, since an entry in an inventory drawn up in Rome in 1311 reads, 'tunic of white Tartar or Lucchese cloth ornamented with horizontal bands of red silk and gold'. [9] It seems that the author was unable to distinguish between cloth made nearby, in Lucca, from that made by the subjects of the Mongols, in distant 'Tartary'.

The rich blue and gold cloth used for a Church vestment (plate 148) illustrates the international repertory of designs that were used at this time. The pelicans depicted on the textile, for instance, might seem more at home in Italy, where they were used as a symbol of Christ's self-sacrifice, but the undulating flower scroll owes a good deal to Chinese motifs of this kind. Yet the structure of the cloth is sufficiently distinctive to allow an attribution to Mongol-ruled Iran. It must have been exported to Europe, since the vestment into which it was made was a dalmatic, a

Left: 145. Silk velvet
with metal thread.
Italy, 15th century.
Length: 298 cm.
V&A: 81–1892.

Centre: 146. Silk
velvet with metal
thread. Turkey,
16th century.
Length: 134 cm.
V&A: 100–1878.

type used by the Western Church. This probably
ensured its survival, stored, perhaps, in the vestry of a
great abbey or cathedral, making it one of the largest
surviving specimens of a fourteenth-century Iranian
textile of this type.

Underlying the production of such rich fabrics was
the use of the drawloom, which was worked by two
craftsmen: a weaver to operate the loom and create
the structure of the cloth, and a 'drawboy' to help the
weaver generate the complex pattern by constantly
raising and lowering the relevant warps. The invention
of the drawloom is thought to have taken place in the

first century AD, but it is not clear where: it may have
occurred simultaneously in China and in the Middle
East. In any event, the drawloom had long been
established around the Mediterranean by the time of
the Mongol invasions in the thirteenth century, and
Italy in particular was competing with the Middle East
in the production of richly patterned textiles of silk
and gold thread. This situation was not affected by the
disappearance of the Mongols from the Middle East in
the mid-fourteenth century, and Italy's weavers
continued to prosper. One of their specialities was the
production of silk velvet.

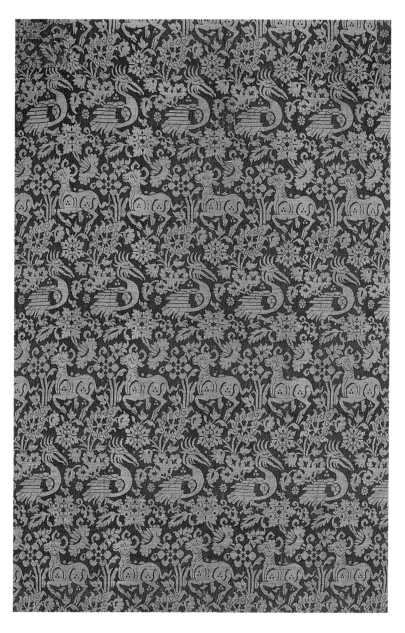

Opposite, right: 147. Silk velvet with metal thread. Turkey, 16th century. Length: 171.5 cm. V&A: 96–1878.

Above: 148. Detail of dalmatic. Woven silk and metal thread. Probably Iran, late 13th or early 14th century. V&A: 8361–1863.

over the following two centuries, and the influence of Italian models can be observed over a good deal of this period.

Some examples from Bursa mimic Italian patterns in their entirety. Others display designs based on very similar principles, but with the individual elements changed (plate 146). In others still, however, the native tradition has triumphed, as when a typically Ottoman floral motif – a stylized, fan-like carnation – is arranged very formally in staggered rows (plate 147). Ironically, the Bursa velvets are most easily recognizable when they include the naturalistic flower motifs adopted by the Ottomans in the mid-sixteenth century, but these motifs were themselves of European origin: it is the way that they were used that makes them distinctively Ottoman.

Islamic or Italian?

It is actually impossible to tell whether some velvets produced in the second half of the fifteenth century were made in Bursa or in Italy. Indeed, interaction between the Christian- and Muslim-ruled shores of the Mediterranean was so intense at this time that there are several areas of material culture in which similar confusion reigns. One is a type of inlaid brassware, in which the surface of the vessel is covered with a dense pattern of arabesques, and silver is used very sparingly. This type of metalwork became very popular in Italy, and so much of it was found there in the nineteenth century that it was presumed to have been made locally, even though many pieces are signed in Arabic (plates 154 and 156). A theory arose that it had been made in Venice by Muslim craftsmen, to whom the medieval name 'Saracens' was applied. As a result, these metalwares were dubbed 'Veneto-Saracenic'.

The truth is more complex. The decoration of the signed examples and pieces with similar decoration must have been carried out in the Middle East, since the guild system operating in Venice at this time meant that no Muslim craftsman would have been allowed to work there. Yet this type of dense scrollwork design was very popular in Italy and other parts of Europe, where it was known as 'moresque', and a second group of metalware decorated with 'moresque' designs was indeed produced in Italy

In the fifteenth century, the weavers of Florence and Venice were the main producers of velvet for both the European and the Middle Eastern market (plate 145). At the Ottoman court it was eventually decided to mount a challenge to the Italian predominance in this field, and looms were established at Bursa, a great silk-trading and manufacturing centre in north-west Anatolia. It is not known precisely when this occurred, but by the end of the century Bursa's velvet-weavers were involved in disputes about a fall-off in quality, predicated on an earlier golden age when standards were high. Bursa velvets continued to be produced

SILVER AND BRASS

Tim Stanley

Tracing the history of precious metalwork in almost every culture that produced it has been made more difficult by the loss of a huge proportion of the material evidence. Because of the inherent value of gold and silver, financial exigencies and changes in fashion led to the melting down of objects and the reuse of the metal for other purposes. Although we know from literary sources that silver and gold vessels were in common use in the courts of the Islamic Middle East, relatively few examples survive that were made before the eighteenth century. Two early Ottoman vessels of silver gilt show that work in this medium was far from static. Although made at dates only one or two decades apart, they have forms of very different origin, and they are decorated in different styles.

One (plate 149) is a pot-bellied drinking vessel with a dragon-shaped handle. Similar jugs were being made in eastern Iran in the fifteenth century, both in carved jade and in brass inlaid with silver (plate 99), but the origin of the form seems to lie in the thirteenth and fourteenth centuries, when gold drinking vessels with handles in the forms of dragons and other propitious beasts were fashionable among the Mongol rulers of Western Asia. The ultimate home of both the Mongols and the fashion for these vessels was in the steppes north of China.

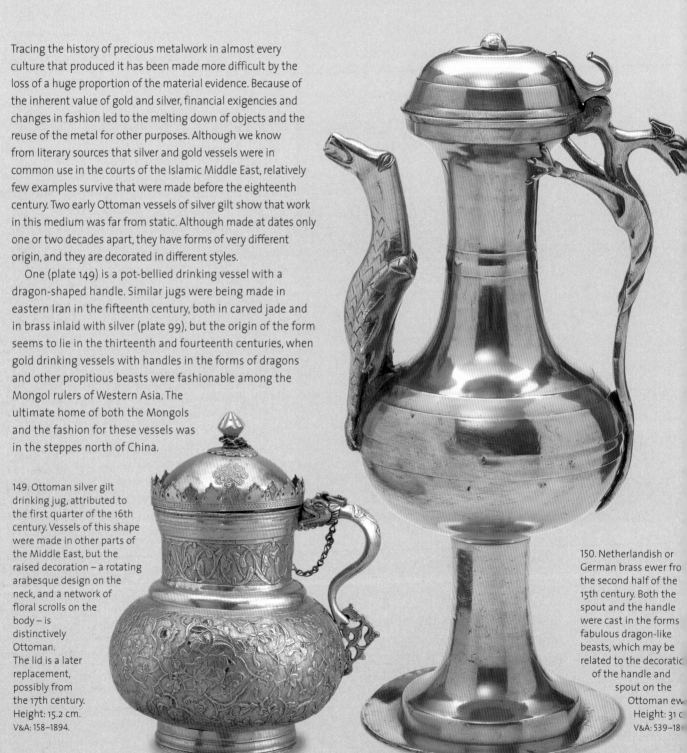

149. Ottoman silver gilt drinking jug, attributed to the first quarter of the 16th century. Vessels of this shape were made in other parts of the Middle East, but the raised decoration – a rotating arabesque design on the neck, and a network of floral scrolls on the body – is distinctively Ottoman.
The lid is a later replacement, possibly from the 17th century.
Height: 15.2 cm.
V&A: 158–1894.

150. Netherlandish or German brass ewer fro[m] the second half of the 15th century. Both the spout and the handle were cast in the forms [of] fabulous dragon-like beasts, which may be related to the decoratio[n] of the handle and spout on the Ottoman ew[er.] Height: 31 c[m.] V&A: 539–18[]

The other piece, a ewer (plate 151), is quite different in both decoration and form. Its raised decoration is a much denser and finer type of scrollwork, and enamelled plaques once added coloured highlights to the overall design. The shape of the vessel was related to that of Late Gothic brass ewers from northern Europe, with handles and spouts in the forms of fabulous beasts (plate 150). There can be no doubt that this type of metalwork was popular in the Eastern Mediterranean, in the light of the Ottoman version and of examples with owner's inscriptions in Arabic, and some of it seems to have been re-exported to Venice once it had been decorated with engraved and inlaid designs in an Islamic style (plate 152).

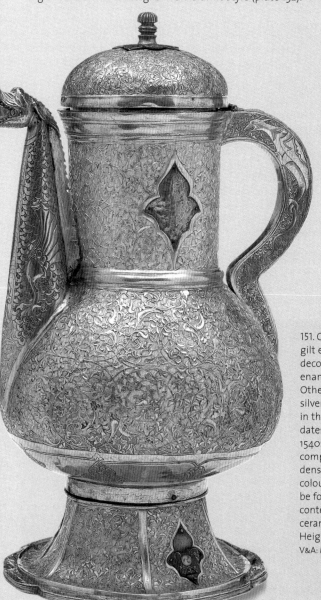

151. Ottoman silver gilt ewer with raised decoration and enamelled plaques. Other pieces of silverwork decorated in the same style bear dates in the 1530s or 1540s, and a comparable pattern of dense scrollwork with coloured elements can be found on contemporary Iznik ceramics (plate 116). Height: 19.5 cm. V&A: M.21–1987.

152. Netherlandish or German brass ewer from the second half of the 15th century. The vessel was later engraved and inlaid in silver with overall decoration, which is generally in an Islamic style but includes the arms of the Molino family of Venice. Height: 34.5 cm. V&A: M.32–1946.

153. Pyxis. Carved ivory with carved and painted decoration. Egypt or Syria, mid-14th century.
Height: 9.5 cm.
V&A: 4139–1856.

in the fifteenth and sixteenth centuries. The treatment of the tiny motifs that fill the compartments within the design often betrays the non-Islamic objects, and these can sometimes be identified, too, on account of their decidedly European shapes (plate 157). On its own, however, the European shape of a vessel proves nothing, since a

considerable amount of European brassware was exported to the Middle East, where 'Veneto-Saracenic' inlaid decoration was sometimes added.

The situation is further confused by the existence of 'Veneto-Saracenic' pieces with engraved and inlaid decoration in a different but still decidedly Islamic style, in which a good deal more silver was used. This suggests that more than one centre in the Middle East was engaged in producing this metalwork. One example started life in the Netherlands or Germany as a Late Gothic ewer (plate 152). It must later have been exported to the Middle East, where the inlaid ornament was added. But this ornament includes the coats-of-arms of the Molino family of Venice, and it is therefore possible that the ewer was sent to the Middle East by a member of the family so that it could be inlaid in silver and then re-exported to Italy.

154. Bucket signed by Zayn al-Din. Brass inlaid with silver. Egypt or Syria, late 15th century.
Height: 13.5 cm.
V&A: 1826–1888.

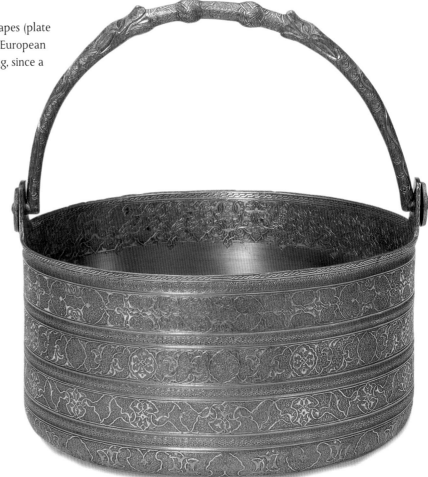

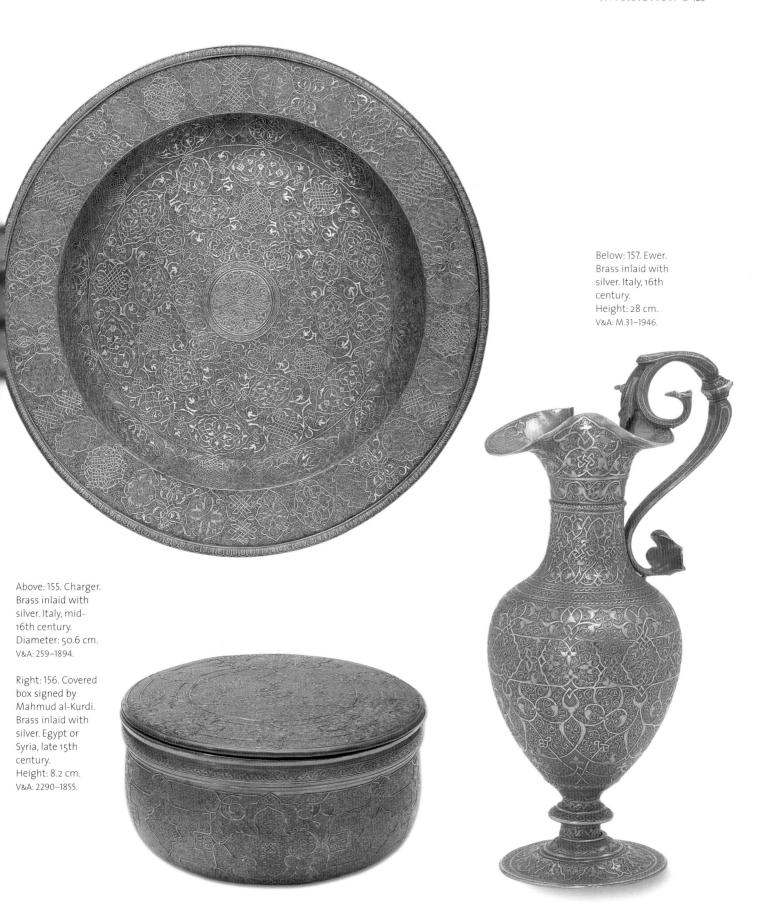

Below: 157. Ewer. Brass inlaid with silver. Italy, 16th century. Height: 28 cm. V&A: M.31–1946.

Above: 155. Charger. Brass inlaid with silver. Italy, mid-16th century. Diameter: 50.6 cm. V&A: 259–1894.

Right: 156. Covered box signed by Mahmud al-Kurdi. Brass inlaid with silver. Egypt or Syria, late 15th century. Height: 8.2 cm. V&A: 2290–1855.

Top: 158. Comb. Boxwood with pierced and marquetry decoration, and studded with silver. Spain, 14th or 15th century. Length: 24.1 cm. V&A: 4229–1857.

Above: 159. Games board. Chestnut wood with ivory marquetry. Spain, 16th century Width: 53 cm. V&A: 7849–1861.

Work in other media was similarly affected by the constant interchanges between the Middle East and Europe in the later Middle Ages. A cylindrical ivory box decorated with a fine openwork pattern (plate 153) is clearly Islamic, as it has an Arabic inscription running around its base, and it has been attributed to the Mamluk empire in the 1340s. On the other hand, a sixteenth-century gaming board decorated with inlay in ivory (plate 159) is probably of Spanish Christian origin, as the patterns used include a ribbon motif characteristic of European work.

What, then, is to be made of a wooden comb that is decorated both with openwork similar to that of the ivory box and with ivory inlay not unlike that on the gaming board (plate 158)? An attribution to Islamic Spain seems likely on a number of grounds. One is that the inlay on the comb resembles that on architectural woodwork made in Granada in the fourteenth century, when the city was still under Muslim rule. It must still be recognized, however, that the inlay on the comb is related to that on the game board since, like lustre production, this technique survived the Christian reconquest of Muslim Spain and – again like lustre – it seems to have been transmitted to Italy.

Crossing boundaries

As the Northern European brass ewer with inlaid work carried out in the Middle East for a member of a Venetian family reveals, some artefacts do not belong entirely to one culture. The Luck of Edenhall, for example (see pp.108–9), may have been produced in Egypt or Syria in the thirteenth century, but most of its subsequent history was spent in Europe, where it gained a significance it could never have acquired in its native land. Equally, a pair of shoes made in England about 1710 (plate 160) may belong to the history of English fashion, but they are also of interest to the history of Islamic textiles, as they are faced with Iranian silk of a slightly earlier period. About this time, however, the balance of power began to alter in favour of Europe, and interaction with the Middle East began to take on new forms.

Four slipper-shaped bath rasps, for example (plate 161), are humble but charming artefacts that make sense only within the context of their own culture.

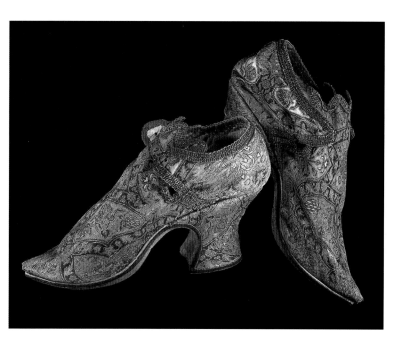

Isfahani, an Iranian potter of the later nineteenth century, revived this form to create a ceramic slipper-shaped *objet d'art* (plate 162), its function had changed completely. His patrons in Tehran included French and English residents, among them Robert Murdoch Smith, who acted for the Victoria and Albert Museum (see pp.136–7). The 'slipper' was therefore

Above: 160. Woman's shoes. Wood, leather, textile. England, early 18th century; the silk covering Iranian. Length: 22.5 cm. V&A: T.444–1913.

Below, right: 161 Shoe-shaped bath rasps. Fritware ceramic with painting under the glaze. Iran, 18th century. Average length: 12.5 cm. V&A: 1067C–1876, 1067B–1876, 651–1889

Far right: 162 Ceramic shoe by 'Ali Muhammad. Fritware ceramic with painting under the glaze. Iran, 1885. Length: 12.5 cm. V&A: C.672–1920.

Designed for use in bathhouses, where the unglazed 'soles' were used for rubbing dead skin and dirt from the body, they are made of fritware and have under-glaze blue-and-white decoration. This decoration may have been of Chinese origin, but it had been completely assimilated in Iran by the time the rasps were produced, in the seventeenth century. Yet when 'Ali Muhammad

made not for use by an Iranian in a bathhouse (the bottom is smooth and glazed, making it useless as a rasp), but for a European who took an interest in the traditional arts of Iran. Such interventions, however well intentioned, presaged more brutal forms of interference (see pp.132–3), which brought the Islamic period in the Middle East to an end.

ARMISTICE DAY, 1918

Tim Stanley

This tray records events on one day, 31 October 1918, in a part of Iraq under British military occupation. This was the day on which the armistice signed at Mondros between the Allied Powers and the Ottoman empire came into effect, and the First World War ended. During the war, the British had gradually occupied the three Ottoman provinces of Basra, Baghdad and Mosul that lay along the Tigris and Euphrates rivers. In doing so they brought the Islamic period, as defined in this book, to an end and ushered in the modern history of the state of Iraq.

The content of the engraved decoration is glossed in a series of five inscriptions of varying length that are found on the object, all crudely written, in contrast to the precision of the rest of the engraving. The longest, which runs along the edge of the design, was composed in sub-standard Arabic, and it may represent an attempt to translate an English text. It reads as follows: 'This is the district of Tuwayrij . . . The troops had left al-Hillah for Hindiyyah, and the political officer ordered that they were to return the refugees to their homes with white flags, on the twenty-fifth day in the month of Muharram in the year 1337.' This date in the Muslim Hijri calendar is equivalent to 31 October 1918.

The town depicted is therefore al-Hindiyyah, also called Tuwayrij, which is situated on the Euphrates between al-Hillah to the east, and Karbala' to the west. It is the seat of the Tuwayrij district of the province of Karbala'. The wide band that cuts horizontally across most of the design represents the river, which is crossed by a pontoon bridge, with a two-storey building at one end, perhaps a guardhouse. Four figures in Arab dress are shown walking across the bridge in the same direction, all carrying the flags referred to in the inscription.

Another significant event is the hanging by the British authorities of a man labelled as 'Sadiq Efendi, who killed a major'. A second label to the left reads, 'This is Sadiq Efendi', and presumably indicates the same man being led to his execution. The two remaining inscriptions gloss the topographical features depicted at either end of the central band, across the 'ends' of the river. That on the left is, 'The area towards al-Rashidah, in the west', or 'al-Rashidah Gharb'. That on the right is, 'The house of Shaykh 'Imran ibn Hajj Sa'dun'.

The coming of the modern world is perhaps most powerfully expressed by the depiction of two RAF biplanes (one left of centre, over the river, the other above the river). The British occupation of Iraq was one of the first military campaigns in which air power played a prominent role, and in the suppression of a Kurdish revolt soon after, aircraft were used for the first time in the bombing of civilians.

163. A round brass tray, with engraved decoration. It was made in Iraq, probably in al-Hindiyyah, on or soon after 31 October 1918. The shape is traditional, but the engraved design is contemporary, both in style and in subject matter. Diameter: 58 cm.
V&A: M.17–2002.
Bequeathed by Mr Bing

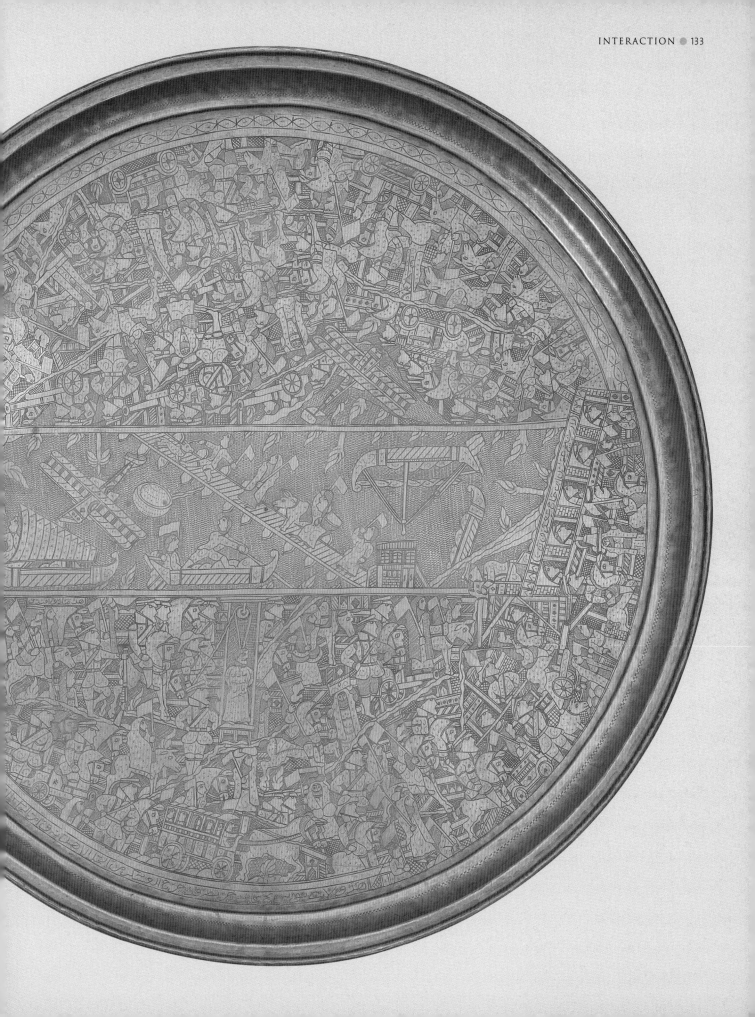

EPILOGUE: ISLAMIC ART IN SOUTH KENSINGTON

A positive aspect of the interaction between Europe and the Middle East in the nineteenth century was the high esteem in which Islamic art was held by Europeans with an interest in art and design. This group included the creators of a new type of museum dedicated to the applied or decorative arts, of which the Victoria & Albert Museum was the first major example.

The creation of the V&A was a result of the enormous success of the Great Exhibition of the Works of Industry of All Nations held in London between May and October 1851. The exhibition comprised more than one hundred thousand objects, housed in a vast ironwork and glass building known as the Crystal Palace, and it received more than six million visitors. The exhibition gave new prominence to British industrial design, which had been a focus of concern since the 1830s. It was the opinion of influential figures such as Henry Cole, one of the exhibition's organizers, and Richard Redgrave, its official Reporter, that despite some efforts by the government, the technical excellence of the British exhibits was not matched by their aesthetic qualities. The remedy they proposed was greater investment in education.

The improvement of industrial design became linked to an appreciation of Islamic ornament primarily through the work of the architect and critic Owen Jones, who became interested in Islamic art and architecture when he visited Egypt, Syria, Turkey and Spain in the years 1832–4. From this time he worked on the Alhambra, the palace complex built at Granada by Spain's last Muslim rulers, the Nasrid sultans (1232–1492), and his investigations culminated in his *Plans, Elevations, Sections, and Details of the Alhambra* (1842–5).

Jones's interest in Islamic artefacts came into its own immediately after the Great Exhibition. In 1852 he gave four lectures entitled 'On the True and False in the Decorative Arts' at the new Department of Practical Art, which published them as its official doctrine. Jones then put forward his thoughts about design in his immensely influential book *The Grammar of Ornament* (1856). This was written essentially as a handbook for students at the schools of design, and Jones organized his material chronologically within geographical and national schools.

The Department of Practical Art was set up by the British government in 1852 and accommodated in Marlborough House, London. Cole and Redgrave were in charge. A Museum of Manufactures, renamed the Museum of Ornamental Art in 1853, was established on the same site and under the same direction. The exhibits were to be used as a means of teaching good design, and from the outset they included non-Western as well as European art and manufactures, following the model established by the Great Exhibition.

Important historical examples of Islamic art, such as the magnificent tray of the Mamluk Sultan al-Malik al-Mansur (plate 105) and Sultan Qa'itbay's basin (plate 112), were acquired for aesthetic reasons: they were admired for their harmony of ornament and form, and their flat, non-illusionistic use of pattern. More recent pieces were acquired for their visual and technical interest, and for reasons that come close to industrial espionage. In the 1850s Britain, like its rivals in Europe and North America, was an aggressive commercial power, and manufacturers needed information on the material culture of non-Western countries so that they could match their production to the needs of overseas markets.

In 1857 the Museum was moved to its present site in London and became the South Kensington Museum, with Henry Cole as its first Director. Here there was an even greater emphasis on 'applied art' as a tool for the instruction of manufacturers, as opposed to the 'fine art' held by the National Gallery in London, and the pieces of historical importance collected by the British Museum. Reflecting the arrangement of Jones's *Grammar of Ornament*, the Middle Eastern objects that entered the Museum were classified by region or

country of origin rather than by religious or cultural context, and they were then regarded from the point of view of materials and techniques, following principles laid down by the German art theorist, Gottfried Semper.

Many of the newer items acquired by the South Kensington Museum were bought from the series of international exhibitions held at South Kensington between 1862 and 1874 and then in Paris in 1867, 1878, 1889 and 1900; these included displays of Islamic art, mainly from Turkey and Egypt. From the Exposition Universelle held in Paris in 1867, for example, the Museum bought the Egyptian collection of Dr Meymar, which included the monumental fifteenth-century minbar of Sultan Qa'itbay (see pp.100–101). The 1867 exhibition was the first in which Iran participated officially, and twenty-five examples of contemporary Iranian crafts were acquired for the Museum, including twelve carved pear-wood spoons, lacquer book and mirror covers, inlaid woodwork and embroideries.

Morocco also exhibited for the first time in 1867, and the Museum acquired several Moroccan pieces direct from the exhibition. These were augmented by the tile manufacturer George Maw, who donated twenty-five pieces of Moroccan pottery to the Museum after two trips to Morocco in 1869 and 1871. Maw acted on his own initiative, but other collecting in the Middle East had official sanction. Caspar Purdon Clarke, a Museum employee, was sent to Tehran in 1875 and Damascus in 1876, and the scholar Stanley Lane-Poole was sent to Egypt after Britain's military intervention there in 1882. He returned with some four hundred objects, and followed his visit by writing *The Art of the Saracens in Egypt* (1886).

An outstanding contribution along these lines was made by Sir Robert Murdoch Smith, who acted as the Museum's agent in Iran from 1873 to 1885 (see pp.136–7). By 1876 the Museum was able to mount an exhibition of nearly 2,000 examples of Iranian art, almost all acquired through the offices of Murdoch Smith, whose handbook called *Persian Art* was published to accompany the exhibition.

Other objects were acquired from dealers and private collectors, both in London and abroad. London carpet dealers supplied both the Chelsea carpet (see pp.54–5), which was purchased in 1890 for £150 from Alfred Cohen of King's Road, Chelsea (hence its name), and the Ardabil carpet (see pp.74–5), which was sold to the Museum by Vincent Robinson in 1893 for £2,500. In 1883 the Museum purchased a collection of about two hundred objects formed by Gaston de Saint-Maurice, who had been the chief equerry of the Egyptian royal stables, and from 1886 the growing collection formed by a serving British officer, Captain W.J. Myers of the 60th Rifles, was exhibited on loan.

After Myers's death in 1899, the Museum authorities bought his Islamic glass for £3,000 and his tiles for £1,000, and dispersed some of these pieces to the similar museums that had been established in Edinburgh and Dublin. Other collections were acquired as gifts, and these included the great bequest made by George Salting on his death in 1909. Although more famous for its Far Eastern ceramics and European art, the Salting Bequest also included outstanding examples of Islamic ceramics and metalwork (plates 30, 115 and 117).

The success of the South Kensington Museum can be judged by several measures. One is the degree to which British industrial design changed under its influence during the second half of the nineteenth century. Another is the inspiration the Museum's collections provided for important figures in the decorative arts, such as the potter, William de Morgan (plate 135). A third is the number of institutions set up in emulation of the South Kensington Museum from the 1860s onwards, both in Britain and the rest of Europe; many also acquired objects from the Islamic Middle East for their collections. The fourth is the official esteem in which it was held, indicated by its change of name in 1899 to The Victoria and Albert Museum, in honour of the Queen and her husband, Prince Albert, who had played a leading role in organizing the Great Exhibition.

This was also the period when the Museum began to assume its current physical form: the large ranges that now form the main facades were opened in 1909. At this time, media-based departments – Metalwork, Ceramics, Textiles and so on – were formed, and the Islamic Middle Eastern collections were distributed among them. The one part of the V&A collections that was not divided up in this way was the Indian

Major General Sir Robert Murdoch Smith

Rebecca Naylor

Robert Murdoch Smith (1835–1900), an energetic and adventurous Scot, first travelled to Asia in 1856 as an officer in the Royal Engineers to assist with the British Museum's excavation of the Mausoleum – the Hellenistic tomb of King Mausolus at Halicarnassus (now Bodrum) in western Turkey. His appetite for archaeology was whetted, and in 1860–1 he conducted his own excavations at Cyrene, in what is now eastern Libya. His skills as a Royal Engineer qualified him for a job with the new Indo-European telegraph, supervising the section that was to run through Iran.

As Director of the Persian Telegraph Department from 1865, Murdoch Smith travelled widely across Iran, rapidly learned Persian and developed an appreciation of the country's history and culture. By 1873 he was acting as the agent of the South Kensington Museum (later the Victoria & Albert Museum), collecting a wide variety of artefacts on its behalf and submitting regular detailed reports on his acquisitions. This role continued until he retired from Iran in 1885, when he took up the post of Director of the Scottish equivalent of the South Kensington Museum, the Museum of Science and Art in Edinburgh.

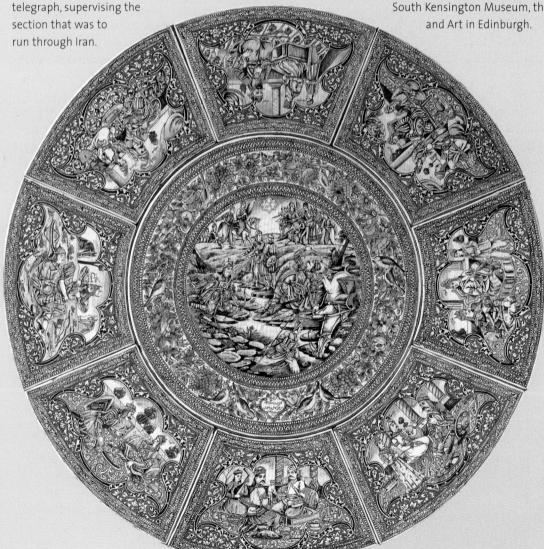

Left: 164. Table top made of nine separate tiles, each decorated with a scene inspired by the *Book of Kings*, the Iranian national epic. An inscription below the central scene records that the piece was commissioned by Colonel Robert Murdoch Smith from Ali Muhammad Kashigar Isfahani in the Hijri year 1304, equivalent to 1887. Diameter: 136 cm. V&A: 559–1888.

Above, right: 165. Robert Murdoch Smith.

Murdoch Smith's collecting activities took several forms. He used the funds provided to buy antiquities from dealers of various kinds, the most notable example being his acquisition of part of the vast collection of Jules Richard, a French expatriate long established in Tehran. Modern crafts were, however, also of interest to South Kensington as a museum of the applied arts established to improve the quality of industrial design. In this field Murdoch Smith's work was not confined to simple purchases: he acted as intermediary for a gift of contemporary textiles and carpets from Nasir al-Din Shah (ruled 1848–96) to South Kensington, for example, and his patronage of the potter Ali Muhammad Isfahani resulted in the Museum's acquisition of some striking tiles, one of which explicitly names the Scotsman in its dedication (plate 164). Ali Muhammad also wrote a treatise *On the Manufacture of Modern Kashi Earthenware Tiles and Vases*, which Murdoch Smith had published in Edinburgh in 1888.

Murdoch Smith's acquisitions quickly became so extensive that in 1876 the Museum was able to mount a pioneering display of almost 2,000 examples of Iranian art. The pieces shown were described in the accompanying *Catalogue of Persian Objects in the South Kensington Museum*, and the context was supplied by Murdoch Smith in a slim handbook, *Persian Art*. This contains the fruits of his researches, including valuable observations on the contemporary manufacture and use of many of the objects, and information on historical issues. A fairly lengthy account is devoted to Iranian blue-and-white fritware, which Murdoch Smith had been able to distinguish from the many examples of Chinese blue-and-white porcelain he had also collected in Iran (plate 136). His interest in this field reflected contemporary taste, and it ensured that the South Kensington Museum acquired the world's largest collection of Iranian blue-and-white wares, eventually comprising over five hundred pieces.

Through the quality and quantity of his collecting and associated research, Murdoch Smith undoubtedly influenced the reception of Iranian art in Britain, and he laid the basis for the V&A's extensive holdings of the decorative arts of Iran.

Section, which had a separate history from that of the main Museum.

The Indian Section had its origins in the years between 1796 and 1801, when a museum was established in London by the East India Company, the commercial organization that ruled British India until 1858. In this year the Company's assets were acquired by the British government, which transferred a large proportion of its museum collections to the South Kensington Museum in 1879. A strong lobby, including former viceroys, successfully supported the retention of the Indian Section in 1909, and as a result, the coverage of Islamic art in the V&A is still divided between two vast geographical units, one being the Middle East and the other South and South-east Asia. This is an unusual occurrence, but it is one that reflects the genuine differences between these two great regions.

Indeed, the very concept of Islamic art was relatively new at this time: it did not gain wide currency until the 1890s and 1900s. Before then, Middle Eastern art of the Islamic period was generally seen as either Arab (or Saracenic) or Persian (that is, Iranian). The Turks, meanwhile, were not considered capable of producing anything noteworthy: Iznik pottery was believed to be a product of Persian craftsmen, one theory even positing that the style was developed by Persian potters marooned on the island of Rhodes in the Aegean Sea. Attitudes began to change in the early twentieth century: F. R. Martin first published a Turkish attribution for Iznik in 1910. Such re-evaluations continued throughout the twentieth century, being increasingly based on information provided by archaeology, technical analyses, textual studies and other means.

The Islamic art of the Middle East is one of the great cultural bequests handed down to us. The central position of the region in the Old World has meant that the development of its art has been intertwined with that of its neighbours, so that it cannot be understood in isolation from Europe, Africa and Asia. Nor can the arts of these regions be fully understood without reference to the Middle East. The V&A, with its great collections formed in the nineteenth and twentieth centuries, and the mission to educate as its founding principle, is well placed to communicate this vital complexity.

Appendix

THE DYNASTIES

The most important dynasties in terms of the artefacts discussed in this book are:

THE UNIVERSAL CALIPHATE

The Umayyads

The founder of the dynasty, Mu'awiyah ibn Abi Sufyan, was a distant cousin of the Prophet. He became Caliph in AD 662 and converted the caliphate into a hereditary office, which his successors held until AD 750. Their capital was Damascus in Syria. After their fall, a single survivor, 'Abd al-Rahman, made his way to Spain, where he established an emirate centred on the city of Córdoba. In the tenth century, after the Fatmids had set up a Shi'ite imamate in North Africa, the Umayyads again assumed the title of Caliph and held it until 1012, after which they reigned intermittently until 1031.

The Abbasids

The Abbasids were closer relatives of the Prophet than the Umayyads, being descended from his uncle, al-'Abbas. The first Caliph of the dynasty overthrew the Umayyads in AD 750 and moved the capital of the Islamic empire to central Iraq, where the dynasty founded Baghdad, Samarra' and other cities. In the tenth century, the Abbasids were challenged by counter-caliphs in Egypt and elsewhere, and lost their independence of action, first to lords of the Buyid dynasty and then, in the eleventh century, to the Seljuk sultans. After the fall of the Seljuks at the end of the twelfth century, the Abbasids regained their independence as rulers of Iraq, but in 1258 they were finally overthrown by Mongol invaders. Thereafter a titular caliph of the Abbasid dynasty resided in Cairo until the Ottoman conquest in 1517.

EGYPT AND SYRIA, TENTH TO FIFTEENTH CENTURIES

The Fatimids

Members of the Shi'ite movements regard the Sunni caliphs as usurpers: the leadership of the Muslim community rightfully belongs to the descendants of the Prophet Muhammad through his daughter Fatimah. In AD 909, one of these descendants became the focus of a successful Shi'ite political movement in North Africa, and a Fatimid state was established. In 969 the Fatimid army conquered Egypt, and the capital was moved to the newly founded city of Cairo. The Fatimid caliphate lasted until 1171, when it was overthrown by the Ayyubids.

The Ayyubids

The first Ayyubid, Salah al-Din (Saladin), was the Sunni chief minister of the last Fatimid Caliph. In 1171 he overthrew his master and declared his allegiance to the Abbasid Caliph in Baghdad, who eventually, in the 1240s, awarded a member of the dynasty the title of Sultan. In Egypt the dynasty was replaced by the rule of the Mamluks in 1250.

The Mamluks

Although *mamluk* means 'owned, possessed', the term indicates political privilege rather than social ignominy, and it designates a political system rather than a single dynasty. During the Abbasid period it became normal for the ruler to recruit his household troops from outside the Islamic world, often from the Turkish lands of Central Asia, since they could be trained as soldiers from childhood and had allegiance only to the ruler. Nevertheless, their role as military strongmen gave these men access to power when their masters faltered, and in 1250, after the branch of the Ayyubid dynasty ruling Egypt had failed to supply a male heir, the sultanate passed to a royal *mamluk*. Mamluk sultans were succeded either by their sons or by a *mamluk* who had proved his military prowess or political wiliness. This system continued to supply rulers until the Ottoman conquest in 1517, which it survived, providing administrators at a lower level until 1811.

IRAQ AND IRAN, TENTH TO FIFTEENTH CENTURIES

The Samanids

As the Abbasid caliphate became less dynamic during the ninth century, provincial governors began to exercise more autonomy, and many established local dynasties. Among the

most important were the Samanids, one of whom was appointed amir of Farghana in western Central Asia in AD 819. By 874, a member of the family was governor of the whole of western Central Asia and of parts of eastern Iran, and the Samanids held power continuously until 1005.

The Buyids

Buyid governors ruled Iraq and western Iran from the 930s until the mid-eleventh century. They were under the nominal suzerainty of the Abbasid calips even though they were themselves Shi'ites. They were eventually overthrown by the Seljuks, who posed as the restorers of Sunnism in these regions.

The Seljuks

The Seljuk Turks invaded the Islamic world from the north-east in the early eleventh century and eventually established a great empire that stretched from Anatolia to Central Asia. After they had conquered Baghdad from the Buyids in 1055, they were acknowledged by the Abbasid Caliph as his protector, with the title of Sultan. The Seljuks lost control of eastern Iran in the mid-twelfth century and were removed from power in Iraq in the 1190s, but a junior branch remained as rulers of Anatolia until the first decade of the fourteenth century.

The Ilkhanids

Devastating Mongol incursions into Muslim Central Asia and Iran in the early thirteenth century were followed by a full-scale invasion in the 1250s, culminating in the conquest of Baghdad in 1258. The Mongols' leader, Hulagu, became ruler of Iran and Iraq as vassal of the Great Khan in China, with the title of Ilkhan. The Ilkhanids fostered an economic and artistic revival of their territories, but their dynasty failed in the 1330s.

The Timurids

Amir Timur emerged as one of the contenders for power in western Central Asia after the collapse of the Ilkhanid empire, and he proved the most successful, destroying those who opposed him. From the 1370s he rapidly acquired a huge empire of his own, ranging from the Aegean coast of western Turkey to the northern plains of India. After his death in 1405, his successors ruled a more restricted domain, eventually comprising eastern Iran and western Central Asia, with capitals in Herat and Samarqand. They were overthrown by the Uzbeks in 1507, but a Timurid, Babur, was later able to establish the Mughal empire in India.

LATER DYNASTIES

The Ottomans

Anatolia was settled by Muslim Turks from the end of the eleventh century. They soon gained political control of the central plateau, and after the Mongol invasion of the mid-thirteenth century, Turkish warlords began to move into the coastlands. One of the most successful was Osman, who established himself in Byzantine territory in north-west Anatolia. From here his descendants were able to invade south-east Europe, beginning in the 1360s. Having survived Timur's invasion of Anatolia in 1402, they established themselves as the leading power there and in the Balkans. In 1453 the Byzantine empire was extinguished when the Ottomans conquered Constantinople, which became their new capital, and in 1516–17 they made themselves masters of the Mamluk empire. Further expansion followed, so that the Ottomans were probably the world's most powerful state in the later sixteenth century. Although they later lost ground, the dynasty proved immensely durable, remaining in power until 1922.

The Safavids

The leaders of the Turcoman tribes of eastern Anatolia, Iraq and western Iran gained political power in the region after Timur's death at the beginning of the fifteenth century. Some allied themselves with the Safavi Sufi brotherhood, which had its centre in Ardabil in north-west Iran. The brotherhood converted to a form of Shi'ism late in the century, and beginning in 1500, its leader, the future Shah Isma'il, began to seize political power for himself. He succeeded in uniting all of Iran under his rule, and he and his successors established a Shi'ite state that survived until 1722.

The Qajars

The collapse of the Safavid state in Iran was followed by a period of political instability, during which the leaders of the Qajar tribe began to play an important political role. Towards the end of the century its forceful leader, Agha Muhammad, was able to gain control of the whole country, with Tehran as his capital. He was assassinated soon after, but was succeeded by his nephew Fath 'Ali Shah (ruled 1797–1834) and the dynasty ruled Iran until 1924.

NOTES ON TRANSLATIONS

1 Quoted from C.F. Petry, *Twilight of Majesty. The Reigns of the Mamluk Sultans al-Ashraf Qaytbay and Qansuh al-Ghawri in Egypt*, Seattle and London, 1993, p.15.

2 Quoted from Werner Caskel, *Arabic Inscriptions in the Collection of the Hispanic Society of America*, translated by Beatrice Gilman Proske, New York, 1936, pp.35–6.

3 Quoted from E. García Gómez, *Anales palatinos del califa de Córdoba*, Madrid, 1967, §237, pp.273–5, lines 4–5.

4 Based on the translation by James T. Monroe, *Hispano-Arabic Poetry: A Student Anthology*, Berkeley, 1974, poem 4, verses 27–31.

5 Based on the translation by A.S. Melikian-Chirvani, *Islamic Metalwork from the Iranian World, 8th–18th Centuries*, Victoria and Albert Museum, London, 1982, p.250.

6 Adapted from A.G. and E. Warner, *The Sháhnáma of Firdausí*, VI, London, 1912, p.382.

7 *The Book of Gifts and Rarities*, translated by Ghada al-Hijjawi al-Qaddumi, Cambridge, Massachusetts, 1996, § 357.

8 Quoted in Alan Caiger-Smith, *Lustre Pottery: Technique, Tradition and Innovation in Islam and the Western World*, London, 1985, p.197.

9 Anne E. Wardwell, '*Panni Tartarici*: eastern Islamic silks woven with gold and silver (13th and 14th centuries)', *Islamic Art*, III, 1989, p.136.

FURTHER READING

Historical surveys of Islamic art have been provided by a number of publications over the last two decades. The earliest were the two volumes in the Pelican History of Art series. The first, *The Art and Architecture of Islam, 650–1250*, has now appeared in a revised edition by Richard Ettinghausen, Oleg Grabar and Marilyn Jenkins-Madina (Yale University Press, 2002). It is matched by a second volume, *The Art and Architecture of Islam, 1250–1800*, by Sheila S. Blair and Jonathan M. Bloom (Yale University Press, 1994). Single-volume alternatives include *Islamic Arts* by Jonathan Bloom and Sheila Blair (Phaidon, 1997) and *Islamic Art and Architecture* by Robert Hillenbrand (Thames and Hudson, 1999). A different, thematic approach was taken by Robert Irwin in his *Islamic Art* (Laurence King, 1997). Other works that cover smaller (but still very large) themes are Oleg Grabar's *The Formation of Islamic Art* (Yale University Press, 1973) and Doris Behrens-Abouseif's *Beauty in Arabic Culture* (Markus Wiener, 1999).

The British Museum Press in London has provided a modestly priced series that includes introductions to *Islamic Metalwork* by Rachel Ward, *Persian Painting* by Sheila Canby (both 1993), and *Islamic Tiles* by Venetia Porter (1995). The same press has published an introduction to the Safavid dynastic style in Sheila Canby's *The Golden Age of Persian Art, 1501–1722* (1999). Edinburgh University Press and New York University Press have a similar series that includes Robert Hillenbrand's *Islamic Architecture* (1994), Sheila Blair's *Islamic Inscriptions*, and Eva Baer's *Islamic Ornament* (both 1998).

More lavish publications of general interest include *The Arts of Persia*, edited by R.W. Ferrier, and *Peerless Images. Persian Painting and its Sources* by Eleanor Sims (Yale University Press, 1989 and 2002 respectively), as well as two splendid books on aspects of Ottoman art: *Iznik. The Pottery of Ottoman Turkey*, by Nurhan Atasoy and Julian Raby (Alexandria Press, 1989), and *Ipek. The Crescent and the Rose. Imperial Ottoman Silks and Velvets*, a collaborative work led by Nurhan Atasoy, Walter B. Denny, Louise W. Mackie and Hülya Tezcan (Azimuth Editions, 2001). Exhibition catalogues offer access to other areas of Islamic art, including those for *Al-Andalus. The Arts of Islamic Spain* (Metropolitan Museum of Art, 1992), *Glass of the Sultans* (same museum, 2001) and *Timur and the Princely Vision. Persian Art and Culture in the Fifteenth Century* (Los Angeles County Museum of Art, and Washington, DC: Arthur M. Sackler Gallery, 1989).

ACKNOWLEDGEMENTS

This book would not have been produced without the generous assistance of a large number of people. They include Silke Ackermann, Sheila Canby and Venetia Porter of the British Museum; Doris Abouseif at the School of Oriental and African Studies in London; Vrej Nersessian of the British Library; Stephen Quirke at the Petrie Museum; Manijeh Bayani in Sussex; Emilie Savage-Smith, Oya Pancaroğlu and Amy Landau in Oxford; Pedro de Moura at the Khalili Collection; and Gerhard Behrens and Nicholas Shaw in London. Much of this assistance was key to the current form of the book, as in the case of Silke Ackermann's advice on science, Fr Nersessian's guidance on the Armenian objects and Manijeh Bayani's epigraphic skills.

Our colleagues in the V&A were also generous with their support. Rosemary Crill in the Asian Department provided experienced guidance and a sense of calm to a relatively new team. Although Oliver Watson was on leave of absence during the writing of this book, he had previously been generous with knowledge and ideas, and we hope this is reflected here. As the transfer of our Middle Eastern collections to the Asian Department is still in process, we have also been dependent on the cooperation of our colleagues in other departments, and we are grateful to them all for their assistance in a variety of ways. Thanks are also due to our project coordinator, Claire Thompson, to Vicky Oakley and the V&A's conservation teams, to our photographer, Mike Kitcatt, to Mary Butler, Ariane Bankes, Geoff Barlow, Clare Davis, Nina Jacobson and Frances Ambler at V&A Publications, and to our volunteers Alice Bailey, Tiziana Tavolieri, Ünver Rüstem and Nadania Idriss, who provided invaluable assistance while we were preparing this book.

A great deal of information found here has been gleaned from other people's publications. These are difficult to acknowledge in a book designed for a general audience: we have provided footnotes only for direct quotations. Nevertheless, it would be improper not to note our debt to A.S. Melikian Chirvani for his catalogue of the V&A's Iranian metalwork, to Yolande Crowe for her work on the Museum's Safavid blue-and-white ceramics, to Anthony Ray for his work on the Spanish tableware, and to Anna Contadini for her publication of the items from the Fatimid period. We must also mention the work on the Mamluk metalwork by James Allan, that of Nurhan Atasoy and Julian Raby on the Iznik ceramics, that of Stefano Carboni on the Museum's Islamic glass, that of Anne Wardwell on the Ilkhanid textiles, and that of Jennifer Scarce on Murdoch Smith and Ali Muhammad.

Finally, we are grateful to those who have been responsible for the travelling exhibition *Palace and Mosque*, which will circulate while the Jameel Gallery of Islamic Art at the V&A is in preparation: Deborah Swallow, Linda Lloyd Jones and Claire Thompson of the V&A; Jame Anderson, Gordon Anson, Susan Arensberg, Wendy Battaglino, Margaret Bauer, Michelle Fondas, Donna Kirk, Mark Leithauser, Lynn Matheny, Judy Metro, Naomi Remes, D. Dodge Thompson, and Tamara Wilson at the National Gallery of Art, Washington; Timothy Potts of the Kimbell Art Museum, Fort Worth; Thomas W. Lentz, former director of the International Art Museums Division, Smithsonian Institution; Dr. Massumeh Farhad, chief curator and curator of Islamic art, Freer Gallery of Art / Arthur M. Sackler Gallery; Tetsuo Taniya and Kyoko Imazu-Nanjo of the Yomiuri Shimbun; and Nick Dodd, Caroline Krzesinska, Nick Booth, Kirstie Hamilton and Dorian Church of the Sheffield Museums and Gallery Trust.

Picture Credits

INDEX

Page numbers in italic relate to material
mentioned in illustration captions.

'Abbas the Great, Shah, Safavid ruler, 40, 61, 66
Abbasids, dynasty, 92, 94, 96, 112, 138
'Abd al-A'immah, instrument maker, 106
'Abd al-Jabbar, calligrapher, 66
'Abd al-Malik, son of the regent al-Mansur, 82
'Abd al-Rahman I, Umayyad Emir of Córdoba,
 138
'Abd al-Rahman III, Umayyad Caliph at Córdoba,
 78, 78, 96
'Abdah, Fatimid princess, 96
Abdullah Khan, painter, 64
Abraham, Jewish patriarch, 10, 44, 56
Abu Bakr, 1st Caliph, 60
Abu Bakr, Mamluk Sultan, 97
Afghanistan, 8, 92, 139
Agha Muhammad, Qajar Shah, 72, 139
Ahmed III, Ottoman Sultan, 105
albums, calligraphy, 61
Alhambra, 134; vases, 120
'Ali, Imam and 4th Caliph, 51, 60
Ali Muhammad Isfahani, potter, 131, 137
amulets, pre-Islamic, 18-19, 19, 23
Ardabil (Iran), Ardabil carpets, 45, 54, 55, 74-5,
 74, 105, 135
Ardashir I, Sasanian king, 20
Armenians, 38, 38, 39; 40, 41
Armistice Day (1918), 132, 132
arrow shafts (al-azlam), 44
astrolabes, 13, 14-15, 14, 15, 106
astrology, 13, see also divination, fortune telling
Ayyubids, dynasty, 97, 138
Azadah, slave of Bahram Gur, 20, 86

Babur, Mughal emperor, 139
Bahram Gur, Sasanian king, 86-7, 87, 91
Banu 'Amir (Umayyad Spain), 77, 82
basins and bowls, ceramic, 48, 49, 82, 83, 91,
 102, 102, 103, 111, 113, 116, 117, 118, 120,
 120, 122;
 inlaid brass, 16, 17, 34, 56, 99, 134;
 rock crystal, 92, 96
Basra (Iraq), 92, 112
bathhouse rasps, 130-1, 131
Bayezid II, Ottoman Sultan, 60
Berber-zade Ahmed Efendi, calligrapher, 61, 106
al-Biruni, as natural historian, 94
Book of Gifts and Rarities, 94
books, bindings, 66, 66, see also Qur'an
bottles, glass, 34-7, 37
bowls, see basins and bowls

boxes, covered, inlaid brass, 129;
 Havdalah spice box, 39
brassware, 46, 132, 132;
 inlaid, 16, 17, 24, 24, 28, 29, 29; 31-4, 31, 39;
 56, 85, 91, 92, 93, 97; 98, 98; 99, 106; 120,
 125-30, 127, 128, 129, 134
bronze, statues, 56
buckets, inlaid brass, 128
Buckley ewer, 95
Bukhara (Uzbekistan), 28
al-Bukhari, compiler of Hadith, 44
burial practices, 12-13;
 textiles and, 32, 32, 33;
 tomb tiles, 28, 51-2, 103
Bursa (Turkey), 125
Buyids, dynasty, 139
Byzantine art, 18, 44
Byzantine empire, 8, 44, 139

Cairo, 7, 53, 56, 92, 94, 95, 96, 96, 118-22, 118
caliphate, 7, 29;
 Qur'an and, 27
calligraphy, 17, 26-7, 26, 27, 28, 28, 34, 37, 56,
 60-1, 60, 61, 66; 77-8, 106
candlesticks, inlaid brass, 24, 28, 97
carpets, 40, 41, 45, 54-5, 55, 58, 64, 74-5, 74,
 105, 135, see also prayer mats
caskets, carved ivory, 77-83, 78, 81, 85, 91, 114,
 114, see also boxes, pyxis
Catalogue of Persian Objects in the South
 Kensington Museum (Murdoch Smith), 137
Caucasus, 8
Central Asia, 8, 9, 18, 28
ceramics, see earthenware; fritware; lustre
 technique; porcelain
chalices, inlaid brass, 29, 29
Chanson de Roland, 115
charger, inlaid brass, 129
Charlemagne, 8
Chelsea carpet, 45, 54-5, 55, 135
China, 8, 9; 71, 99, 102, 106, 111-17, 123-4, 131,
 see also porcelain
Chinese motifs, 34
Christians, 22, 23, 29, 38, 38; 39, 40, 41, 43-4, 80,
 81, 94, 123-4
Churchill, Sir Sidney, collector, 66
Cilicia (Turkey), 38
Clarke, Caspar Purdon, museum official, 135
clocks and watches, 11;
 pocket watches, 12;
 Safavid clock dial, 46-7
Cohen, Alfred, 135
Cole, Sir Henry, 134
combs, boxwood, 130, 130

Constantinople, see Istanbul
Coptic community (Egypt), 118
Córdoba (Spain), 78, 78, 80, 81
Crystal Palace, London, 134
Ctesiphon (Iraq), Arch of Kisra, 20

Damascus, 44, 138
Damghan (Iran), 52
Dayr al-Madfan, monastery, 29
de Morgan, William, 117-18, 117
Deruta (Italy), 123, 123
dishes, ceramic, 22, 38, 39, 48, 49, 82, 83, 116,
 118, 123, 123
divination, 44, see also astrology, fortune telling
Dome of the Rock (Jerusalem), 44, 106
dress, 30-1, 30, 32, 58, 64, see also textiles
Durri al-Saghir (Umayyad official at Córdoba), 81

earthenware, 18-22, 18, 19, 22, 23, 69, 91, 111,
 see also fritware; porcelain
Ebüssuûd Efendi, Sunni jurist, 30
Egypt, 17, 18, 19, 19, 22, 23, 24, 28, 32, 45, 49,
 52, 53-6, 91, 92-3, 93, 94, 95, 96-7, 98, 98, 99,
 99, 108, 109, 114, 115, 116, 118, 118, 128,
 129, 130
Eleanor of Castile, 120
embroidery, prayer mats, 11, 11
England, 130, 131
Esref-zade Rumi, Sufi sheikh, 106
ewers, brass, 31-4, 31, 56, 120, 127, 127, 129;
 fritware, 43, 49, 83;
 silver gilt, 92, 126-7, 126, 127;
 rock crystal, 94, 95, 96
Eye of Horus, amulet, 19, 23

faience ware, 19, 23
Fath 'Ali Shah, Qajar Shah, 72, 72, 139
Fatimids, dynasty, 92-3, 94, 96-7, 114, 115, 118,
 138
Figani, poet, 56
filters, for water jars, 19, 19
Firdawsi, Book of Kings/Shahnamah, 52, 66, 86,
 87
fireplaces, 106
Florence, 125
fortune telling, 44, see also astrology, divination
Frankish empire, 8
fritware, 7, 13, 18, 28, 34, 43, 48, 49-51, 49, 50,
 53, 56, 58, 58, 69, 70, 82, 83-5, 88, 88, 91-2,
 99-102, 102, 103, 103, 105, 106, 106, 116-17,
 116, 117, 118, 122, 123, 130-1, 131,
 see also earthenware; lustre technique
furnishings, 58
Fustat (Egypt), 120

gambling (*al-maysir*), 44
gaming boards, marquetry, 130, *130*
German metalwork, *126*, 127, *127*
'Gianpetro', signature on pocket watch, *12*
glass production, 8, 34
glassware, *16*, *21*, 24, 34-7, 37, 45-9, *45*, 52, 108, *109*, 112-13, 130
'Golden Horn' ceramics, 56
Great Exhibition (London, 1851), 134
Guangzhou (China), 111
Gubbio, Giorgio di, *111*, 123
Gunbad-i Qabus, Jurjan hoard, 91-2, 116

Habiballah son of 'Ali Barharjani, metalworker, 106
Hadith, 44
Hafiz of Shiraz, poet, 84, 92
Hagia Sophia (Constantinople), 23-4, *23*
al-Hakam II, Umayyad Caliph at Córdoba, 80, *81*, 89
Hamdullah, Ṣeyh, calligrapher, 60, 61
Herat (Afghanistan), 92, 139
herbals, European, 72
Hercules, amulet, *19*, 23
Hijrah, the, 10
al-Hilli, Shi'ite jurist, 44
Hisham I, Umayyad Caliph at Córdoba, 78, 89
hoards, 88-9, *88*
hookah bases, *43*, 50
Hulagu, Ilkhanid ruler of Iran, 139
hunting horns, carved ivory, 114-15, *115*
Hürrem Sultan, wife of Sultan Süleyman, 103

Ibn Taghribirdi, historian, 56
Ibn Taymiyyah, Hanbali jurist, 52-3
Ibrahim Pasha, Ottoman vizier, 56
iconography, 23, 43-75
Ilkhanids, Mongol dynasty, 139
images in Islamic art, 23, 43-75
India, 9, 71-2, *71*, 135, 137
inscriptions, 19-23, 24, 28, *28*, 33, 34, 37, 49, 52, 53, 56, 83, 85, 92, 94, 97, 100
Iran, *12*, 13, *13*, 18, *18*, 19, 20, 22, 31, 32, 33, 34, 43, 45, 48, 49, 50-2, *51*, 53-6, *53*, *58*, 64, 66, 69, *70*, 72, 74-5, *74*, *82*, 83-7, 88, *88*, 91-2, 94, 116, *116*, *117*, 118, 123, 131, *131*, 139
Iraq, 18, 112, 118, 132
Isfahan (Iran), 13, *14*, 38, 46, 58, 106;
 Isfahan cope, 40, *41*
Islamic law, 7; luxuries and, 30-1
Isma'il, Shah, Safavid ruler, 58, 64, 74, 139
Isma'il, Mamluk Sultan, 49
Istanbul (Constantinople), 23-4, *23*, 53, *106*, 139
Italy, 115, 117, 123, 124-8, *124*, *125*, 129
ivory, 77-83, *78*, *81*, 85, 91, 114, *114*, 115, 128, 130, *130*
Iznik (Turkey), 7, 56, 70, 99, 102-5, *102*, *103*, 105, 106, *106*, *116*, 137

jade, jugs, 92

Jerusalem, 10; Dome of the Rock, 44, 106
jewellery, Murcia hoard, 88-9, *88*
Jews, Judaism, 38, 39, 43
Jones, Owen, 134
jugs, ceramic, *48*, 49;
 inlaid brass, 85, 92, 106;
 jade, 92;
 silver gilt, *126*, *126*
Jurjan (Iran), fritware hoard, 88, *88*, 91-2, 116
Justinian, Byzantine emperor, 23

Ka'bah (Mecca), 10, *10*, 12, 32, 44, 56
Kafur al-Rumi, 49, 52
karalamas, calligraphic exercise sheets, 61
Kashan (Iran), 13, 43, 48, 49, 50, 53, 82, 83, 88, *88*, 91-2, 116, *116*, 122
Khamsah (*Five Tales*) (Nizami), 66
Khusraw Anushirvan *see* Kisra
Khusraw Parviz, Sasanian king, 20, 66, 85
Khusraw and Shirin, 20, 66, *66*, *67*, *77*, 85
Kisra (Khusraw Anushirvan), Sasanian king, 20
Kütahya (Turkey), 38, 39

lamp-holder, inlaid brass, 24, 98, *98*
lamps and lamp-shaped vessels, *16*, 24, 28, 37, 45-9, *45*, 52, *105*, 106
Lane-Poole, Stanley, 135
leather, book bindings, 66
Longfellow, Henry Wadsworth, 108
Los Angeles County Museum of Art, 75
love poetry, 83-5
'Luck of Edenhall', 108, *109*, 130
lustre technique, 118-23, *see also* fritware
luxuries, and Islamic law, 30-1

Madinat al-Zahra (Spain), 78-82, *78*
magnetic compasses, 11, *12*
Mahmud al-Kurdi, metalworker, *129*
maiolica, 117, 123
Málaga (Spain), *120*, *120*, 122
al-Malik al-Mansur, Mamluk title, 134
Mamluks, rulers of Egypt and Syria, 28, 34-7, *37*, 53-6, 58, 97, 138
Manises (Spain), *120*
al-Mansur, regent (Umayyad Spain), 82
al-Maqrizi, historian, 106
Maqsud Kashani, carpet designer, 74, 105
marble, 78
Margar Dpir, illuminator, 38
Marlborough House (London), Museum of Manufactures, 134
marquetry, 130, *130*
Marwan I and II, Umayyad Caliphs at Damascus, 32, 33
Maw, George, 135
Mecca (Arabia), 7, 10-12, *10*, *12*, 13, *14*, 97
Medina (Arabia), 10, 24, 32, 33, 97, 100
Mehmed II, Ottoman Sultan, 24, 99-102, 123, *123*
Metropolitan Museum of Art (New York), 115

mihrabs, 7, 11, 13, 23, 24
Mina'i wares, 48, 49, 83, 91
minbar, 7, 24, 28, 37;
 of Sultan Qa'itbay, 98, 100, *101*, 135
Mir 'Imad, calligrapher, 61
Mongols, in Iran, 27, 50-1, 64, 83, 86-7, 88, 92, 116, 123
moon, personified in cartouche, 34
'moresque' decoration, 125-8
Morocco, 52, 135
Morris, William, *74*
mortars (culinary), 46
mosques, 7, 11, 13, *16*, 17, 23, *23*, 24, 28, 37, 44, 98, 100, *101*, 135, *see also* mosques by name
Mouradgea d'Ohsson, Ignace, *10*
Mu'awiyah ibn Abi Sufyan, Umayyad Caliph at Damascus, 138
Muhammad, Prophet, 7, 10, 32, 33, 100
Muhammad, Mamluk Sultan, 97
Muhammad Khalil Isfahani, astrolabist, *14*
Muhammad Mahdi Yazdi, astrolabist, *14*
Muhammad Muhsin Tabrizi, book binder, 66
Muhammad, son of Muhammad Nishapuri, potter, 92
muhaqqaq style (calligraphy), 60, *60*
Murcia hoard, 88-9, *88*
Murdoch Smith, Major General Sir Robert, 131, 135, 136-7
Museum of Science and Art (Edinburgh), 136
musicians, depictions of, 82-3, 85
Muslu the Painter, 106
Mustafa II, Sultan, 61
Mustafa ibn Muhammad, calligrapher, *61*
Myers, Captain W.J., 135

Nasir al-Din Shah, Qajar ruler, 137
naskh style (calligraphy), 60, 61
nasta'liq style (calligraphy), 60-1, 66
Natanz (Iran), 52
Netherlandish metalwork, *126*, 127, *127*
Nishapur (Iran), 22
Nizami, *Khamsah* (*Five Tales*), 66;
 Khusraw and Shirin, 66, 77, 85
Noble Sanctuaries, *see* Mecca; Medina
Normans, in Sicily, 114

'oliphants' (ivory hunting horns), 114-15
Osman, 139
Ottoman empire, 17, 28, 56, 58, *58*, 64-71, 92, 98-105, 126, *126*, 139

Pamplona casket, 82
patronage, 23-30, 38, 77, 91, 92-3, 94, 96-105, 117, 118
Persian Art (Murdoch Smith), 135, 137
Piccolpasso, Cipriano, 118
pilgrimage, Christian, 23; the Hajj, 12
poetry, 66, 77-87, *87*
porcelain, 97, 99, 106, 112-13, *113*, 118, 137, *see also* earthenware; fritware

portraiture, 56, 72, *72*, *73*, 123, *123*
prayer mats, 11, *11*, 13
prayers, determining the times of, 11, 13, 14-15; towards Mecca, 10-12, 13, 14
pulpit, *see* minbar
pyxis, inlaid brass, 29, 39; carved ivory, 77, 80, *81*, *128*, 130, *see also* boxes, caskets

al-Qadisiyyah, battle of, 20
Qa'itbay, Mamluk Sultan, 24, 37, 56, 97-8, 134, 135; mosque of (Cairo), 96
Qajars, dynasty, 17, 72, 139
Qiblah, 10-11, *11*, 12, *12*, 13, 14-15, 32
Qur'an, 10, 12, 17, 26-7, *26*, *27*, 30, 43, 44, 61

Raqqah (Syria), 122, *122*
Redgrave, Richard, 134
relics, idolatry and, 52; textiles, 32
reliquaries, ivory caskets, 80, *81*; rock crystal, 94; with Sasanian silk, 20
retes (star maps), 14, *14*
Richard, Jules, 137
Riza 'Abbasi, book illustrator, 66, 67, 106
Robinson, Vincent, 135
rock crystal, carvings, 8, 92, 94, *95*, 96
Roman Catholics, 40
Rukn al-Din Muhammad al-Baghdadi, patron, 97

Sacrifice, Feast of, 12
Safavids, dynasty, 13, 46-7, 58-64, 71, 74, 139
Safi II, Shah, Safavid ruler, 13
Safi al-Din, Shaykh, Sufi leader, 56-8, 74; shrine of, 45, 74, 75
St Leu (Paris), church of, 20
Saint-Maurice, Gaston de, 135
St Menas, 22, 23
Salah al-Din (Saladin), Ayyubid ruler, 97, 138
Salting, George, 135
Samanids, dynasty, 138-9
Samarqand (Uzbekistan), 139
Sasanian empire, 18-19, *19*, 20-1, 34, 87
Sasano-Islamic artefacts, 18-19, 111
Schranz, Antonio, 96

Seljuks, dynasty, 139
Semper, Gottfried, 135
senmurv motif, *20*, 21, 34
Şeyh Hamdullah, *see* Hamdullah
Shahnamah/Book of Kings (Firdawsi), 52, 66, 86, 87
al-Sharif al-Taliq, poet, 83
Shi'ites, 44, 58, 60, 92, 138, 139
shoes, 130-1, *131*
shrines, Shaykh Safi al-Din, 45, 74, 75
Sicily, 114, 122
silks, *11*, 20, 22, 30-1, *30*, 32, *32*, 33, 40, *41*, 58, *58*, 64, *64*, 65, 70, 98, 123, 124-5, *124*, *125*, 130, *131*
silverware, 126-7, *126*, *127*
Sinan, court architect, 24
Six Pens style (calligraphy), 60, 61
South Kensington Museum, 134-5, 136, 137, *see also* Victoria and Albert Museum
Spain, 8, 77-83, *78*, *81*, 85, 88-9, *88*, 96, 120, *120*, 122-3, 130, *130*, 138
star maps (retes), 14, *14*
statues, Sultan Süleyman and, 56
stones (*al-ansab*), , 44
storage jars, ceramic, 18, *18*, 34, 69, 122
Subh, wife of Caliph al-Hakam II, *81*
Sufi brotherhoods, 56-8, 74, 85, 106, 139
Sulayman, Shah, Safavid ruler, 13
Süleyman (the Magnificent), Ottoman Sultan, 24, 28, 56, 103, 106
Süleymaniye mosque (Istanbul), *23*, 24, 28, 37, 103
Sultan Hasan mosque (Cairo), 7
Sultan Husayn Mirza, Timurid ruler of Herat, 92
Sunnis, 44, 58, 60, 97, 98
swords, 28, 29
Syria, 17, 18, 22, *22*, 28, 45-9, *45*, 52, *91*, 92, 108, *109*, 122, *122*, *128*, *129*, 130

tables, tile-top, 103, *106*
Tahmasp, Safavid Shah, 74, 75, 105; sword of, 29
Takht-i Sulayman palace (Iran), 86-7, *87*, 91
Taq-i Bustan (Iran), rock-cut monument, *20*
Tell Minis ware, 122
textiles, *see* carpets; dress; embroidery; silks

tiles, 7, 13, *13*, 28, *28*, 50-2, *50*, *51*, 53, 56, 58, 60, 64, *70*, 71, 85-7, 87
Timurids, dynasty, 58, 64, 92, 139
tombs, tiles, 13, *13*, 28, 51-2, *51*, 103
trade, 8-9, 18, 71, 111-17, 123, 125-9
trays, brass, 132, *132*; inlaid brass, 93, 97, 134
Turkey, 7, 8, *11*, *12*, 56, 58, *58*, 64, *70*, *91*, 99-105, *102*, *103*, 125

Uhland, Johan Ludwig, writer of 'Luck of Edenhall' ballad, 108
Ulughbeg Mirza, Timurid ruler, 92
'Umar, 2nd Caliph, 60
Umayyads, dynasty, 44, 77-83, *78*, *80*, *81*, 91, 96, 138
'Uthman, 3rd Caliph, 60
Uzbekistan, *28*
Uzbeks, 58, 139

Valencia (Spain), *120*, 122
Varamin (Iran), *50*, 51-2
vases, ceramic, 49, *49*, 83, *111*
velvet, silk, 64, *64*, 65, 71, 125, *124*, 125
Veneto-Saracenic metalwork, 98, 125–30, *128*, *129*
Venice (Italy), 125
Victoria and Albert Museum, 117-18, 134, 135-7, *see also* South Kensington Museum

al-Walid II, Umayyad Caliph, 92
water jars, earthenware, 19, *19*
wine (*al-khamr*), 44, 49, 83, 85

Xian (China), 8

Yasa, Mongol laws, 64
Yazdagird III, Sasanian king, 20

Zamora (Spain), Cathedral, *81*
Zayn al-Din, metalworker, *128*
Ziegler & Co., of Manchester, 75
Ziyad ibn Aflah, Umayyad official at Córdoba, 80, *81*
Zodiac Man, 46-7
Zoroastrians, 20, 38, 43, 44